ALASKA'S ARTS, CRAFTS & COLLECTIBLES

ANN CHANDONNET

ALASKA'S ARTS, CRAFTS & COLLECTIBLES

By Ann Chandonnet

Library of Congress Cataloging in Publication Data
Chandonnet, Ann, 1943-
 Alaska's Arts, Crafts and Collectibles by Ann Chandonnet.
Includes index, biographies
Library of Congress Catalog Card Number: 98-92499
ISBN 0-9662999-0-6
 1. Decorative arts--Alaska. 2. Painting--Alaska. 3. Indians of North America--Art--Collectors and collecting--History 4. Beadwork--Alaska. 5. Indians of North America--Costume and adornment. 6. Eskimos--Alaska--Art--Collectors and collecting. I. Title.

Published by Chandonnet Editing & Research
 6552 Lakeway Drive
 Anchorage, AK 99502-1949
 afchan@alaska.net

Distributed by Todd Communications, 203 West Fifteenth Avenue, Suite 102, Anchorage, AK 99501. (907) 274-8633. FAX: (907) 276-6858. sales@toddcom.com

Edited by F.L. Chandonnet
Layout and design by Julie Stricker and Sam Harrel
Cover photos and others as noted by Roy Corral, Corral Photography, Eagle River
Printed and bound in the USA by Gilliland Printing

Cover art:
 * Front cover: Striped background: Closeup of Aleut bentwood hat by Rich LaValle. Black and white insets: Top left, one-of-a-kind silver pendant by Ron Senungetuk. Top right, parky by Esther Norton. Bottom left, cream pitcher with blanket toss drawings by Robert Mayokok. Bottom right, baleen basket from Barrow topped with ivory seal. All photos by Roy Corral, 1998.
 * Back Cover: Top, "The Four Saints of Alaska," print of an original icon by Byron Birdsall; photo by Roy Corral. Bottom right, boy modeling Aleut bentwood hat by Rich LaValle; photo by Ann Chandonnet, 1990.

Table of Contents

APPENDICES

INDEX

ACKNOWLEDGEMENTS

Thanks to Ron and Lynn Dixon of Cook Inlet Book Co. for sharing their expertise, to the publications division of Artique Ltd., to Mousa S. Obeidi of Obeidi's Fine Art Gallery, to Don Decker of Decker/Morris Gallery, Nicole Nathan of the Marvin Oliver Gallery, Kasey Correia of Tundra Arts, Mary Beth Michaels of Sky High Publishing, to Teresa Ascone, Nancy E. Brown, Kim Corral, Bill and Mindy Dwyer, Diane Brenner, Leo F. Fay and Mina Jacobs of the photo archives at the Anchorage Museum of History and Art; Nancy Jordan Strohmeyer, Joanne Townsend, David Mollett of SITE 250 Fine Arts, Flip Todd, Steve Levi and Susan Braund for lending their ears and encouragement. I try to thank my dear husband every day for his strong shoulder — but my thanks are always insufficient to the gifts he lavishes.

Thanks to those artists who generously supplied black and white photos of their work.

Dover Publications Inc. allowed the reproduction of four renderings by Paul E. Kennedy from the *North American Indian Design Coloring Book* (Mineola, N.Y., 1971).

Jeffrey R. Patrick, "Sculptor for All Alaska," granted written permission to photograph and publish an image of "Pound O' Truth."

Mary Beth Michaels granted written permission to quote from her book *Expressions: Art by Interior Alaskans* (1994).

Larry Garfinkel of Vancouver, B.C., gave written permission to use Garfinkel Publications' postcard image FPC 26, "The First People: Big House."

The chart, "Artists of All Alaska Juried Art Exhibition Series, 1976-1996 ... " is reproduced with the written permission of Wanda Seamster of Anchorage, publisher of the arts newsletter, *Vizual Dog*.

Thanks to Susan Springer whose card borders have been used as decorative elements.

Last but not least, thanks to Julie Stricker and Sam Harrel for their patience and professionalism.

INTRODUCTION

"In pre-industrial societies generally, art is not a thing apart but an element in the objects and activities of everyday life. It is well-known, for example, that the Eskimo have no word in their language for 'art' as such. In an Eskimo village, nearly all of the adult males probably will be engaged part time in ivory carving, and as many as half may be thought of as 'best.' Their definition appears to include versatility as well as proficiency, suggesting a resemblance to the medieval European craftsman's guild."

— R. L. Shalkop, Director, Anchorage Historical and Fine Arts Museum, in *An Introduction to The Native Art of Alaska* (1972).

Weather-bleached bone, scraps of wood, hanks of grass — things other cultures might have considered refuse — have been cleverly used by Alaska's Native peoples to create adornments, amulets and tools that are both functional and beautiful.

To the aboriginal Eskimo, an oarlock wasn't just a boat fitting. It had its utilitarian function, of course, but could also take the shape of the wished-for prey, be carved into a seal's sinuous neck and inquisitive face. Driftwood handles for water buckets, stone lamps for heat and light, ladles for the fish soup, intestine pouches for storing bird bone needles and beluga sinew thread — whenever Alaska's indigenous peoples had sufficient livelihood and leisure, they lavished decorative flourishes on the most common household items.

Among northern and interior Alaska's Athabascan Indians, where hunting and gathering required traveling over huge territories, most art objects were tiny and portable. In contrast, among the Tlingit and Haida of Southeast Alaska, where supplies of food were more stable and available within narrower compass, there was more time for art. Consequently, enormous, permanent creations like totem poles and plank houses were aesthetic possibilities — and magnificent realities.

Among the Aleut and Athabascan, the tunic of an important person should demonstrate his social and economic status, both tied directly to his skill as a subsistence hunter. Eagle feathers, bear claws, wolverine paws, puffin beaks, sea lion whiskers and caribou teeth adorned belts and parkys, raincoats and hats. Lichens, bark and minerals were used to dye fur trim for leggings, mukluks and moccasins.

To the Tlingit, even a fishhook for catching halibut should, by its beauty, show the respect the fisherman had for the immortal spirit of his intended catch. A fishhook was a prayer in wood.

Archaeological digs have revealed that Pacific Northwest peoples were skillfully and artistically weaving grass and bark, working wood and sculpting ivory at least 2,500 years ago. As soon as they encountered Europeans, indigenes saw the possibilities for trade in a variety of items, and began producing items specifically for trade. Some craftsmen even modified their craft to suit the newcomers; they scrimshawed soap labels and American flags on walrus tusks, or carved argillite into sailor look-alikes.

When these objects came to rest in curio cabinets around the world, there was considerable debate about them. Should a carved Nisga'a mask called "Keeper of Drowned Souls" be compared with "The Night Watch"? Could an ivory seal be displayed on the same shelf as a Roman bust?

What does one call this art? "Primitive"? "Naif"? "Tribal"? "Aboriginal"?

"Tribal" has been chosen by The New York Tribal Antiques Show, which held its third annual event at The Armory at Gramercy Park October 17-19,1997. The 90 international dealers participating all exhibited and sold "pre-1940 American Indian, African, Asian, Oceanic, Folk, Devotional, Textile & Tribal Art & Antiques." The schedule included a "tribal tour" and a lecture series. A show preview benefited the Museum for African Art. The example included in the show's display ad was a Canadian mask.

When French artist Georges Braque saw his first African masks, he termed them "instinctive things."

But, considering the sophistication of design, the formal repetitions, the stylized appendages of many of these pieces, as well as the complex of legend behind them, whether African or Arctic, is "instinctive" really applicable?

Is a man who creates a totem pole a "craftsman"? An "artist"? An "artisan"? Is art only what can be hung on a wall or installed on a pedestal in an urban plaza? Can one wear it? Sleep warm under it?

Those debates are for another place and time. Let it suffice to say that beauty is in the eye of the beholder. Pat Austin once advised me, "You should only collect what you lust after." What she meant is, if you feel a strong pull toward a certain object, snap it up immediately. If you don't, walk on.

I'd add, snap up only what is complex enough to enjoy for a lifetime. Avoid the cartoon of the mountain or the reflection of the moose in the pond — unless it's on a postcard.

"INDIAN CURIOS.
Finely carved Totem Poles and Dishes.
Indian Baskets from Yakatut and Chilcat.
R. Meyers & Co."
— Display advertisement in the *Alaska Traveler's Guide*, Skagway, August 2, 1900.

What do collectors want from Alaska? A century ago, John Muir was annoyed when fellow tourists along the Inside Passage turned away from the spectacular vistas of glaciers, forests and mountains to haggle over Tlingit baskets.

Today, collectors also seek baskets, but the range of souvenirs has broadened considerably. For example, photographer/printer Rollie Ostermick of Trapper Creek fields phone calls about postcards: "They're looking for lighthouses, or they're collecting postcards with maps of all the states. We get a few such calls a year," Ostermick says. "But most people are looking for cards with wildlife like moose and wolves."

Which Alaska collectibles are most prized? According to Dory Stucky of Alaska General Store, there are certain standouts: "I get calls from all over the country about tokens, drugstore bottles, medicine bottles, milk bottles, and bottles from the Nome Bottling Company [a Gold Rush brewery]. Alaska never had many dairy farms, so there are some things you can set your own prices for. And, of course," she added, confidingly, "if I get certain items, there are collectors I call first."

On Anchorage's main drag, Fourth Avenue, Alaska General Store stocks everything from seven-foot thunderbird totem poles to movie posters, antique postcards, beadwork, rare books, T-shirts by Ray Troll and glass net floats. A vintage caribou trophy head hangs above a table displaying a dozen new zinc-roofed bird houses. Alaska General also has a Juneau location. Each may resemble Grandma's attic — but it's Grandma's attic with mastodon teeth and forget-me-not seeds. Fortunately for collectors, there are havens like this all over the Great Land.

"Spawn Till You Die"
"Migs and Turbot"
"The Archfishop"
"Rousseau's Humpies"
"Ain't No Nookie Like Chinookie"
"Time's Fun When You're Having Flies"
"Coelacanth at Midnight"
"Cutthroat Businessmen"
"Bass Ackwards"
"Bear Attack at Art Opening"
--titles of paintings, drawings and silkscreens by Ray Troll, *Shocking Fish Tales* (Alaska Northwest Books).

For collectors whose yearnings are not for objects from the past, consider what's happening as we speak. Contemporary art in Alaska is all over the map. It is Native and non-native, functional and decorative. In 1981, Joseph E. Senungetuk entered a sculpture called "Arctic Terns Doing It" (33x38x11 inches) in the "Wood, Ivory and Bone" show, a statewide competition for Alaska Native artists, sponsored by the Alaska State Council on the Arts and the Alaska State Museum. Or was it a mask? Or a wall hanging? Or all three? The materials Senungetuk used in this amusing work were laminated walnut and oak, ivory, brass, ebony, human hair, leather, nylon line and acrylic paint. Senungetuk used two of the required materials (wood and ivory), but his choice of form (insectoid) and his subject (sexual) were definitely "in your face."

Of Alaska's 560,000 residents, only 16 percent are Native Americans like the omni-talented Senungetuk. The remaining 84 percent includes hundreds of professional artists as well as part-time craftsmen and artisans.

As Native Americans are stepping away from the traditional forms and materials of the past, so are non-Natives. The name of the game at this end of the 20th century seems to be "mixed media." Everything from broken toys to brown paper shopping bags may show up in art work. Casts of roadkill? Of course. Bronzes of sea otter skulls in various stages of decomposition as a result of the *Exxon Valdez* oil spill? Right on.

And there's no stopping now. Fiber and even fish skin surfaces as basket material. Consider Cordova environmentalist Rikki Ott's sofa pillows appliquéd with sea life or Cordova fisherwoman Rocky Stone's kimonos. What are we to make of Sally Oberstein's mixed media jewelry? Lowell Zercher's wooden clocks in the new Anchorage courthouse? Arnold Geiger's spinning wheels? Alice Gant's reverse-appliqué fiber art with its *mola*-like layering and Ree Nancarrow's improvisational art quilts? Carolee Pollock's quilt patterns like "Puffin Dreams"? Wooden "environments" by former finish carpenter Jeffrey R. Patrick? Tracy Anna Bader's one-of-a-kind, appliquéd plush swing coats and vests? Walrus masks incorporating chrome hub caps and oil funnels? Zinc etchings on handmade blue-jean paper by Dianne Anderson? Fiber artist Paula Dickey's "Tide Pool," a basket-like pool with two, twenty-foot, interlocking, wave-shaped strands attached? Norma Sorby's mixed media construction, "Picking Lemons," an open-front box just under a foot square, with a jointed wooden figure inside and a lemon and a toy two-decker bus perched on top? Artwork featuring neon light sources?

Alaska's fabric arts are alive and well, with weavers and spinners turning out creative works from their own sheep and even from sled dog hair. The multifarious quilts alone are worth an entire volume.

And then there's Jeff Patrick's latest scherzo, a "limited edition" of 10,000 chunks of lead, each in a molded form very like a plumb bob, bearing on one of its three sides the word TRUTH. The whimsical work is called "Pound O' Truth." Makes a

great paperweight. Keeps the strings of helium balloons well anchored. But, certainly there's more connotation waiting in the wings. Is this not a sly modern amulet, a reminder of the elusive prey that is sought? A hefty, shining spirit helper to hang about the neck on a velvet cord? Isn't its very weight a joke about weighty creations?

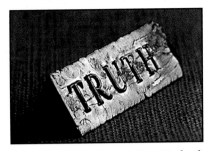

Only Patrick can say for sure.

Before leaving the subject of arts in Alaska, it's imperative to make note of (pun intended) music. The ancient and rhythmic melodies of the Eskimos and Indians were performed by drums and voices only, and lacked any method of notation. However, the music of groups like the King Island Dancers (founded by ivory carver and tradition bearer Paul Tiulana and led of late by Teddy Mayac and Sylvester Ayek) has influenced composers like Craig Coray, Gordon Wright, Fairbanks's Father Normand Pepin, Wasilla's Philip Munger and John Luther Adams. One of Coray's most recent works is "We Walk to the Sky," a 14-minute symphonic composition which debuted in Washington, D.C., in1995, a commission from the National Symphony Orchestra. Alice Countryman (Anchorage) is known for setting contemporary Alaska poetry to music.

"Pound O' Truth," 63/10,000, lead, 3.75 x 1 3/8 inches, 1997, Jeffrey R. Patrick.

Ensconced in his own popular nightclub, in the "sleazy" shade of satin palms, Mr. Whitekeys earns applause for setting street signs, personalized license plates and municipal regulations to music.

Athabascans have taken up the fiddle in the last 100 years, and fiddling concerts take place regularly in Fairbanks. The fiddle's tones are usually combined with those of guitar and, occasionally, accordion.

Among the newest collectibles, therefore, are cassettes and CDs of Alaskan music.

"Cultural tourism is one of the fastest growing segments of the world travel industry. According to the Division of Tourism, the number of visitors to Alaska between 1992 and 1994 who sought cultural experiences increased by 27 percent. These tourists stay longer and buy art and crafts from local artists and artisans."

— "Cultural Resources Sector Working Group Report," Marketing Alaska, Draft 10/11/95.

ONLY PART OF THE PICTURE

The following text is intended only as an outline of and introduction to an extremely broad and diverse and continually changing field. The listings of practitioners, historical practitioners, and sources supplied herein are not intended to be complete, but merely to offer a modicum of guidance. The omission of any particular artist's or craftsperson's name is a consideration only of space available — not an artistic dismissal.

Consider visiting galleries and private studios for the whole picture. And please consult the recommended references and the reading list for more in-depth knowledge.

Museums, trading posts and galleries located outside Alaska have been mentioned to show the world-wide appetite for and disposition of collectibles.

ABOUT THE FORMAT

In the following entries about Materials, Art Forms and Motifs, each entry is divided into handy bits of information (although all entries do not include all the components):

* A definition.

* Historical background and/or a description of how materials are harvested or processed, and/or how materials are/were used.

* Further background reading.

* "See Also" lists the titles of related entries within the text.

* "Alaska Live": If performances/demonstrations of this artform occur.

* "Museums," public collections where examples of this artform can be viewed.

* "Teacher Alert," if there is educational information available.

* "Historical Practitioners," deceased individuals whose work is especially prized or noteworthy.

* "Practitioners": Contemporary artists and craftspeople. Tribal associations, current place of residence, and artistic specialties may also be listed.

* "Insider Tips": Facts that first-time visitors are unlikely to know.

* "Sources": Shops known to carry this artform.

* "Referrals": Experts or shops who can refer collectors to practitioners in the area.

* "Notes" or "Consumer Alerts" include other details of relevance.

"Sky Sections: Tenakee Springs," aquarelle, 30 x 22 inches, 1986-95, Pat Austin.

MATERIALS, ART FORMS, MOTIFS

ABALONE SHELL

The abalone is a large, tasty mollusk. The inner surface of its single shell is a source of mother-of-pearl. This mollusk was common along the Pacific Coast in the early 1800s, but was subsequently over-harvested.

Spanish explorers introduced California abalone to Pacific Northwest tribes, who found it more colorful than their local species, and coveted it for artistic applications.

Salish, Tlingit and other Pacific Northwest peoples used inserts of gleaming abalone to ornament bone war clubs, cedar dancing headdresses, ceremonial rattles, face masks, forehead masks, shaman's gear, grease dishes, feast ladles and other carvings. Kwakiutl Indians (from Northern Vancouver Island and the adjacent mainland) carved abalone shell into nose ornaments.

Like bits of mirror (later substituted for it), abalone shell glinted in the firelight. Sometimes the insets took the form of rectangular plaques; on other occasions insets glittered from the gums or eye sockets of masks. Some button blankets used plaques of abalone in addition to mother-of-pearl buttons to limn crest figures like ravens and frogs. For illustrations of a variety of abalone applications, see Allen Wardwell's *Objects of Bright Pride: Northwest Coast Indian Art from the American Museum of Natural History* (University of Washington Press, 1979).

Because abalone is a member of the gastropod family *Haliotidae*, the material is sometimes referred to as "haliotis."

See also BUTTON BLANKETS, CARVINGS, FRONTLETS.

Practitioners: Nathan Jackson (Ketchikan; uses abalone as inlays in alder frontlets); Norman Jackson (Kake, uses abalone in necklaces made of sea lion teeth and glass beads and in canes and briar wood pipes).

Sources: Black Elk Leather (Anchorage) and similar beading supply houses/stores.

ALABASTER

Alabaster is a finely granular variety of gypsum, often white and translucent. It is used for figurines, lamp bases, vases and sculptures.

Traditionally, Alaska's carvers worked in local woods such as alder and cedar. However, carvers born in the 1940s and thereafter have availed themselves of other materials, such as alabaster, marble and ebony. Lawrence Ahvakana, an Inupiat born

1

in 1946, is typical of the modern, formally educated Native American artist who works in materials such as alabaster. Ahvakana studied at the Institute of American Indian Art (Santa Fe, N.M.) and the Cooper Union School of Art (New York City).

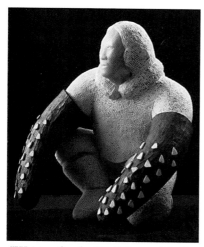

"Waiting for the Wolf Dance," Italian alabaster, 1985, by Lawrence Ahvakana. CIRI Collection.

He received his BFA from the Rhode Island School of Design, and has been awarded numerous public commissions. He has also taught glass blowing in Barrow — a medium brand new to this Inupiat area.

For more on Ahvakana, see *The Alaska Journal*, II, 4:37.

See also CARVINGS, SCULPTURE, SOAPSTONE.

Historic practitioner: Melvin Olanna.

Practitioners: Lawrence Ahvakana (Inupiat, b. 1946); John Kailukiak; Simon S. Koonook (Haines; works in alabaster and soapstone); John Penatac; Daniel K. Seetook (Wales, also works in ivory, baleen, bone, driftwood and soapstone).

Sources: Alaska Native Arts and Crafts (Anchorage); Boreal Traditions (Anchorage); Burke's Jewelry & Gifts (Northway Mall, Anchorage); New Horizons Gallery (Fairbanks).

ALASKA CORAL

Coral is the hard, stony skeleton secreted by certain marine polyps. It can be polished to a glassy finish. Red and pink corals have been popular for jewelry for decades. An organic gem, coral has been treasured through the ages for its mythical protective and curative powers.

A relatively new material for Alaskan arts and crafts, Alaska coral is dredged from deep waters off the coast of Kodiak Island. It ranges in color from beige and tan to brown, and is found nowhere else in the world. Alaska coral is used to make jewelry; it can be seen in the form of tiny sculptures to hang on charm bracelets or necklaces. Most Alaska coral is being worked by commercial jewelry manufacturers rather than individual artists. However, department store jewelry counters (Fred Meyer, etc.) typically do not stock Alaska coral; seek it at gift shops oriented to the tourist trade.

Practitioner: Bernard K. Passman (Ketchikan) works in black coral only, creating sculptures and jewelry.

Sources: Bernard K. Passman Galleries (Ketchikan); Once in a Blue Moose (Anchorage).

ALASKANA

Sometimes "Alaskana" is defined as rare and out-of-print books about Alaska; at other moments, it is collectibles such as kissing Eskimo salt-and-pepper shakers. Let's go with the former.

Author, copies printed in original edition, rarity, quality of illustrations, presence (or absence) of dust cover, inscription, book plate (identifying famous previous owner), type of press used, and condition of pages and binding, all affect the value of books. Terms like "foxed" come into play; "foxed" indicates yellowish brown stains or spots. Serious book collectors should read books about book collecting.

The journals of the three voyages of British explorer Captain James Cook, 1773-1785, were published in eight volumes and illustrated with two atlases. Lower left, drawing of "A Man of Prince William Sound," by John Webber.

Browsing is recommended for collectors of books, as unknown or lost manuscripts *can* turn up. Consider the papers of the Billings-Sarycev expedition, for example. The expedition was commissioned by Catherine the Great. It spanned four years 1785-89, and involved a detailed reconnaissance of the Siberian and Alaska coasts. Carl Heinrich Merck, the expedition's naturalist, kept a journal. The journal disappeared without a trace but was recovered in 1935, nearly a century and a half later, among some old papers at a Leipzig bookshop!

Museum: National Bank of Alaska's Heritage Library (Anchorage).

Sources: Alaskan Renaissance Bookstore (Anchorage); Alaskana Book Store (Anchorage); Cook Inlet Book Co. (Anchorage); Kaye Dethridge (Sitka); The Observatory (Juneau); Blue Dragon Book Store (Ashland, OR); Editions (Boiceville, NY); Pepper & Stern Rare Books (Santa Barbara, CA); Ken Lopez, Bookseller (Hadley, MA); Strand Book Store (NY); Reed Books (Birmingham, AL); Dick Perrier Books (Vancouver, WA); Colin Bull's Polar Books (Rolling Bay, WA); David Ewens Books (Ottawa, Ontario); Parmer Books (San Diego, CA); High Latitude (Bainbridge Island, WA); Robert W. Matilla Bookseller (Seattle, WA); Shorey Book Store (Seattle); Peter Hennessey Bookseller (Peconic, N.Y.); David L. O'Neal Antiquarian Booksellers (Boston, MA); Dellas Devine Books (Laurence, KS).

ALDER

Four species of alder grow in Alaska. Most infamous is the Sitka alder *(Alnus sinuata)* which presents a tangle of bent trunks that make it very difficult to bushwhack — make one's own trail — cross country.

Because it does not impart undesirable tastes to food, alder wood was used by the Tlingit for grease bowls and by the Athabascans for dishes and spoons. Alder was also carved into frontlets and masks. The alder is a large, many-trunked shrub, which does not grow big enough or straight enough to yield wood for totems or house posts, but is useful for smoking fish. Its outer bark is pleasantly mottled like the skin of a fawn. The dark inner bark of red alder *(A. rubra)* is used for dying parky trim red. Aboriginally, it was also used to tint fishing nets.

See also CARVING, FRONTLETS, MASKS.

Museums: Alaska State Museum (Juneau); Anchorage Museum of History and Art; Yugtarvik Regional Museum (Bethel).

Practitioners: Fred Anderson (Anchorage, uses alder and koa in combination in masks); Jack Hudson (Metlakatla, uses alder to carve masks); R. James Schoppert (Tlingit, maskmaker).

Sources: Anchorage Museum of History and Art gift shop; Bear Gallery (Fairbanks).

ALEUT BASKETS

Aleut baskets are twined of split leaves of wild beach grass. They may be woven over small food tins, and have straight sides; or over discarded glass bottles. At the turn of the century, a popular form of "basket" was the card case, made in two rectangular, open-ended parts that slipped together. Some baskets are decorated with colored embroidery thread. Others have an open weave with crossed warp to give them lace-like bands of contrasting texture. A small basket can take months to complete.

For details, see *Aleut Basket Weaving* by Kathy Lynch (Adult Literacy Laboratory, UAA, 1974). This hands-on guide is available from Circumpolar Press (907 248-9921).

See also ATTU ISLAND GRASS BASKETS, BASKETS.

Sources: Anchorage Museum of History and Fine Arts; Aatcha's Shop (Haines). Others listed under BASKETS.

AMBER

Amber is the yellow, red, or yellowish-brown translucent, fossilized fossil resin of coniferous trees. It is sap that hardened 20 to 100 million years ago. The ancient Greeks called this primordial tree sap *elektron,* or "substance of the sun." As fans of the futuristic film "Jurassic Park" are aware, amber deposits often trap within them

fragments of prehistoric organic material — even entire insects — as if "under glass." Thus each cabochon cut from amber is a unique work of nature.

In Denmark, a wedge of amber was unearthed in a 10,000-year-old burial site. Amber was widely traded in ancient and medieval times, and has long been worn as a talisman against evil and as a safeguard of virtue.

Incandescent and honey-colored, amber is used for jewelry such as necklaces, cufflinks, bracelets and earrings, and, as "Baltic gold," is often imported to Alaska from the Baltic region of Russia. Another source of amber is the Dominican Republic. In Indonesia, some craftsmen have switched from elephant ivory to amber, producing inch-high carvings of frogs, butterflies and dolphins, as well as tiny, stoppered bottles. For more information, consult *Amber, Window to the Past,* a record of an exhibition at the American Museum of Natural History.

Let the buyer beware: A synthetic amber may be produced by compressing pieces of various resins at a high temperature; request a certificate of authenticity.

Museums: American Museum of Natural History; National Museum of Natural History, Smithsonian.

Sources: Alexsandr Baranov Russian Gifts (Anchorage); Arctic Rose Galleries (Anchorage); By Nature catalog (Miami, FLA., 800 938-8811); Katherine The Great (Anchorage); The Nature Company (1-800-227-1114); The Russian American Co. (Sitka); Smithsonian Catalog, 800 322-0344; The Winterthur Catalog, 800 767-0500.

ANAKTUVUK PASS MASKS

Anaktuvuk-style masks are a recent invention, said to have been created as a Christmas joke by two village trappers in 1951. About five years later, villager Simon Paneak suggested the idea of a mask cottage industry as a source of income for remote Anaktuvuk, where there are few jobs for residents.

These distinctly regional masks are made of barren ground caribou leather, formed wet over a wooden mold. Eyes and mouth are cut out, and the edge of the mask is trimmed with caribou fur. Strips of fur form eye lashes. Usually the masks are a single adult face, but sometimes a female visage has a baby's face peering over her shoulder (as if from a parky hood). The masks are extremely lightweight, and may be encircled by a caribou ruff. Female faces usually are framed by black horsehair braids. Male faces may sport mustaches or beards. From the mask has developed a doll with a caribou mask face, made by Susie Paneak.

Anaktuvuk Pass is situated at the center of one of three natural corridors penetrating the Brooks Range. Caribou roam through these corridors in great herds; the village name means "dung of caribou." To provide regular schooling for the area's Nunamiut Eskimo children, the village was permanently established about 1950. Prior to that, the indigenous people of the area were semi-nomadic.

For more information, see *The Alaska Journal,* II, 4:30. For an interesting com-

parison, see a sealskin and fur mask made by Labrador Eskimos in the early 20th century, on p. 342 of Richard Conn's *Native American Art in the Denver Art Museum.* The mask was said to be worn by a clown at a summer feast.

Insider Tip: To tour Anaktuvuk Pass, contact the Northern Alaska Tour Co., Fairbanks, 907 474-8600.

Museums: Naval Arctic Research Laboratory (Barrow).

Practitioners: Lela Ahgook (Anaktuvuk Pass); Susie Paneak (Anaktuvuk Pass, masks wearing labrets, dolls wearing masks).

Sources: Gift shops all over Alaska.

ANTLER/HORN/HOOVES

Eskimos traditionally used durable antlers as material for sleds, tool and weapon handles, and parts of boats and houses. Tlingits used mountain sheep horns to make elegant ceremonial spoons.

Bull moose and both sexes of caribou naturally shed their antlers each winter. They serve as a source of calcium for small animals. For humans who gather them in the spring, they bring $5 a pound — which adds up quickly because a large set of moose antlers can spread more than 60 inches and weigh 50 pounds.

During the early 1900s, antlers were fashioned into chandeliers, coffee table legs, chair frames and other furnishings appropriate for cabins and rustic hunting/fishing lodges; today this durable, ivory-like material is being carved into spoons, letter openers, knife handles and doll bodies. Attractive sweater buttons are sliced from caribou antlers, and at least one Alaska snowmachine has been fitted with antler handlebars. Sections of antler are often utilized as door pulls for log homes or fishing cabins. A greenish tinge to the antler means it lay on the mossy tundra for some time before it was recycled. Exposed in two-dimensional relief carvings, the inner material of antler resembles ivory, and may have an attractive shell-pink color.

From 1971 to 1973, Melvin Olanna traveled with the Advisory Committee of Village Artists Upgrade Program, directed by the Division of Statewide Services. He traveled 12,500 miles, and identified 33 promising artists. Olanna also learned how to use local mediums like caribou hooves, which he had not worked with previously. "Quickly he learned how to boil a hoof, clean it, and clamp it firmly before it dried," Esther DeWitt wrote in *Alaska Journal* (vol. 1, no. 4, 1971). "Boiling brings out a special color that makes it more attractive for jewelry. He carried this new knowledge to villages that have many caribou, such as Noorvik and Kiana, and taught the people there to use their plentiful material to the best advantage."

See also HORN DOLLS.

Insider Tip: Glen Simpson (b. 1941, Tahltan Athabascan) has reproduced the old sheep horn spoon in sterling silver, ebony and walnut. His "A Raven Potlatch Spoon," 1985-86, can be seen in the CIRI Collection at the Anchorage Museum of History

and Art.

Museums (mountain sheep horn grease dishes/ bowls): Royal Scottish Museum (Edinburgh); Smithsonian Institution.

Practitioners: Thomas W. Cooper (Soldotna); Jill Choate (Talkeetna, baskets incorporating carved and scrimshawed horn/antler); Gilbert Delkittie (Palmer; moose antlers); Sharon Dudek (Wasilla, Drifting Antler Basketry, baskets incorporating antler, animal bones); Robert Ekstrom (Anchorage; antler and bone carvings); Lyle Johnson (Soldotna); Michael and Sandra Lettis (Anchor Point); Mickey Nicolai (Yupik, Lower Kalskag; carves moose horn, bone, ivory, baleen); Glen Simpson (Fairbanks, caribou antler powder flask). Michael Sausedo of the Hunter's Shack in Sterling works in caribou and moose, and eight of his pieces are displayed at the Kenai Visitors and Cultural Center.

Sources: Alaska Horn & Antler (Soldotna; specializing in ram horn carvings, plus carvings in moose, caribou, fossil ivory and mastodon; custom orders welcome); Antler Art (Soldotna); Arctic Art (Anchorage); Arctic Images (Whitehorse, Yukon Territory); B. Merry Studio (Anchorage, horn and antler carving, bone sculptures, stone sculptures); Birch Tree Gift Shop (Fairbanks, soapstone and antler carvings, ulus); Chilkat Art Co. (Anchorage; buys and sells horns, bones); Ivory House (Anchorage); Juneau General Store (Juneau); Northern Trading Post (Yellowknife, Canada); Shishmaref Native Store; Timberline Creations (Anchor Point); The Yankee Whaler (Anchorage, antler carvings mounted on jade pedestals).

ARCTIC OPAL

"Arctic Opal" is a mineral blend discovered in 1988 near Fairbanks. The term is a recently coined romantic pseudonym for a gem cut from deposits of two minerals of moderate value, azurite (a blue ore of copper) or malachite (a green ore of copper). Bright with the hues of planet earth viewed from outer space, Arctic opal bears only an imagined resemblance to Australia's iridescent opals. Arctic Opal lacks the precious opal's play of colors; it has been compared to turquoise. This mineral is made into jewelry.

Sources: Alaska Shop (Seward); Arctic Art (Anchorage); Arctic Minerals (Fairbanks); J.C. Penney (Anchorage); Pristine's (Fairbanks); Marchant Inc. (Anchorage); Taylor's Gold-N-Stones (Fairbanks).

ARGILLITE

When non-Native explorers encountered the Haida in the late 1700s, the Haida began producing carvings from argillite, a sedimentary black shale, to trade. Grease bowls, small boxes and miniature totems were popular. Many figures were carved for trade to seamen — and given the figures of uniformed seamen or the lines of European vessels. Argillite calumets (ceremonial tobacco pipes) often portray a styl-

ized array of mythological creatures, and have a complexity of design that resembles the artistry of the best scrimshawed walrus tusks. Argillite carvings, however, are more deeply incised, sometimes multiply pierced, and thus three-dimensional.

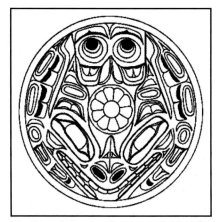

Argillite dish carved as a sculpin. The fish is viewed from above; teeth, nostrils, face spines at bottom; flanks and fins along the sides; tail recurved, so that underpart may be seen, toward central rosette. Haida, modern. Rendered by Paul E. Kennedy.

Work in this material did not become widespread, because there is only one known source — a quarry at Slatechuck Mountain on Graham Island in the Queen Charlotte Islands.

Argillite is soft enough to take a fine luster from the blades of the tools used to carve it. The material is easily scratched and should be kept out of reach. Argillite carvings are sometimes decorated with inlays of bone, abalone shell, wood or ivory.

Argillite lidded boxes — essentially miniatures of bentwood boxes — have been carved since the 1880s.

An argillite totem (11.75 inches tall) auctioned at Sotheby Parke Bernet in October, 1979, was assigned an estimated value of $2,000 to $2,500.

To view intricate argillite pipes, figures, model totem poles, chests and platters from the late 19th century, consult Bill Holm's *The Box of Daylight* as well as Ralph Coe's *Lost and Found Traditions*.

See also TOTEM.

Teacher Alert: For argillite carvings in a coloring and story book form, see *Myths & Legends of the Haida Indians of the Northwest* by Martine J. Reid, Ph.D., with drawings by Nancy Conkle (Bellerophon Books, 1991). For coloring only, see *North American Indian Design Coloring Book* (Dover Publications, 1971); beadwork and porcupine quill designs are included as well.

Museums: American Museum of Natural History (NYC); Burke Museum (Seattle, WA).; Denver Art Museum; Field Museum of Natural History (Chicago); Florida State Museum; Glenbow Museum; McGill University Museum; Museum fur Volkerkunde (Vienna); National Museum of Canada; National Museum of Denmark; National Museum of Ireland; National Museum of Man (Ottawa); University Museum, Cambridge, England.

Historic practitioners: John Robson, Charles Edenshaw (Haida, born Tahigan in the Queen Charlotte Islands).

Practitioners: Steve Collison; Claude Davidson; Pat Dixon (Haida; Skidegate, Queen Charlotte Islands); Bill Reid (Haida; a master carver who also works in silver,

gold and wood); Henry White (Haida, Masset, Queen Charlotte Islands).

Sources: Boreal Traditions (Anchorage; modern pieces as well as historic pieces).

Note: Argillite carvings are sometimes reproduced today in clay as well as cast resin. Beware imitations.

ARTIFACTS

"There were Eskimo artists before they were touched by the dollar, which happened around the time of the whalers (in the early 1800s.) Those are the ones I am interested in. I like to look at artifacts. They are so pure ."
— Melvin Olanna, *Anchorage Daily News*, Sept. 1, 1981

According to U.S. Customs law, an antique is anything produced at least 100 years before its date of purchase. An artifact is something handmade, or a fragment of something handmade (such as a shard of pottery), created during an earlier cultural period — especially such an object found at an archaeological dig.

Antiquities laws prohibit excavation of both historic and prehistoric sites without a permit. Alaska's laws extend to tidal lands; i.e., it is illegal to pick up artifacts on the beach. Laws also extend to the disturbance of fossils, such as prehistoric mammals like mammoths. Penalties range from a $1,000 fine to six months in jail, or both.

In the summer of 1997, one looter was tracked all the way to his home in Connecticut, fined, and made to return all the objects which he had removed.

"People who loot or destroy archaeological sites — both historic and prehistoric —rob us all from ever knowing the real story of our nation's past," says Robert King, Bureau of Land Management-Alaska state archaeologist. "In Alaska, as elsewhere, sites are being destroyed, and with them, knowledge about the past and the lessons it can teach us are gone forever."

To combat looting of sites, the BLM has launched a national program, "Project Archaeology," to teach America's youth about the meaning of irreplaceable cultural resources from the past.

In the Far North, Eskimo artifacts are attributed to various periods, including:

Denbigh Flint period (4500-1600 B.C.)

Okvik Period (c. 300 B.C.-500 A.D.)

Old Bering Sea (100 A.D. to 500 A.D.)

Ipiutak (0 to 500 A.D.), characterized by chains, pretzels and imaginary animals.

Birnirk Period (500 to 900 A.D.)

Punuk (600-1500 A.D.), characterized by deep, evenly cut, parallel lines, probably made with metal-pointed tools.

Thule Period (700-1400 A.D.), characterized by pictographs, such as hunting, traveling, boating scenes; typical of Eskimos from Greenland and Canada as well as Alaska.

MELVIN OLANNA

Melvin Olanna was born in 1941 at Ikpik near Shishmaref. He wanted to be a hunter, but he realized that was not possible. A bad limp, the result of a poorly healed broken leg, prevented him from keeping up on rigorous outings.

He started carving at age 12, and made $25 a day carving ivory billikins by the inch.

Like most Alaska Native children of his generation, he went Outside to school. He attended Chemawa Indian School in Salem, OR. Then he received two years of formal art instruction at the Institute of American Indian Arts in Santa Fe. Subsequently he studied at the Native Arts and Crafts Extension School at the University of Alaska in Fairbanks. While teaching at UAF, he designed the pilot for the school district's artist-in-the-schools program.

Olanna worked in driftwood, whale bone, ivory inlaid with baleen, silver, marble, teak, soapstone and black walnut.

His work can be seen at the Egan Convention Center, Mears Junior High School and Bear Valley Elementary School as well as in the permanent collection of the Anchorage Museum of History and Art; at the Fairbanks Correctional Center; the U.S. Department of the Interior Indian Arts and Crafts Board; the Amon Carter Museum in Fort Worth, TX., and the Whatcom Museum (Bellingham, WA). In 1981, his large sculptures commanded $5,000 to $9,000 and graced the board rooms of corporations such as Exxon, Rainier Bank, and the Skinner Corporation.

Historic Period (begins with Vitus Bering's sighting of Alaska in 1741; ends in 1900).

For more information on the characteristic styles and decoration of ivory artifacts, consult Henry B. Collins Jr.'s *Prehistoric Art of the Alaskan Eskimo* (Smithsonian publication 3023, 1929; facsimile from The Shorey Book Store, Seattle, 1969). For background, read *The Late Prehistoric Development of Alaska's Native People* by Robert Shaw, Roger Harritt and Don Dumond, editors (Aurora Monograph Series No. 4, Alaska Anthropological Assn., 1988).

See also Paul and Mary Thiry's *Eskimo Artifacts Designed for Use* (Seattle, 1997).

See also FOSSIL IVORY, MASTODON IVORY, OKVIK.

Teacher Alert: Archaeologist Robert King has co-authored a student handbook for grades four through seven, *Intrigue of the Past: Discovering Archaeology in Alaska*. The narrative involves time-travel by children who eye-witness the past. Lesson plans are available.

Museums: Haffenreffer Museum of Anthropology (Brown University); Berne

Historical Museum; Museum fur Volkerkunde (Vienna, Austria); Museum of Anthropology and Ethnography (Leningrad); Royal Museum of Physics and Natural History (Florence); NARL (Barrow); University of Alaska Museum (Fairbanks); United States National Museum, Smithsonian Institution.

Reproductions: Rich LaValle (Portland, OR; harpoon points, bentwood boxes and hats, bird darts, etc.; catalog available).

Sources: The Ivory Broker (Anchorage); A-Alaska Old Ivory Dealer (Fairbanks); Alaskan Fossil Products (Fairbanks); Mary Holland (Delta Junction); Timberline Creations (Anchor Point). Elaine S. Baker (Anchorage) displays a Pleistocene tusk measuring 52 inches, mounted on a custom cherry base.

ATTU ISLAND GRASS BASKET

"Probably because Aleuts considered boasting reprehensible and fulsome praise by others in bad taste, no name of a famous carver or a master basket-weaver has come down to us in any known story or song."

— Lydia T. Black, *Aleut Art* (Aleutian/Pribilof Islands Association, 1982).

"Attu Island grass basket" is another, more specific, name for the delicate, twined "Aleut grass basket." Seal gut (dyed or natural) is often interwoven with the grass.

Attu is the furthest west and most isolated island in the Aleutian chain. Aleut peoples have lived on the island for at least 2,000 years. During World War II invading Japanese took the Attuans prisoner and shipped them to Japan. American bombers leveled the village to keep the enemy from making use of it. Many Attuans now live in Atka and practice their basket-weaving there.

See ALEUT BASKETS, BASKETS.

Alaska Live: Basket weavers can be seen engaged in their demanding craft during the annual Native craft show at the Anchorage Museum of History and Art in March.

Museums: Anchorage Museum of History and Art; Sheldon Jackson Museum (Sitka).

Practitioners: Raynelle J. Gardner (Sand Point); Vasha Golidorff (Atka); Sharon P. Kay (Anchorage); Arlene Skinner (Kodiak); Agnes Thompson (Aleut, originally from Atka); Parascovia Wright; Tatiana Zaochney (Atka).

Sources: Alaska Native Arts & Crafts (Anchorage); Alaska Commercial Co. (Unalaska); Carl's (Unalaska); Aleutian Mercantile Co. (Unalaska); Anchorage Museum of History and Art gift shop.

Referrals: Atxam Corporation (Atka); Ounalashka Corporation (Unalaska); Nicky's Place (Unalaska); Grand Aleutian Hotel gift shop (Unalaska).

BABY BELT

A baby belt (AKA baby "sling" or "strap") is one of the largest bead-covered

objects being made today in Alaska. This belt was used by an Athabascan woman to pass under an infant's buttocks, to sling him on her back. The baby was first wrapped in a buckskin blanket or woven shawl, creating a package something like a baby in a parky hood. The belt passed under the baby's bottom, around the mother's upper arms and tied in front, over her breast. (Mothers, sisters, aunts and grandmothers all "packed" babies, as the extended family shared child-rearing chores. Young girls played by packing puppies and even stones, imitating their elders.)

Belts were beaded on smoked moose hide and trimmed with bright yarn tassels. Along the edges, large trade beads may be hung as further decoration.

Today's belts, created for collectors, are beaded on lined velvet or felt — much easier to coax a fragile beading needle through than leather. A baby belt measures about 44 inches long, plus ties. Baby belts were also used in Canada among Great Slave Lake Athabascan groups, and are still in use around Fort McPherson. For more information, consult *Northern Athapaskan Art: A Beadwork Tradition* by Kate C. Duncan (University of Washington Press, 1989).

See also BEADING.

Insider Tip: For an example of a beaded baby belt, see a permanent display at the Anchorage Airport. "Tradition, Innovation and Continuity," an exhibit of 157 Native Alaskan objects, also includes an octopus bag by Martha Shields, baskets, masks, paddles and ivory carvings.

Museums: Anchorage Museum of History and Art.

Practitioners: Delores Sloan (Fort Yukon).

Sources: Alaska Native Arts & Crafts Coop (Anchorage).

BALEEN

Baleen has been called "nature's plastic." It is a finger-nail-like material with the capacity to bend yet spring back to its original curvature.

Baleen is harvested from baleen whales, such as the bowhead, gray, humpback and minke. Poking up from the lower jaw like tines on a huge rake, the fringed baleen filters plankton and small, shrimplike krill from gulps of sea water the whale takes in when feeding.

In some species, baleen plates grow to 8 or 10 feet long, and there may be 600 in a single adult whale's mouth. Whole baleen plates of three to five feet long were traditionally used to make one of the rarest collectibles, the Eskimo baleen sled. Made of slats lashed together side-by-side, kept rigid with a driftwood stanchion, these compact, lightweight sleds were used to drag home heavy seals speared through breathing holes in pack ice in winter. A bank branch in Barrow displays one of these sleds on the wall directly behind the tellers' windows.

In the 1800s, there was a major trade in baleen by white whalers. Because of its plastic qualities, baleen, confusingly dubbed "whalebone," was used in the manufac-

ture of a wide variety of products, including corset stays, umbrella ribs, Venetian blinds, buggy whips.

Traditionally, baleen was used for buckets, scoops and sled runners. One of the most recent uses found for baleen is in baskets, a new art form introduced in the early 1900s and practiced by men. In Barrow today, baleen is also cut, shaped, glued and lashed into model sailing vessels, 6 to 12 inches from bow to stern.

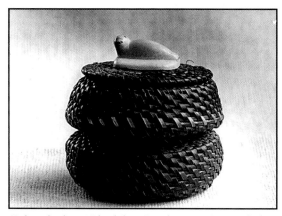

Plates of baleen are etched scrimshaw-fashion, autographed and sold as wall hangings. A single plate may sell for $100 or more.

Possession of raw, unworked baleen is restricted under Alaska law to Native whale hunters. Consult the Alaska Department of Fish and Game for current regulations.

Baleen basket, 3" high by 4" in diameter (not including ivory seal finial), 1.25" ivory base plate, 1992, Barrow, signed "RF" on base plate. The wasp-waisted shape varies from the typical oblate or spherical form. A stripe of lighter baleen has been woven into the gray flannel baleen for contrast. Private collection.

For detailed information about this craft, consult Molly Lee's *Baleen Basketry of the North Alaskan Eskimo* (Barrow: North Slope Borough Planning Department, 1983).

See also BASKETS, SCRIMSHAW, WHALE BONE.

Museums: Alaska Wild Berry Products (Homer, small room at back); Heritage Library and Museum (National Bank of Alaska, Anchorage); Anchorage Museum of History and Art.

Historic practitioner: George Omnik (Point Hope).

Practitioners: Walton Irrigoo (Nome); Robert C. Johnson (Eagle River; also works in cottonwood and soapstone); John Kokuluk (Nome); Victor Nick (Kwethluk); Mickey Nicolai (Yupik, Lower Kalskag) carves baleen); Harry Ningealook (Shishmaref, baleen jewelry); Edith J. Rivera (Anchorage); Daniel K. Seetook (Wales, AK.); Leo Gregoire (Anchorage).

Sources (baskets): Anchorage Museum of History and Art.

Sources (etched): Native store in Point Hope; Boreal Traditions (Anchorage); Native store in Shishmaref.

Sources (ship models): Arctic Coast Trading Post (Barrow), Cape Smythe Trading (Barrow); Chilkat Arts (Anchorage); NANA Museum (Kotzebue).

BARK

A tough, flexible, waterproof renewable resource, tree bark was a valuable raw material for Alaska's native peoples. Alutiiq peoples living along Prince William Sound stripped large sections of bark from the trunks of spruce and hemlock. The scars on "CMT's" ("culturally modified trees") can sometimes still be seen. The typical scar is one to two feet wide at the base, tapered to the top. These triangles were used for roofing houses. Small pieces of bark were used as "paper plates." The Athabascans had similar uses for birch bark.

Several Pacific Northwest Indian tribes wove watertight baskets from cedar bark. Traditionally, Haida women and children hiked into the mountains in July (*San gias,* Killer Whale Month) to gather cedar bark. (The month bears this name because the sound of bark being ripped from the trunk reminded them of the exhalation of a killer whale.) Properly done, bark stripping does not harm trees; furthermore, then, too, in an effort to appease the dendroid spirits, trees were thanked for their gift.

The Haida used bark for clothing. (Cedar bark is not used for food storage baskets because it is aromatic and may taint delicate foods like berries and clams.) The Tlingit used the shredded bark for sleeping mats, raincoats, capes and skirts, as well as the wonderfully unruly punk "hair" of ceremonial transformation masks.

See also BIRCH, CEDAR BARK, COTTONWOOD BARK, MASKS, WILLOW.

Museums: American Museum of Natural History (New York City); Anchorage Museum of History and Art; Burke Museum (Seattle); Makah Museum (WA.); National Museum of Man (Ottawa); Sheldon Jackson Museum (Sitka).

Practitioners: Irene Bienek (Ketchikan; cedar bark baskets decorated with maidenhair fern); Holly Churchill (Haida; shaman's aprons of cedar bark decorated with small abalone shells and strips of dark fur).

Sources: Alaska Fur Factory (Anchorage). By commission.

BASKETS

"It has been said that 'civilization killed the basket.' When pots, pans, kettles, boxes and cloth containers became the preferred domestic utensils, the need to spend days, weeks or months in basketmaking was blunted. Although baskets continue to be produced today, they do not generally compare in quality with the older baskets."
— Allan Lobb, *Indian Baskets of the Pacific Northwest and Alaska* (Graphics Arts Center Publishing Co., 1990)

In the Pacific Northwest, baskets were created from a wide variety of materials, including cedar and spruce root, cedar and cherry bark, bear and beach grass, hazel-

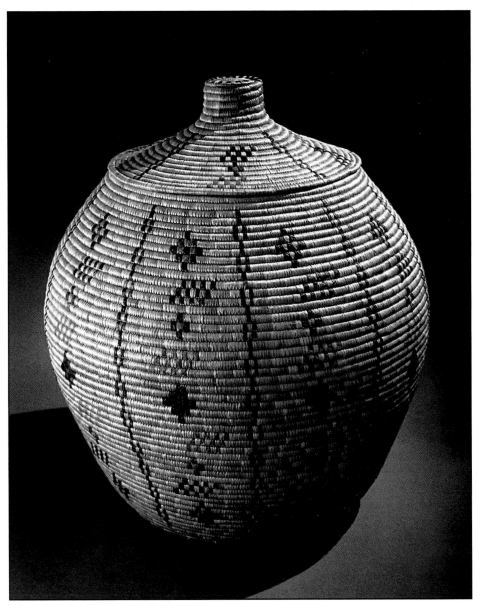

Coiled grass basket decorated with geometric designs rendered in dyed seal gut, 16.5 x 19 inches, by Mary Black of Kongiganak. Exhibited at the Festival of Native Arts, 1971, Anchorage Museum of History and Arts.

nut shoots, maidenhair fern, hemp, cornhusk, tulle and cattail. Some of these same materials were utilized by Alaskan basketmakers, who also used alder, willow root, marsh grass, and birch bark. Purple decorative material was provided by horsetail; black by maidenhair fern. Roots could be dyed yellow with moss, or red with alder bark. Swan quills or dog's hair might wrap the rim. Sea lion whiskers, beads and feathers were favorite ornamental materials.

Depending on their strength and structure, baskets were used for cooking, gathering ("burden baskets"), storing, cradles, as trade items, as gifts, and as heirlooms. Baskets were woven with flat backs, so they could hang neatly against a post or wall; these usually held pipes and tobacco. Round baskets served as pails, soup bowls and kettles. Open-mesh baskets were used for collecting then rinsing barnacles, clams and mussels. Woven mats were used for sleeping, or to wrap the dead for burial. Bowl-shaped hats were very similar to baskets.

Typical of Alaska's Southwest villages are baskets called *mingqaaq* or *tapernat*, made of coils of beach grass. The grass is harvested in October, and weaving begins in December, when cold weather forces the people to remain inside. The baskets are decorated with seal intestine, dyed grass or fur. Hooper Bay baskets typically feature thin coils and an urn shape. Unlike dancing and mask-making, which were discouraged, basket making was encouraged by missionaries. In the early 1900s, for example, Moravian missionaries valued the tradition of basket making because they could resell baskets outside Alaska to support church missions.

For more about construction techniques and decoration, consult *Indian Baskets of the Pacific Northwest and Alaska* by Allan Lobb, with photography by Art Wolfe. See also *Pacific Basket Makers: A Living Tradition* edited by Suzie Jones (University of Alaska Museum, 1983). Back issues of *American Indian Basketry* magazine constitute another valuable research source. An early reference is Otis Mason's *Aboriginal American Basketry: Studies in a Textile Art without Machinery* (U.S. National Museum Report, Smithsonian, 1904).

Baleen: Perhaps the world's most unusual baskets are made with baleen from the mouth of the bowhead whale. Baleen baskets are an art form introduced — some say by a white trader in Barrow — to Inupiats in the early 1900s. When synthetics began to replace the need for baleen, some other income-producing use for baleen needed to be found. Originally, baleen baskets were made entirely by men — probably because only men could hunt whales. In order to work this stiff material, baleen is soaked in water for several days. When it has softened, thin layers can be peeled or shaved off. These layers are then split into narrow strips for weaving.

Called "whalebone" during Victorian times, but more a fingernail-like material than a true bone, baleen comes in several colors, from charcoal to green to off-white.

Some baleen baskets bear decorations (or "finials") on their covers; these top-knots take the shape of whales' tails, seals, polar bears, etc. The bottoms may be cen-

tered on and woven into a perforated ivory disk.

Techniques used in basketry include folding (birch bark), plaiting, coiling, twilling, and twining. Basket decoration may be achieved by overlay, false embroidery or beading. Some of the finest basketry in the world was produced in the last two centuries by Native Americans of the Northwest Coast including Alaska.

Alaska's basketmakers are an inventive bunch. They've learned from basketmakers around the world, absorbed Native traditions — and gone on from there. Artists Cheri Terrell and Linda Smyth, for example, weave baskets from willow, pine needles, grass, horse hair, bone and found materials. Penelope Cyr-Lorenson of Kodiak incorporates driftwood, blacktail antlers, fur and shells into her work.

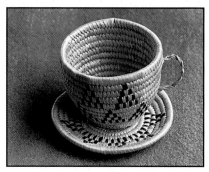

Grass basket in shape of cup and saucer, Elizabeth Powell, Kipnuk, 1997. Saucer, 3.25 inches across. Cup, 2.34 inches at rim, 2 inches high. Decorated with dyed grass. Private collection.

Practitioners (baleen): James Omnik Sr., John Omnik, James Omnik Junior; A.P. Simmonds (Barrow).

Sources (baleen): Anchorage Museum of History and Art; ivory carvers cooperative at Gambell; Savoonga Native Store and Wayne Penaya's Grocery Store (Savoonga); native store in Point Hope.

Grass: Beach grass (AKA rye grass, *Elymus mollis*) for Aleut- and Yupik-style baskets must be gathered after the first frosts have rendered the blades brown or white. Each tough, glossy blade must be split into 8 to 10 fine strands, which explains why delicate, twined Aleut basketry has been described as "cloth made of grass." The grass is usually kept wet when it is worked, because it is more flexible when wet. Some grass baskets are only one to two inches in diameter, yet sport knobbed conical lids. The discovery of gold near Nome in 1898 greatly stimulated the souvenir market for Yupik coiled baskets. Whether twined or coiled, tiny grass baskets may be decorated with colored embroidery floss, silk thread, or fine yarn — materials originally introduced by Russians. Only women create grass baskets.

Molly Lee, University of Alaska Fairbanks anthropologist, told the Associated Press in December 1997, that Yupik grass baskets represent "one of the most, if not the most, vibrant art forms in Alaska today."

Fish skin: Some non-Native artists are creating baskets of abstract shapes on a framework of twigs. Tough, durable halibut skin is one of the chosen wraps for these translucent art works.

Because baskets cannot be signed, collectors should request the basket weaver to write his or her name and village on a slip of paper, which are then stored within the

basket itself. Dating this informal record is a worthwhile practice.

For more on this fascinating subject, see Susan W. Fair's *Alaska Native Arts and Crafts* (Anchorage, Alaska Geographic Society, 1985).

See also ATTU GRASS BASKETS, BALEEN, BIRCHBARK, WILLOW ROOT.

Teacher Alert: Lark Books (Asheville, N.C.) offers a splendid catalog of how-to books on many subjects (from treehouses to gourd baskets and from slumped glass to Nordic knitting), as well as a kit called "Earth-Tones Coiled Beaded Basket Kit," $19.95. Call 800-284-3388.

Insider Tip: Spend your vacation at McFarland's Floatel on Prince of Wales Island, and instructions in pine needle raffia basketry are available for those who shun fishing and hunting.

Museums: American Museum of Natural History (New York City; basketry hats); Anchorage Museum; British Columbia Provincial Museum (Victoria, B.C.); Burke Museum (University of Washington, Seattle); Denver Art Museum; Field Museum of Natural History (Chicago); Makah Museum (Olympic Peninsula, WA.); Museum of the American Indian (NYC); Museum of Natural History (NY); Museum of Anthropology of British Columbia (Vancouver); Oregon History Center (Portland); Phoebe Apperson Hearst Museum (Berkeley, CA); Sheldon Jackson Museum (Sitka); Smithsonian Institution; Anchorage Museum of History and Art; Museum of Anthropology and Ethnography (Leningrad).

Practitioners (birch bark): Elena Charles (Yupik, grew up in Kasigluk, wife of mask maker Nick Charles, Sr. of Bethel); Katherine Cleveland (Ambler); Helen Dick (Lime Village); Marilyn Paul; Florence VonFintel (Wasilla).

Practitioners (cedar bark): Irene Bienek (Ketchikan); Diane Douglas-Willard (Ketchikan); Selina Peratrovich (Ketchikan); Brenda White (Metlakatla).

Historic Practitioners (grass): Anastasia Hodiekoff; Sophia Pletnikoff (Unalaska).

Practitioners (grass): Vickie Nina Alto (South Naknek); Teresa Anderson (Anchorage); Mary Black (Kongiganak); Rita Blumenstein (originally from Tununak); Susan Buterin (Kodiak); Susie Chanigkak (Kongiganak, coiled basketry replica of kerosene lamp); Carol Ann Chernoff (Kodiak); Delores Churchill (Ketchikan, daughter of Selina Peratrovich); Amelia Davidson; Belle Deacon (Athabascan, Grayling); Raynelle Gardner (Sand Point); Vasha Golidorff (Atka); Marilyn Hansen (Naknek); Carol Hoelscher (Anchorage); Kathy Katchatag; Annie King (Anchorage; King also carves and does skin sewing); Neva Mathias (Chevak); Jane Oscar (Tununak, baskets with butterflies in their design); Selina Peratrovich (Haida, Ketchikan); Elizabeth Powell (Kipnuk, trays, cup and saucer); Anfesia Shapsnikoff (Unalaska); Mary Simeonoff (Aleut, Anchorage); Rachel Smart (Yupik, Hooper Bay); Arlene Skinner (Kodiak); Gertrude Therchik (Tooksook Bay); Agnes Thompson (Atka); Jeannette Trumbly (Yupik, Anchorage); Loulare Wassillie (Togiak); Ida Wesley (Mekoryuk);

Parascovia Wright; Tatiana Zaochney (Atka).

Practitioners (grass, miniature baskets as earrings): Colette Brantingham (Anchorage).

Practitioners (willow): Lina Demoski (Anvik).

Practitioners (multiple ingredients): Jill Choate (Talkeetna); Penelope Cyr-Lorenson (Kodiak, Nantucket purses, fishing creel purses, Nantucket lamp baskets, bread baskets, dinosaur wall baskets, key baskets, floor baskets, pineapple baskets, step baskets, Adirondack backpack, wine tote, garlic basket, star basket, etc.); Mavis Beth Muller (Homer, zodiak baskets, "Birth Time" baskets); Linda Smyth; Cheri Terrell; Terri Springer (Kodiak).

Sources: Alaska Commercial Co. (Unalaska); Anchorage Museum of History and Art; Aurora Fine Arts (Anchorage); gift shop (plus seasonal sales) at the Alaska Native Hospital (Anchorage); Baskets & Bullets (Thorne Bay); Bristol Bay Historical Museum gift shop (Naknek, open in winter by appointment only); Fireweed Gallery (Homer); Iliamna Lake Resort (Iliamna); King Salmon Airport gift shop; Nicky's Place (Unalaska); Petro Mart (Unalaska); Galeria Primitivo/Art of the Americas (Santa Monica, CA); Tucker Robbins (NYC); Sara Penn/Knobkerry (NYC); University of Alaska Museum (Fairbanks, baskets woven of husky fur and wool).

BEADWORK/BEADING

In 1492, Christopher Columbus introduced glass beads to the Americas. With the exception of obsidian (a black glass produced during volcanic explosions), glass was previously unknown on this continent. Manufactured glass was totally unknown. Native Americans had previously used seeds as dangles, and also fashioned beads from bone, shells, stone and clay.

However, it was not until the 18th and 19th centuries that beads were introduced to Alaska's indigenous peoples by Russian traders, European explorers and agents of the Hudson Bay Co. (Although some trade beads are called "Russian," most, whether

Table cover, 27 inches in diameter, beads on felt, made at Bettles in 1984 by Jeanne Stevens.

bartered in Africa or the Aleutian Islands, were created in Italy or Czechoslovakia.)

Both Eskimo and Athabascan skin sewers were quick to adopt these shiny, colorful and durable ornaments as jewelry and as materials to adorn clothing and footwear;

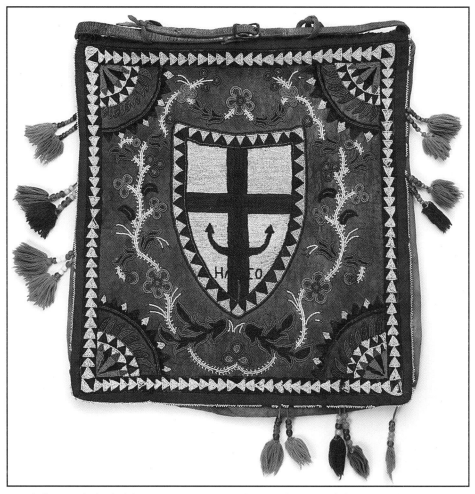

Beaded moosehide sled bag, 20.75 x 18.75 inches, made for Archdeacon Hudson Stuck, an Episcopal missionary in Alaska from 1903 to 1920. The gaily colored, tasseled bag is outlined with a border of red fabric. It was made in Arctic Village or Fort Yukon c. 1905.

intricate bead embroidery became an important post-contact art as well as a means of female expression. It generally replaced the aboriginal art of porcupine-quill weaving and embroidery in both Canada and Alaska. Many of the designs in which beads appeared were based on local plants, such as the wild rose. Others derived from fabric and magazines.

In Alaska, beadwork is often used in combination with other crafts, such as skin-sewing. Beads may be used to ornament baskets, to make hair ornaments for dancers, to adorn the clothing of Eskimo dolls, on the backs of gloves that will be worn by dancers, to form the crests on button blankets, etc.

Many Alaskan craftspeople who work with beads are not indigenes. As in Victorian times, when women of the leisure class created beaded lamp shades and beaded purses, women of all cultural backgrounds have been drawn to the glint, elegance and texture of beads. Fireweed Gallery (Homer) is one of the sources of such contemporary expressions, which may take the form of vests, wall quilts and even blown glass.

Glass beads today are manufactured in the Czech Republic, India, Italy, France, China and Japan. Beads are also made from shell, clay, metal, plastic, amber, silver, jade, hematite and bone.

For more information, consult Monte Smith's *The Technique of North American Indian Beadwork* (Liberty, Utah, Eagle's View Publishing), which features examples and photos of beadwork from 23 American tribes, from 1835 to the present. Another invaluable reference is William C. Orchard's 1929 classic, *Beads and Beadwork of the American Indian*. See also Kate C. Duncan's *Northern Athapaskan Art: A Beadwork Tradition*.

See also BABY BELT, FUR, MUKLUKS, OCTOPUS BAG, PORCUPINE QUILLS, TRADE BEADS.

Beadwork at the Smithsonian: The Smithsonian recently commissioned poet and beadworker Dixie Alexander to create an Athabascan chief's coat for permanent display. The coat, which sports fringed, beaded epaulets and beaded pockets, required 135 hours of exacting work; the fee paid was $8,000.

Teacher Alert: Consult Wendy Simpson Conner's *The Best Little Beading Book* (Lark Books, Asheville, N.C.). Students can learn how to make their own beads from Tina Casey's *Creating Extraordinary Beads from Ordinary Materials* (Lark).

Insider Tip: Beadworkers can often be seen at work at the Southeast Alaska Indian Cultural Center in Sitka.

Museums: Anchorage Museum of History and Art; British Museum (London); Museum of Mankind (British Museum, London); Royal Scottish Museum (Edinburgh); National Museum of Canada (Ottawa); Denver Museum of Natural History; Robert H. Lowie Museum of Anthropology, University of California (Berkeley); Peabody Museum (Salem, MA); Robert Hull Fleming Museum, University of Vermont (Burlington); The University Museum, University of Pennsylvania (Philadelphia); Haffenreffer Museum of Anthropology, Subarctic Collection, (Brown University, Bristol, RI); National Museum of Natural History, Smithsonian Institution; Royal Ontario Museum (Toronto); Sheldon Jackson Museum (Sitka); University of Alaska Museum (Fairbanks).

Insider Tip: Examples of framed beadwork are increasingly available in interior decorating showrooms/gift shops. These are often Chinese beadwork — especially dress clothing made for infants and children; the collars have been cut from the silk garments and framed. Elaine Baker and Flypaper are two Anchorage shops carrying these items.

Historic practitioners: Frances Howley Demientieff (Athabascan, b. 1895 near Bettles, later lived in Holy Cross, also a skin sewer); Martha White Brush (Circle, Nulato, d. 1997); Eva Moffit (Athabascan, b. Salchaket 1918; d. 1993); Martha Shields (Tlingit, d. 1990; octopus bag). Demientieff's masterpiece is considered six beaded altar cloths for the Catholic church in Holy Cross. She also worked on a white beaded stole for the Pope's visit to Alaska.

Practitioners (traditional): Georgianna Ahgupuk (Shishmaref); Catherine Ahkinga (Shishmaref); Elsie Ahnangnatoguk (Nome); Dixie Alexander (North Pole); Solvay Ava Bakke (Wrangell, beaded jewelry); Fannie Barr (Shishmaref, mukluks, parkys, slippers, mukluk bottoms, mittens, hats); Eunice Carney (Kutchin, Clear; Athabascan dance boots); Ruth Demmert (Kake, Tlingit); Eloise M. Howard (Tok); Lisa Huffaker (Fairbanks, beaded mukluks); Ellen M. Ivanoff (Elim); Deloris Ivins (Ketchikan, vests); Brandy Jenkins (Wrangell); Dolly Johnson (Kiana, hair clips); Rose Johnson (Nome); Jennifer Jones (Shishmaref, beaded pins, hats); V. Chris Judy (Sitka); Lorraine Jungers (Shishmaref); Mary Kakoona (Shishmaref); Judith June Kalkins (Anchorage); Ann Keener (Haines); Lisa M. Keown (Juneau; pins, earrings, necklaces, booties); Pauline Kohler (Aleknagik; mukluks, mittens, earrings, hairpieces); Deborah Krum (Ketchikan); Rose Koezuna (Nome; slippers and pincushions); Esther Littlefield (Tlingit, Sitka); Emma Marks (Tlingit); Josephine Mountain (Nulato, Athabascan); Edith Olin (Metlakatla); Mabel Pike (Anchorage); Lisa DeWilde Pitka (Huslia); Carolyn Richards; Jeanne Stevens; Judy Thomas (Northway, Athabascan, circular mats); Lillian Walker (Athabascan); Doris Ward (Athabascan, Fort Yukon); Alene Weyiouanna (Shishmaref); Shirley Weyiouanna (Shishmaref); Elsie Weyiouanna (Shishmaref); Diane Douglas Willard (Ketchikan, Haida); Addie Woods (Fairbanks).

> "I raised 14 children in the days with Pampers and jars of baby food, but I never laid off from my beadwork."
> —Hannah Solomon, 77, Athabascan, Fort Yukon, in an interview with The Anchorage *Times,* 1986.

Practitioners (contemporary): Marie Bader, Debbie Bella, Kate Boyan, Guiguite Caine, Shawn Fate, Julie Goodwin, Chris Hoffman, Anne Jackson, Sandy Lane (Anchorage, lamp-worked beads); Darlene Lind, Sandy Olson, Cathleen Pook (Sitka, antique beaded earrings); Shelley Rainwater, Susan Ridgeway, Delores Sloan (Fairbanks, beaded portraits); Susan Woodward Springer (Seldovia, handmade beads, "The Fisherman's Wife Collection"); Jean Steele, Judy Summers, Sandra Thompson, Tree.

Sources: Alaska Native Medical Center gift shop (Anchorage); Anchorage Museum of History and Art; Aurora catalog; Beads and Things (Fairbanks); Black Elk Leather (Anchorage); Hayner's Trading Post (Tok Junction); Northland Gallery &

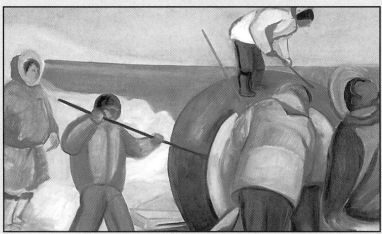

"Cutting the Whale," painting by Claire Fejes. From the collection of Yutaka Murase, Japan.

CLAIRE FEJES

A petite woman full of piss and vinegar, Claire Fejes has come a long way from her home town, New York City. In 1946, she followed her husband Joe to Fairbanks, the last stop on the Alaska Railroad, where he wanted to mine for gold.

In the five decades since, Fejes has interviewed and sketched Eskimos and Athabascans at remote villages and whaling camps, painted Tlingits in traditional costume in Sitka, had more than 31 one-woman exhibits at museums in the U.S. and Japan, and designed postage stamps. Her work was shown in 1996-7 at the Cincinnati Museum Center's Great American Artists Exhibition.

She has worked in stone, watercolor and oil. As she wrote in her memoir, "I painted small watercolors on the kitchen table, but soon learned that what Alaskans held in high esteem were Sydney Laurence's realistic paintings of Mount McKinley. People did not seem to care for my simplified forms and brilliant colors, my impressionistic style. It was no use telling them that the world of painting had changed since the early 1900s. I painted alone without encouragement. My influences were Picasso, Gauguin, Van Gogh, Hartley, and Rivera."

Fejes' paintings are in permanent collections at the Frye Art Museum (Seattle); the Michener Collection (Archer Huntington Museum, University of Texas); West Point Museum; University of Alaska Fairbanks Museum; Alaska State Museum (Juneau); and the Anchorage Museum of History and Art.

For more about her life and art, see Fejes' books: *People of the Noatak, Villagers, Enuk, My Son,* and *Cold Starry Night: An Alaska Memoir* (1996).

Wildlife Studio (Soldotna); Anchorage Museum of History and Art gift shop; Eagle Feather Trading Post (Ogden, UT.); Fireweed Gallery (Homer); One People (Anchorage, South American beadwork); The Raven's Journey (Juneau); Sheldon Jackson Museum Shop (Sitka, beaded earrings, vanity boxes of smoked moose hide trimmed with beads); Southeast Alaska Indian Cultural Center (Sitka); Sundance catalog (1-800-422-2770); The Yankee Whaler (Anchorage).

Classes: Fireweed Gallery (Homer) sponsors an annual exhibit of contemporary beadwork. Beading classes for children may be available during this celebration.

Note: Small items adorned with "Indian" beadwork, items such as change purses and key chains, are increasingly being produced in Asian sweatshops. If an item costs under $50, it is probably imported. Genuine beadwork commands high prices because it is labor intensive. In a recent issue of *Architectural Digest*, foot-square pillows solidly beaded on African mud cloth by non-Native Americans retailed for several thousand dollars. See also "A Question of Authenticity," page 165.

BENTWOOD BOXES

"The basic lines of a box design start with a major image, rush to the limits of the field, turn back upon themselves, are pushed and squeezed towards the center, and rippling over and around the internal patterns, start the motion again. Where form touches form, the line is compressed, and the tension almost reaches the breaking point, before it is released in another broad flowing curve."

— Bill Reid, Haida carver, "The Art —An Appreciation," *The Arts of the Raven* (Vancouver Art Gallery, 1967).

Sometimes called a "bent-corner box," the elegant bentwood box is a Tlingit storage container fit for royalty. It was made from a single plank steamed until soft enough to bend at 90-degree angles. (The bending was enabled by the removal of triangular cuts or bending groove (a "kerf") inside each corner. Because of the bending, three of the box's corners were smooth, while the fourth corner was joined with pegs or spruce root lashing. The hollow cube was then fitted with a custom bottom and a close-fitting lid, making it watertight, oiltight, and vermin-proof. These boxes were generally painted, and sometimes carved as well. Occasionally the lids were inlaid with glistening opercula, the shells of a marine snail. Boxes from the early 19th century are distinguished by beveled lids, rounded and protruding.

Bentwood boxes were fashioned from straight-grained red cedar, yellow cedar, spruce or yew. The wood was split with wedges, then adzed into a regular plank shape.

These magnificent containers are usually squarish, but somewhat taller than they are wide. They may be as large as steamer trunks or as small as laser printers. Bentwood chests served as storage for dried foods, ceremonial clothing, shaman's

equipment and other valuables. They were also strong enough to serve as shelves and hassocks. On the death of its owner, a superb and commodious specimen might serve as his mortuary box, and be set into a niche on his mortuary totem.

Bentwood boxes play a supporting role in one of the best-known legends of the Northwest Coast, a legend that tells how Raven the trickster stole the sun to benefit benighted mankind. A greedy chief, Nas shuki yelhl, kept the sun, the moon and the stars in three bentwood boxes in his house; he refused to let these light sources out to help other human beings. Greediness and selfishness are not appreciated by Native Americans, and Nas shuki yelhl was taught a lesson by Raven, who (taking the form of a spruce needle floating on a bucket of drinking water) impregnated the chief's daughter and impersonated Nas's grandson. Wailing and inconsolable, the "grandson" tricked his doting grandpa into allowing his precious heir to play with these balls of light. Raven, of course, cast them into the sky to light the world.

With the government's banning of potlatches, plus the breakdown of traditional Northwest cultures, a breakdown fueled by alcoholism and disease, the crafting of bentwood boxes was abandoned for decades. However, this painstaking craft has been resurrected during the last 30 years. Because of the woodworking skills required to produce them, bentwood boxes remain rare objects.

For more information, read *Boxes and Bowls: Decorated Containers by Nineteenth-Century Haida, Tlingit, Bella Bella, and Tsimshian Indian Artists* (National Collection of Fine Arts, Washington, D.C., 1974).

See also BENTWOOD HUNTING HATS, DRUMS.

Teacher Alert: Get your hands on the *Bentwood Box Activity Book* by Nan McNutt, Yasu Osawa (Sasquatch).

Museums: Burke Museum (University of Washington, Seattle); Denver Art Museum; University Museum (Philadelphia); Makah Museum (Olympic Peninsula, WA.); Royal British Columbia Museum. The Burke Museum boasts the largest collection of 19th-century Tlingit objects in western America. Some objects were collected at Klukwan before 1905.

Practitioners: Greg Colfax (Makah, Neah Bay, WA.); Jacob Simeonoff; Rich LaValle (Portland, OR).

Sources: Alaska General Store (Anchorage and Juneau); Decker/Morris Gallery (Anchorage, carries masks and hats by Jacob Simeonoff); Saxman Native Village (near Ketchikan); Southeast Alaska Indian Cultural Center (Sitka).

BENTWOOD HUNTING HATS

Sometimes called "visors," bentwood hunting hats were used by Alutiiq hunters when they paddled out to sea in their baidarkas (skin boats). The hat shaded their eyes from the glare of the sun on the sea as they sought Steller's sea lions, whales, or sea otters, or fished for halibut and other food species. They also deflected wind and kept

BARBARA LAVALLEE

Barbara Lavallee likes folds: folds of parkas, folds of laundry, folds of calico skirts, folds of walrus, folds of Russian folk costumes, folds of friends in a hot tub on a snowy winter evening. She likes stripes and patterned fabrics and bright colors.

Barbara Lavallee

Let's have fun, her watercolors say; let's have a good laugh. Let's dance, let's sing, let's share.

"I prefer to portray the magnificence of man," she says, "his joy and humor, his tenacity, his ability to overcome."

Lavallee's whimsical, stylized work can be found on everything from pot holders to mugs, from aprons to sweatshirts, from greeting cards to Christmas tree ornaments--even refrigerator magnets. She is perhaps best known for her illustrations for the children's book, *Mama, Do You Love Me?* (Chronicle) which has sold more than a million copies. However, she has also illustrated the "Imagine Living Here" series authored by Vicki Cobb; those titles include *This Place is Cold, This Place is Wet, This Place is Crowded,* etc. The special delight of this Anchorage resident is traveling to other places — Africa, Brazil, Peru, Japan — and sketching on site.

Lavallee grew up in Iowa and Wisconsin and studied art education at Illinois Wesleyan University. After teaching on a Navajo reservation in Arizona, she accepted a position at Mount Edgecumbe school in Sitka in 1970.

Now an Anchorage resident, Lavallee paints in a studio with spectacular mountain views. With the help of her sons, Chip and Mark, she has her own catalog and mail order business. Many of her originals are reproduced as limited edition prints. For more about this prolific artist, see *Barbara Lavallee's Painted Ladies and Other Celebrations* (Epicenter Press, 1995).

off the rain — much more common in the Aleutian Islands than sunshine.

The hats were decorated with sea lion whiskers (a sea lion grows only four whiskers, so these demonstrate prowess in hunting), cormorant feathers, carved ivory amulets/prey figures and trade beads. They were also painted in striped curving designs of different colors, especially black and red.

Bentwood hats with open crowns looked much like the eyeshades worn by bank tellers in old movies. Those with closed crowns and a significantly longer bill are unique in shape. In an auction held Oct. 9, 1997, at the Anchorage Museum, several

closed-crown hats were referred to as "Aleut sunshade hats." Contemporary versions with polychrome stripes, sea lion whiskers and a single ivory finial were valued at $1,000 to $1,500.

See also SEA LION WHISKERS, photo on back cover.

Museums/Displays: Alaska State Museum (Juneau); Anchorage Museum of History and Art; Thomas Burke Memorial Museum (Seattle); King Salmon Visitor Center; Museum of the American Indian, Heye Foundation (NYC); Museum of Anthropology and Ethnography (Leningrad); National Museum of Man (Ottawa); Peabody Essex Museum (Salem, MA.; this museum boasts a diverse collection of 28,000 Eskimo and American Indian objects); Peabody Museum of Archaeology and Ethnology (Harvard University,

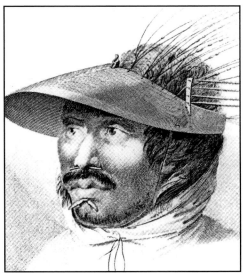

The engravings of John Webber, official artist for Cook's third voyage (1776-1780), provide valuable information on Native dress and culture more than two centuries ago. This portrait of an Aleut man shows facial jewelry, hooded kamleika, and painted bentwood visor typical of the era.

Cambridge, MA); Rijksmuseum voor Volkenkunde (Leyden, Netherlands); Royal Museum of Scotland (Edinburgh); Sheldon Jackson Museum (Sitka); State Museum of Ethnography (Leningrad, Russia); Uebersee-Museum (Bremen, Germany).

Practitioners: Andrew Gronholt (Unangan/Aleut, Unalaska); Rich LaValle (Portland, OR.); Peter Lind Sr. (Homer, originally from Chignik); Jacob Simeonoff; Gertrude Svarny (Unangan/Aleut, Unalaska).

Sources: Anchorage Museum of History and Art gift shop; Decker/Morris Gallery (Anchorage); Rainsong Gallery (Juneau); Portfolio Arts (Juneau).

BERING SEA ORIGINALS

Beginning in 1969, Bering Sea Originals was a line of souvenirs produced by a Seattle department store on such functional "canvases" as place mats, glasses, ceramics and note paper. The drawings of noted Siberian Yupik artist Florence Malewotkuk (1906-1971) was among those reproduced by this company.

However, in 1975, Gordon and Carol Rock of Anchorage purchased the company and changed its emphasis. "Increased competition from the Philippines meant that it was no longer practical to produce ceramics or place mats," Carol Rock told me in February, 1998. Bering Sea Originals is now a single collectibles shop which carries

items such as C. Alan Johnson figurines, Hummels, Harbour Lights lighthouses, Dept. 56 Snow Babies, Precious Moments, Cherished Teddies, Calico Kittens, Dreamsicles Angels and Boyd's Bears.

BILLIKENS

Billikens are lumpish, kewpie-doll-like walrus ivory carvings invented in the early 1900s. The pointy-headed, Mona Lisa-smiling figures frequently came equipped with a verse which directed owners in their use; rub their plump tummies, and they will bring good luck. Although common into the 1960s, these figures have dropped out of favor as more traditional, more detailed dancing figures have come into vogue.

For the best information on this carving, see *Artists of the Tundra and the Sea* by Dorothy Jean Ray.

See also IVORY.

Museums: University of Alaska Museum (Dorothy Jean Ray Collection, Fairbanks); Corrington's Ivory Museum (Skagway).

Historic practitioner: Billy Komonaseak (Wales, d. 1943).

Practitioners: Edgar Ningeulook (Shishmaref); Elliot Olanna (Shishmaref); Melvin Olanna (as beginning carver in 1950s); Roderick Seetamona (Shishmaref); John Sinnok (Shishmaref); Delbert Eningowuk (Shishmaref).

Sources: Baranof Museum (Kodiak); The Ivory Broker (Anchorage).

BINGLES

"Bingle" is another word for token — something taken in the place of legal tender. During the decades when the Alaska Territory experienced a shortage of small change and currency, Bureau of Indian Affairs stores, canneries, saloons and even the NCO open mess at Cape Newenham issued their own units of exchange, which were accepted as money. Uncirculated sets are in the best condition, and thus bring the best prices. Bingles from the federal agricultural experiment at Palmer, the Matanuska Colony (1935), reached collectible status in the late '50s and early '60s and are some of the best-known, but not necessarily the most valuable.

See also EPHEMERA, TOKENS/MEDALS.

Sources: Kaye Dethridge (Sitka).

BIRCH AND BIRCH BARK

"They always respect the birch bark ... Where you go you respect the trees because they make big canoes out of it ... It's based on respect for the birch, because the birch tree, you can make sutures out of it, sleds, and lots of good out of it."

<div align="right">

—Basketmaker Belle Deacon, in *Pacific Basket Makers,*
A Living Tradition (1983).

</div>

Athabascan Indians in Alaska use both birch bark and birch wood for many pur-

poses. In fact, multiple, ingenious uses of birch bark is one of the things that identifies members of this clever, adaptable linguistic group.

The Athabascan peoples invented the birch bark canoe. Some species of birch do not grow to tree size; two that do are *Betula papyrifera* (paper birch) and *Betula kenaica* (Kenai birch). Both these species have smooth bark that peels easily. Bark is stripped from live, standing trees, usually in spring, when it is loose. Some Athabascan basketmakers "pick" the bark only in June when it is honey-gold in color.

In addition to canoe coverings, Athabascans used this renewable resource for berry baskets, cooking containers, baby cradles/carriers, cups and dishes for camping, rain hats, wrappers to keep kindling dry, wrappers for meat, liners for pit caches, siding and roofing for raised caches, casts for broken limbs and megaphone-like calls for bull moose. Willow branches and spruce roots are used to reinforce the rims of birch bark baskets. Spruce roots lash the peeled willow and birch together, and serve as strengtheners and shapers around the rim — which may be gracefully curved.

> "Art was one with the culture. Art was our only written language."
> — Haida artist Robert Davidson, in *Robert Davidson: Eagle of the Dawn,* edited by Ian M. Thom

Athabascan basket makers may overlap zigzag pieces of pinkish or yellowish bark set on off-white bark as decoration, gray bark against dark brown bark, or may superimpose smooth inside-out pieces against rough outer pieces complete with lichens and other growths. At the basket maker's whim, the spruce root or red willow shapers around the rim will be dyed to supply a color accent.

For more information refer to B*irch Bark Basket Making — Oiagumik Amminialio* by Minnie Gray, Tupou Pulu, Angeline Newlin and Ruth Ramoth-Sampson (available from Circumpolar Press, Anchorage). Photographs show techniques and tool use. See also *From Skins, Trees, Quills and Beads: The Work of Nine Athabascans* (1984). Charles Backus was the able photographer for the latter.

A modern application of birchbark is as decorative picture frames. These are a specialty of the village of Kobuk (300 miles west of Fairbanks). Often imported to Alaska from Russia are small birchbark boxes, with the top layer of bark cut out in a lacy design so that red felt showns through.

Birch wood traditionally turned up as drum frames, slatted chest armor, boat frames and ribs, bows and arrows, spoons and dishes, tool handles, fleshing tools (for working hides) and sledges. Modern carpenters like it for kitchen cabinets. Nested bowls made in this light-colored wood are also popular.

See also BARK, BASKETS, WILLOW ROOT.

Practitioners (baby cradles/carriers): Molly Galbreath (Fairbanks); Minnie Gray (Ambler); Marilyn Paul (also creates model boats and baskets; see her work at Alaska

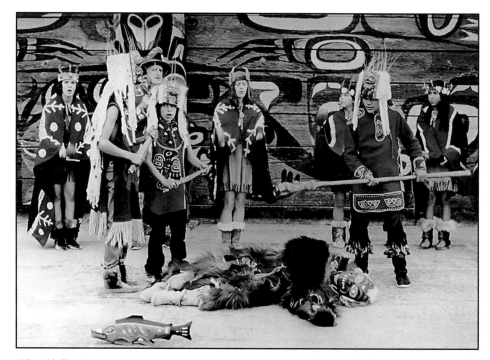

The Chilkat Dancers recreate a tale from tribal folklore before a plank house on the parade grounds of Fort William Seward in Haines, 1974. The defeated figure (reclining) is wearing a carved mask and a bear skin. The victorious youth standing at right sports a beaded tunic, set off with a carved frontlet hung with ermine skins and topped with sea lion whiskers. Six choral figures (rear) wear button blankets. The dancers were organized in 1959 by retired Army officer Carl Heinmiller of Alaska Indian Arts, Inc. Heinmiller founded AIA to revive and perpetuate the arts, crafts, music, and dances of the Tlingit.

Native Arts & Crafts).

Sources (baby cradles): Alaska General Store (Anchorage); Alaska Native Arts & Crafts (Anchorage); Alaska Native Hospital gift shop (Anchorage); Inu Craft (Kotzebue).

Practitioners (baskets): Nora Alexie (Lime Village); Katherine Cleveland (Ambler); Belle Deacon (Grayling); Daisy Demientieff (Anchorage); Helen Dick (Lime Village); Ursula Graham (Lime Village); Sarah Malcolm (born in Eagle, 1905); Janice E. Perkins (Jan's Holitna Creations, Sleetmute; also works in willow, grass and other natural materials).

Practitioner (birch wood objects): Charles Jimmie, Sr. (Haines; grease bowls).

Sources (baskets): Anchorage Museum of History and Art; Alaska Fur Exchange (Anchorage); Alaska Native Arts & Crafts Coop (Anchorage); Alaska Native Hospital gift shop (Anchorage); Snowshoe Fine Arts & Crafts (Tok, 800 478-4511); gift shop of Innoko National Wildlife Refuge (McGrath); University of Alaska Museum

(Fairbanks). Bowls: Rebecca Weatherford (North Pole).

Alaska Alive: Events where basketmakers appear and demonstrate their craft: Festival of Native Arts, March, Anchorage Museum of History and Art; Annual Festival of Native Arts (University of Alaska, Fairbanks); Made in Alaska Trade Show.

BLANKETS

Alaska's pre-contact blankets were the skins of animals, used singly (when the skins were those of large animals such as bears and caribou), or sewn together into robes (when the skins were those of wolves). Athabascans netted blankets of strips of rabbit skin, in a method akin to crocheting.

Warm, woven wool blankets, such as the brightly striped Hudson Bay blankets, were traded to Alaska's Native peoples from the early 1800s on. Some of these have become collectors' items. Capotes (winter coats) are still made of them in Canada.

Today a new series of blankets, the Spirit Keeper Series, is being marketed by The Doyon Foundation of Fairbanks. "Seyelneyo (My Relatives)" is the first in the series, designed by Kathleen Carlo (b. 1952, Tanana) and woven at Pendleton Woolen Mills in a limited edition of 1,000. The sale of the Seyelneyo blanket benefits a scholarship program.

See also BUTTON BLANKETS, CHILKAT BLANKETS.

Designers: Kathleen Carlo; James L. Grant, Sr. ("Medzeyh Te Hut'aane, People of the Caribou"); Marvin Oliver.

Manufacturers: Pendleton Woolen Mills.

Details: The Doyon Foundation, Athabaskan Heritage Collection, 888-478-4755; or wrightm@doyon.com.

BRACELETS

Although ivory amulets and charms abounded in traditional Alaskan Eskimo culture, ivory bracelets do not seem to be an aboriginal form of Eskimo art. Carvers apparently began producing bracelets and necklaces in the 1920s, in response to increased tourism. Each link of a typical bracelet may have a two-dimensional, raised animal figure on it, and some are incised scrimshaw-fashion in order to tell a story with the action moving from link to link. Bracelets may be all ivory, or alternate baleen with ivory links. Links were connected with elastic thread c.1960.

Likewise, silver bracelets are not a traditional form of Tlingit art. They were first made from silver dollars obtained in trade from explorers and gold rush stampeders. In 1962, several Southeast Alaska workshops were established in order to afford talented silversmiths further training. Today, silver jewelry is available in many forms, including pins and pendants.

See also IVORY, JEWELRY, SCRIMSHAW, SILVER.

Practitioners (ivory bracelets): Francis M. Kakoona (Shishmaref, bracelets, watch-

bands, earrings); John J. Koezuna (Teller); Lincoln Millagrook (originally from Little Diomede; gave carving demonstrations at museums in Denver, New York, Washington, D.C., and Bonn, Germany); George Milligrock (Shishmaref, bracelets and rings); Frank Ongtowasruk (Shishmaref); George Penatac (Nome); Carl Pelowook (Savoonga); Teddy Sockpick (Shishmaref, old ivory bracelets); Willy Topkok (Anchorage); Ronnie Toolie (Savoonga); Raymond Toolie (Savoonga); Mitchell Toolie (Savoonga); Herman Toolie (Savoonga); Erroll Thomas (Chugiak); Amos Wallace (silver bracelets); Willie Wassillie (Togiak); Cliff Weyiouanna (Shishmaref); Esau Weyiouanna (Shishmaref); John Weyiouanna (Shishmaref); Frank Wrenn (silver); John L. Wulf (Kenai).

Sources: Alaska Native Arts and Crafts cooperative (Anchorage); Anchorage Museum of History and Art; Gallery of the North (Juneau); Fire & Ice (Juneau); The Raven's Journey (Juneau); Mt. Juneau Artists (Juneau).

BRACKET FUNGUS/BEAR BREAD

Bracket fungus is a fleshy or woody basidiomycetous fungus whose fruiting bodies grow like "shelves" from the trunk or branches of trees including the birch.

A handful of Alaskan artists paint on bracket fungus. They include Paul & Linda DellaZoppa (Hoonah).

Historic practitioner: Ruben Gaines (cartoonist, poet, broadcaster).

BRONZE

An alloy of copper and tin, bronze was made as early as 3000 B.C. Gold in color, bronze is harder than copper, harder than iron. Nevertheless, it melts readily, making it easier to cast than iron. Early uses were in tools, coins, cutlery, mirrors, weapons, and bells. Bronze has been used to cast heroic sculptures since the days of the ancient Greeks and Romans. It continues to be popular today.

Alaskan carvers who begin in wood often move on to alabaster, marble, and even into casting their originals in bronze. Many of these bronze works are produced in very limited editions, or created only on commission.

Inupiat artist Larry Ahvakana's bronze and glass sculpture, "Last Chance," portrays a whaling crew with "one last chance" to harpoon a bowhead whale before it dives and escapes. The figures in the skin boat closing on the whale are modeled after historic Inupiat whaling captains. Ahvakana's sculpture was the centerpiece in a major new exhibit, "Pacific Voices," which opened in November 1997 at Seattle's Burke Museum. The artist hopes to complete a life-size version of "Last Chance" for the North Slope Borough Cultural Center in Barrow.

Combinations of mediums inspire contemporary artists like Tom Knapp, who creates bowls covered with bronze in totemic designs, in editions of 250.

See also ONE PERCENT FOR ART, SCULPTURE.

Insider Tip: Alaska has pledged support to the visual arts through a state program, "One Percent for Art," where-by one percent of the cost of any public building is pledged to commissioning original art works expressly for that structure. For instance, the late Melvin Olanna created a six-foot-high, exterior bronze polar bear for the Fairbanks Jail Expansion, 1983-84. Olanna also created a smaller bronze bear for the Patty Gym at the University of Alaska Fairbanks.

"Tussock Trekker," bronze, Shoe Size 9, by Wendy Croskrey.

Bronzes of crabs, dolphins and polar bears by Jacques and Mary Regat start at $600. Their prices rise quickly to $10,000 when they portray goddess of the undersea Sedna or other figures from Eskimo legend. Occasionally the Regats work an alabaster face or two into their wooden relief panels; visit the PAC.

Historic practitioners: Bill Berry, Melvin Olanna.

Practitioners: Larry Ahvakana (Inupiat, formerly of Bethel and Anchorage, now living near Seattle); Peter Bevis (Seattle, bronzes of animals and other sea life cast after various oil spills in Washington and Alaska); Kitty Cantrell; Wendy Croskrey (b. 1960, casts in iron and aluminum, too; teacher of sculpture and design at Arizona State University and University of Alaska Fairbanks); James Grant Sr. (Athabascan, born in Tanana, educated in California, now living in Fairbanks); Gary Lyon (Homer, wildlife); B. Hugh McPeck (ravens); Marvin Oliver (works in bronze, steel, glass, wood and paper); Jacques and Mary Regat (Anchorage, figures from Eskimo legends, paperweights, corporate awards); R. James Schoppert (work in bronze, lithography, alder); R. T. Wallen; Steve Clement (Wasilla).

Sources: Alaska Eagle Arts Gallery (Ketchikan); Boreal Traditions (within the Captain Cook Hotel, Anchorage); Dockside (Ketchikan); Elaine S. Baker & Assoc. (Anchorage); Gallery of the North (Juneau); Julie's (Ketchikan); Lynch & Kennedy (Skagway); Marvin Oliver Gallery (Seattle); Stephan Fine Arts (Anchorage); Fremont Fine Arts Foundry (Seattle); R.T. Wallen Gallery (Juneau); Scanlon Gallery (Ketchikan); SITE 250 Fine Art (Fairbanks); Walleen's Northlight Gallery (Anchorage).

BUTTON BLANKETS

Art historians are unsure precisely when or where the earliest Pacific Northwest

button blankets were created. However, in 1844, when a Russian sketched the funeral of a Tlingit chief, some of the mourners were wearing them.

The Northwest Coast button blanket is a ceremonial robe that is entirely a product of white contact. That is, it did not exist in prehistoric times. It developed when its materials became available through trade: woolen blankets, flannel and mother-of-pearl buttons from China. Trade buttons were introduced about 1850, and craftspeople quickly became discriminating: buttons of saltwater pearl shell were prized more than those cut from freshwater shells, because the former had more color.

The button blanket art form took hold quickly, and by the end of the 19th century had spread over much of the coast. It took much less time and skill to create a button blanket from existing fabric than a Chilkat blanket which had to be woven from scratch from dog wool or mountain goat wool.

The "ground" of the typical button blankets was a dark blue Hudson's Bay Co. blanket. Scarlet wool flannel was used to create a broad border around three sides. In the center of this frame was sewn the heraldic design of the important person who would own and wear the blanket; the crest was rendered in fabric applique´ or entirely in glistening mother-of-pearl buttons. Today the crests may be cut from the best quality wool felt, and then completely covered in beadwork, creating a raised, textured surface.

Tlingit people of Southeast Alaska are actively creating button blankets today, for such occasions as weddings or the raising of a totem pole, and for dance performances. The blankets are worn draped over the shoulders like heavy capes. Buttons and loops or hooks and eyes secure them over the chest.

Robert Davidson (Haida, Queen Charlotte Islands, British Columbia) and Dorothy Grant (Northern Haida, Prince of Wales Island) collaborated on several button blankets or "wearing blankets." Davidson designed; Grant sewed. A button blanket they created in 1982 used a Hudson's Bay blanket as the base, and applied plastic buttons, shell buttons, dentalium shell, antique Chinese buttons and felt with cotton thread. Central to the design was a dogfish.

In an October, 1979, auction at Sotheby Parke Bernet, Inc., two button blankets were given estimated values ranging from $12,000 to $25,000.

See also BEADWORK, BLANKET, CHILKAT BLANKET.

Blanket Trivia: As of July,1987, the Burke Museum boasted 13 button blankets in its collection. One of the finest was a late-19th-century Tlingit example decorated with the frog crest of the Raven clan, in lines formed of triple rows of buttons.

Museums: Anchorage Museum of History and Art; Burke Museum (Seattle, WA.); Rasmussen Collection, Portland Museum of Art (Portland, OR.).

Practitioners: Rosa Alby (Haida, Hydaburg); Robert Davidson (Haida, designer); Florence Donnelly (Sitka; button robes for dolls); Dorothy Grant (Haida, Prince of Wales Island); Esther Littlefield (b. 1907, Tlingit, Kiksadi clan); Edith "Essie" Olin

(Metlakatla; Tsimshian button blankets with bone and abalone buttons; also bead-work); Irene Peratrovich (Klawock); Clara Peratrovich (Ketchikan); Vicki Soboleff (Juneau); Carrie Sykes Skrzynski (Juneau).

Sources: Generally by commission. Occasionally available at the gift shop of the Vancouver Museums and Planetarium Association (British Columbia).

CARVINGS

One of the first Westerners to comment on the appearance and aesthetic of Pacific Northwest Coast Native art was the British mariner Captain George Dixon, who explored the Queen Charlotte Islands in 1787. Confounded by but appreciative of what he saw, Dixon described Native carvings as decorated with "fig-ures which might be taken for a species of hieroglyphics: fishes and other animals, heads of

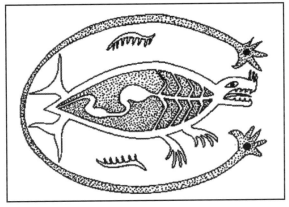

Carving on wooden dish. Seal surrounded by monster. Note representation of internal anatomy. Eskimo, Alaskan, modern. Rendered by Paul E. Kennedy.

men and various whimsical designs, are mingled and confounded in order to compose a subject...yet they are not deficient in a sort of elegance and perfection."

Tlingit carving abhors a vacuum; Tlingit design is simultaneously abstract and rep-resentational—but it does not allow blank spaces. Elements like ovoids were developed as fillers.

The art of Tlingit carving essentially disappeared for the first half of this century, but fortunately was resuscitated in Haines under the direction of World War II veter-an Carl Heinmiller.

Athabascan carvers generally had less time for decorative art than did the Tlingit, and their work was usually limited to utilitarian creations such as snowshoes, bows and arrows and wooden bowls. However, like Tlingit "medicine men," Athabascan shamans employed carved masks, rattles and dancing sticks during their ceremonies.

Not all Alaskan carving is executed by Native Americans, of course. In their spare time, loggers may take up small chain saws and whip out standing black bears, sour-doughs with plenty of whiskers, rude totems and other generic yard sculptures. Finer carvers like John A. Nelson of Homer create a wide variety of marine, shorebird and waterfowl; Nelson is particularly known for his perky puffins.

See also ANTLER, CEDAR, COTTONWOOD BARK, DRUMS, IVORY, MASKS, OVOID, SCULPTURE, SOAPSTONE, TOTEM, WHALE BONE.

Excursions: The carving of Southeast Alaska is so well known that the Art Institute of Chicago regularly schedules museum-guided excursions for those with a special interest in it. The cruises encompass British Columbia and Southeast Alaska, highlighting "wildlife, folklore and indigenous art." For details, call (312) 443-3917.

Museums: The Art Institute of Chicago, Burke Museum (Seattle); Anchorage Museum of History and Art; Canadian Museum of Civilization; National Museum of Ethnology (Osaka, Japan); Museum of Ethnology (Hamburg, Germany); University of British Columbia Museum of Anthropology (Vancouver).

Historic practitioners: Mungo Martin (Kwagiutl, d. 1962); Numayuk (St. Lawrence Island); Horace Marks (Haines, Juneau, Tlingit, d. 1994); Raymond Nielson Sr. (Sitka, Tlingit, d. 1997; he and his father carved a panel for the Seattle World's Fair).

Practitioners: Rose Anderson (Ketchikan, cedar paddles); Steve Brown (Wrangell, house posts); Dale Campbell (Tlingit/Tahltan); Freida Dreising (Haida); John Hagen (Haines, panels); Homer W. Hoogendorn (Nome); John Hoover (Grapeview, WA); John C. Hudson (Metlakatla, Northwest Coast Indian style carvings); Nathan Jackson (Saxman, near Ketchikan); Doreen Jensen (Gitksan); Gary James John (Tok); Robert C. Johnson (Eagle River; works in cottonwood, soapstone, baleen); John J. Koezuna (Teller, works in ivory and bone); John Komakhuk (Eagle River; works in baleen and soapstone); Simon S. Koonook (Haines; works in soapstone and alabaster); Terenty Merculief (Unangan/Aleut, St. George, boat models); Tim Murnane (Homer, wood block prints); John A. Nelson (The Bottom Line, Homer; 888 663-2444); Ray Neilson (Sitka); Delbert Obruk (Shishmaref); Wayne Price (Wrangell, house posts); Bert Ryan (Metlakatla); Wayne Smallwood (Juneau, masks, paddles, rattles); Ernie Smeltzer (Ketchikan); Sandy Stolle (Seward, wood); Francis Williams (Haida, grease dishes).

Tlingit carver Nathan Jackson of Saxman is so well known that his portrait, in full Tlingit dance regalia, appeared on a U.S. postage stamp in 1996. Jackson carves totems, masks and dugout canoes.

Sources: Alaska State Museum gift shop (Juneau); Bobbi's Treasure Chest (Dillingham); Boreal Traditions (within the Captain Cook Hotel, Anchorage); Chinook Gifts (King Salmon airport); Juneau General Store (Juneau); Metlakatla Native Reserve; Northwest Tribal Arts (Juneau); Northwind Fine Arts (Homer); The Reluctant Fisherman gift shop (Cordova); Saxman Village (near Ketchikan); Sheldon Jackson Museum gift shop (Sitka); Ship Creek Center (Ship Creek Hotel, Anchorage); Southeast Alaska Indian Cultural Center (Sitka); galleries and gift shops throughout the state.

CEDAR

A wood that does not rot easily, western red cedar *(Thuja plicata)* grows in south-

eastern Alaska. Cedar has a natural ability to resist insects and disease as well as decay.

The Tsimshian and Tlingit of Southeast steamed red cedar into box drums and also carved it into totem poles. Old-growth trees with few knots were preferred. Traditional tools were adze and curved knife, with shark skin serving as sandpaper.

To the north, Tanaina Athabascans around Cook Inlet collect cedar drift wood, and carve it into pegs for ground squirrel snares and arrow shafts.

See also CEDAR BARK, DRUMS, TOTEM POLES.

Teacher Alert: Consult *Cedar* by Hilary Stewart (University of Washington Press). Another useful source, especially for ages 9-12, is *The Cedar Plank Mask* by Nan McNutt (Sasquatch).

Insider Tip: The Beaver Clan House in Saxman (just outside Ketchikan) is constructed of hand-adzed cedar. It is the only clan house built in Alaska in the last 50 years. See John Hoover's free-standing

> "Personal gain or glory is not my motive. I work in the name of my father and for the hope of helping the Aleut people. I see all these Eskimo things — and there are no Aleut things. It's just so frustrating."
> — Elaine Smiloff, Kodiak mask-maker, in a 1990 interview with Ann Chandonnet.

"Volcano Woman" sculpture carved in red cedar in the foyer of the William A. Egan Civic and Convention Center (Anchorage). The group of 12 large carvings depicts an Aleut creation legend in which cormorants watch as the first human woman emerges from the crater of a volcano. The cormorants then distribute the woman's offspring over the Aleutian chain, populating the previously barren islands.

Practitioners in red cedar: David Boxley (Tsimshian); Wayne Hewson (Metlakatla); John Hoover (Aleut, now living in Washington state). Bert Ryan (Metlakatla) carves ceremonial paddles in red cedar. Norman Jackson (Kake) uses red cedar for walking canes inlaid with abalone.

Sources: Anchorage Museum of History and Art; Burke Museum gift shop (Seattle); seasonal gift shop (Saxman); Kaye Dethridge (Sitka, old carvings); Makah Museum (Olympic Peninsula, WA.); Sheldon Jackson Museum (Sitka, cedar bark baskets, wooden potlatch spoons); C.E.D.A.R. (Anchorage).

Yellow cedar is used in the carving of masks, boxes and totems. The twisted bark of yellow cedar trees served as some of the warp threads in a Chilkat blanket.

The mask "Eternal Youth" in yellow cedar and copper by Carmen Quinto-Plunkett was an Alaska Contemporary Art Bank Purchase in 1981 after appearing in the "Wood, Ivory and Bone" show.

See also CARVINGS, MASKS, TOTEMS.

Practitioners in yellow cedar: John Hagen (Haines, killer whale panels); Carmen Quinto-Plunkett (masks); Wayne Smallwood (Juneau, paddles, masks, rattles).

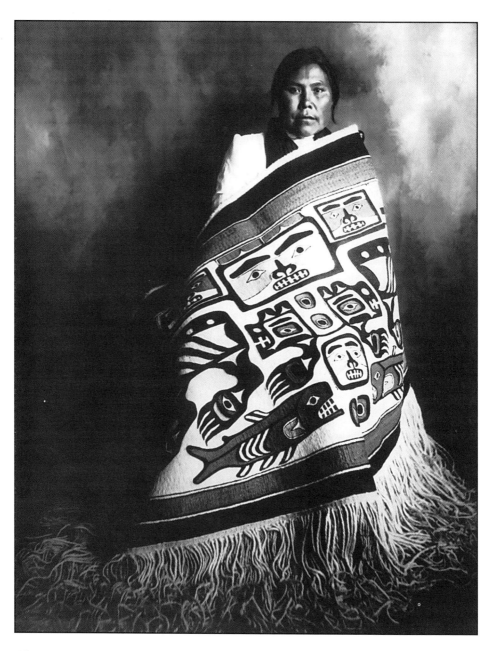

Tlingit woman draped in a generously fringed Chilkat blanket, c. 1900.

Sources: Northwest Tribal Arts (Juneau); seasonal gift shop (Saxman).

CEDAR BARK

The bark of the cedar tree was removed in long strips from the trunks of trees in the spring when the sap was running. The smooth inner bark was separated from the tough outer layer, and dried. Tlingit, Makah and other peoples of the Pacific Northwest and Alaska used cedar bark in a variety of ways. Wide strips of natural bark were made into boxes, cradles, canoebailers and harpoon sheaths. Narrow strips of bark, split into even widths, were used for twined hats, mats and baskets. Shredded red cedar bark was used for toweling, as babies' diapers, and rope or cording. Yellow cedar bark, tougher than red, was first soaked in salt water to soften it, and then pounded. After processing, it was used for rain capes, skirts and robes. It was yellow cedar bark that was twisted with strands of spun mountain goat wool to form the warp threads for Chilkat blankets.

See also BARK, CHILKAT BLANKET.

Museums: Burke Museum; Colville Confederated Tribes Museum (Coulee Dam, WA.); Samish Cultural Center (Anacortes, WA.).

Sources: Makah Cultural and Research Center (Neah Bay, WA.); Sheldon Jackson Museum (Sitka); Ship Creek Center (Anchorage); U.S. Department of Interior Craft Shop (Washington, D.C.).

CHILKAT BLANKET

Chilkat blankets are ceremonial robes, capes or "mantles" woven of mountain goat wool and yellow cedar bark. A single robe required the wool from three goats. The wool was dyed colors such as brown, yellow, green and blue. Then strands of spun wool were twisted with yellow cedar bark to form the blanket's warp threads.

A Juneau craftswoman told me that the Chilkats sold permission to the Tlingits to make these blankets for the price of a song. According to *Native American Art in the Denver Art Museum,* the history of these twined textiles goes even further back; Chilkat tradition holds that the Tsimshian taught them to make these blankets. However, the Tsimshian abandoned the art in the mid 19th-century.

This intricate, labor-intensive weaving represents a pinnacle in the art of the Tlingit. Because of the investment of time and skill required, Chilkat blankets had a higher status than button blankets. Only about a dozen authentic 19th century Chilkat blankets reside in museum collections around the world.

In a traditional division of labor by gender, Tlingit men painted the blanket designs on boards, plotting out just half of the complex design. Tlingit women undertook the painstaking weaving, reversing the pattern for the half not shown. Long fringes decorate the bottom edges of the blankets.

The pattern for a Chilkat blanket is taken from a tribal crest and made symmetri-

⊲❧-❀-❀-❀-❀-❀-❀-❀-❀-❀⊲

C. ALAN JOHNSON

Toctoo, Sally, Oopik, Bobby, Nutchuk, Judy, Eetook, Sammy, Toolik, Martha, Lisa ...

What do these names have in common? They're all ceramic figures by C. Alan Johnson of Poulsbo, WA. Martha pets her pup. Charming Lisa dances wrapped in her miniature Chilkat blanket.

And they're all retired.

Many visitors to and residents of Alaska are avid collectors of figurines by C. Alan Johnson. Born in Pasadena, CA., "Bud" Johnson was raised on a farm in Idaho. From early childhood, he knew he wanted to be an artist.

After three years in the Navy during World War II, Johnson studied at the Burnley School of Art and Design in Seattle.

Johnson began sculpting figurines in 1956, although it was not until 1958 that his Alaska Figurine Collection was first shown to the public. In 1961 Johnson, his wife and three young children spent six weeks at Point Hope during the spring whaling season, resulting in characters like Whaling Captain Kunuk (1962, 9 inches) and Anna with her baby snug in her parka hood (1962, 8 inches). Each figurine represents six to 15 molds and 40 handlings.

To celebrate 1993, his 35th year of Alaska figurines, Johnson created Jack and Seekoo, Annie and the dancing Sahkolik. For his 40th year, he is working on a new sculpture of two children. Devoted fans are quick to snatch up new issues, and there is a growing secondary market for his retired creations.

Over the years, Johnson has branched out into an ornament line, Alaska Classics — reproductions of miniature paintings. Typical subjects are polar bears, the Northern Lights, a Christmas gathering, a cozy cabin in the snow, puffins and so on. Each copyrighted painting is fired onto a 3-inch ceramic disk. The rims are hand-painted in 24k gold.

Between 1961 and 1983, Johnson had one-man shows in Anchorage, in Fairbanks, on Bainbridge Island and in Seattle's Stonington Gallery. Today his works (including watercolors, prints and bronzes) can be found in collections around the world.

cal. The image is stretched, bent or stylized to fit the rectangular space of the blanket, making the identify of the crest used somewhat mysterious to those unfamiliar with Tlingit formline "shorthand." Raven is generally distinguished by his long, straight beak, for example; but in his beak may sometimes be a circle—representing the sun whose light he stole.

At potlatches a century ago, Chilkat blankets might be cut into sections and distributed — to show the wealth of their owner. Some of these scraps survive as heirloom dance aprons and dance leggings.

Lt. George T. Emmons was one of the first to write about this fabric marvel. For details, read Emmons' 1907 report, or consult *The Chilkat Dancing Blanket* by Cheryl Samuel (Pacific Search Press, 1982).

See also BUTTON BLANKET, FORMLINE, RAVEN'S TAIL WEAVING.

Teacher Alert: See *The Spindle Whorl* by Nan McNutt (Sasquatch, 1997). This book for ages 9-12 includes instructions for making a whorl that can spin yarn.

Insider Tip: A blanket by skilled weaver Anna Brown-Ehlers can command as much as $35,000.

Museums: Burke Museum (at the University of Washington, Seattle); Chilkat Center (Haines); National Museum of Natural History; Peabody Museum (Salem); University Museum (Philadelphia).

Historic practitioners: Maria Miller (Haines, d. 1995; listed on the National Registry of Living Treasures during her later years); Selina Peratrovich (Haida, d. 1984); Esther Kasakan Littlefield (Sitka, Tlingit; beading, button design, leatherwork, basketry; d. 1997. Honored in 1991 as a National Heritage Fellow by the NEA.); Jennie Thlunaut (Shax'saani Keek', "Younger Sister of the Girls," Chilkat Tlingit,1892-1986). For the fascinating life story of Jennie Thlunaut, see the profile by her granddaughter Rosita Worl in *The Artists Behind the Work.*

Practitioners: Anna Brown-Ehlers (Juneau); Penny Carson (Craig); Selina Peratrovich's daughter, Delores Churchill; Delores' daughter, Holly; Ernestine Glessing (Hoonah); Clarissa Hudson; Marie Laws (Raven's Tail weaving); Lani Strong Hotch (Klukwan); Tri Roskar (Sitka); S. Joy Rusch (apprentice); Cheryl Samuel (British Columbia); Jeannette Tabor (Juneau; studied with Clarissa Hudson). Because of the time involved, most practitioners work strictly on commission.

Sources: Commission.

Referrals: Alaskan Indian Arts (Haines); Chilkat Dancers (Hotel Halsingland, Haines); Chilkat Valley Arts (Haines); Sealaska Corp. (Juneau); XudzidaaKwaan Dancers (Angoon).

CHRISTMAS TREE ORNAMENTS

These vary from blown glass spheres bearing individual sketches of walrus in Santa hats, etc., to flat ceramic plaques bearing paintings by artists like Byron Birdsall and Barbara Lavallee, to inexpensive metal cut-outs. Some have traditional Tlingit designs of eagles or salmon; some look like Eskimo children in charming poses (such as holding a baby seal); others are intricate snowflakes cut from lightweight wood.

In the1980s, Naomi Leonard of Eagle River began marketing kits for Christmas ornaments of such items as a Tlingit Chief in a button blanket. (Because of the size of

the ornament, beads take the place of actual buttons.) Look for the "Calico Cache" brand.

Northern Light Ventures of Sitka produces glazed ceramic ornaments in totemic form—wolves, killer whales, etc. Chief colors are red and black on white, with occasional green accents. On the reverse, the real thing has a snowflake motif with the word "Alaska" inside, plus a copyright date and the initials "NLV."

Christmas ornament in the shape of a butterfly, 2.25 x 2.25 inches; sealskin, beads, sequins, thread, by Minnie Sinnok, Shishmaref, 1990. Trimmed on both sides.

The rarest Alaskan Christmas ornaments are "chrismons" — an art-form invented when Lutheran missionaries introduced Christian symbols such as the cross. Chrismons are sealskin cutouts outlined with bead-work. They are a specialty of Shishmaref and now and then surface in limited numbers at Alaska Native Arts & Crafts or the Alaska Native Medical Center.

Dog Bites Tree: During the 1996 Christmas season, the dog belonging to the family of Governor Tony Knowles made quick work of one of the ornaments on the mansion tree in Juneau. The decoration by Anchorage artist Fran Reed included dyed salmon skin —which Shadow, a black Labrador, mistook for lunch. The rest of the ornament —netting of metallic stars and silver, blue and gold seed beads —wound up trailing down the staircase.

The governor's tree also boasted:

* A paper shopping bag painted with blue and gold forget-me-nots by Jean Shadrach of Anchorage.

* Totemic ornaments inscribed with religious greetings in Tsimshian, Haida and Tlingit by George Mather of Juneau.

* A ship inside a light bulb by W.H. Hagmuller of Cordova.

* A mosquito, done in the form of a Tlingit-style mask, by Rebecca Welti of Ketchikan.

Insider Tip: Unique Christmas ornaments are always available at the annual Crafts Weekend held at the Anchorage Museum of History and Art during the three days immediately following Thanksgiving.

Practitioners: Jennifer Cameron (Fairbanks, original porcelain pieces/ornaments); David Edlefsen; Norm Hays (Anchorage, Ornaments by Norm); Conrad Mentjes (wood snowflakes); Ida Ruth Nayokpuk (Shishmaref, hats, mittens, ornaments);

Tea pots and storage containers decorated with halibut designs by Ahna Iredale, Sitka, 1982.

Sharon F. Nayokpuk (Shishmaref, beaded ornaments); Sharon L. Nayokpuk (Shishmaref, tops, hats, ornaments); Karon Ricker (spirited Santas); Janine Strickler (fiber ornaments).

Sources: Alaska Native Arts and Crafts cooperative (Anchorage); Ann's Tiques and Christmas Shop (Sitka); Art Shop Gallery (Homer); Artique Ltd. (Anchorage); Bayberry's (hand-blown ornaments, Fairbanks); Carrs Quality Centers (Anchorage, Eagle River); Coal Alley Gifts (Fairbanks); Daisy A Day (Fairbanks, ornaments for theme trees); Great Alaska Tourist Co. (Wasilla); J.C. Penney; Nayokpuk General Store (Shishmaref); North Wind Home Collection (Homer); Northern Lights Ventures (Sitka).

CLAY/CERAMICS/PORCELAIN/POTTERY

Alaska's ceramics include everything from coffee mugs to fish platters, from halibut-shaped spoon rests to wind chimes, from decorative tiles to tiles with mirrors or hooks set into them, to jewelry. A good proportion of the pottery is hand-built and functional as well as decorative.

Alaska Live: The Clay Arts Guild usually holds a show every September in Anchorage.

Insider Tip: Every fall, Ahna Iredale and other members of the informal group dubbed the Fly-By-Night Potters hold a four-hour show at the Fly-By-Night Club in Anchorage.

Practitioners: Buz Blum (represented by Decker/Morris Gallery; also creates

KASEY CORREIA

While vacationing in Alaska in the spring of 1984, potter Kasey Correia fell in love. "I found the beauty of the land and the warmth of the people so inviting that I made Alaska my home."

Correia was born in Castro Valley, CA. She began working in clay in high school, supporting herself at a variety of jobs, including laboring as an electrical apprentice on the North Slope. In a humorous mood, she created the "Alaska Raisins" T-shirts and magnets.

In January, 1991, Correia founded her Anchorage own gallery, Tundra Arts and Gifts.

"As a potter, my whole strategy has changed in the last three years," she told me. "I have made a lot of self growth. Owning the gallery, working with 50 different artists, the different work we do inspires us all. All the different energies become a synergy. We are all communicators, whether we write or paint or throw clay on a wheel. We have great conversations.

"The philosophy of raku celebrates imperfections. Western culture faults us with our imperfections. We need to embrace our flaws and imperfections because they are our strengths. Since I reached these conclusions, I find my art is more flowing and looser. I let it evolve--instead of controlling it.

"My motto for the gallery is 'build it and they shall come.' I push for the locals.

"It's not about money; it's about self-fulfillment," Correia added.

woodturnings); Peter Brondz (Anchorage); Alex Duff Combs; Janet M. Flaherty (Fairbanks); Lisa Conway (UAA); Marie Herdegen (Anchor Point); Kasey Correia (Anchorage, Eskimo dancers in raku); Ahna Iredale (Homer; hand-thrown porcelain with fish designs); C. Alan Johnson (figurines since 1958); Robert Joiner (raku and functional ware); Brad McLemore (functional ware; Anchorage); Marilyn Miller (spiritual masks; Anchorage); Norma Nelson (Anchorage); Ann Newbury; Shirley Odsather; Mary Kunoruk Peters (Palmer); Carla Potter (Ketchikan); Romney Dodd Ortland and Steven Ortland (ceramic lamps with beaded and hand-painted shades); Sharon Randall; Tom Rohr (plates); Bobbie L. Sublett (Sterling, handmade ceramic dolls); Martin Tagseth (teapot sets); Al Tennant; Linda Blankenship Vollertsen (clay jewelry).

"I made my first halibut piece in 1979, but people still want that motif," Iredale told me in November, 1997. "I've learned how to throw better, and how to paint better, but right now I have two children under two, and the volume's not what it was." Iredale

recently had a show of plates that narrated her first five months as the mother of two, one of whom suffered colic for that entire period. Every August, she mans her own booth at the Alaska State Fair in Palmer.

Sources: Ahna Iredale/Rare Bird Pottery (Homer); The Alaska Porcelain Studio (Soldotna); Alaska Shop (Seward; C. Alan Johnson); Annie Kaill's Fine Crafts Gallery (Juneau); Arctic Circle Gifts (Juneau; C. Alan Johnson); Artique Ltd. (Anchorage); The Artworks (Fairbanks); Aurora Fine Art Gallery (Anchorage); Birch Tree Gallery (Soldotna); Bunnell Street Gallery (Homer); Decker/Morris Gallery (Anchorage, represents Buz Blum, Alex Combs and others); Dockside Jewelers (Juneau, C. Alan Johnson, Hummel); The Frame Workshop (Anchorage); Fields House Alaskrafts/The Fur Shack (Delta Junction); Gallery of Earth & Fire (Fairbanks); George's (Juneau, C. Alan Johnson figurines); Girdwood Visual Arts Center; Golden Heart Dolls & Accessories (Fairbanks; limited edition plates); Great Alaska Tourist Co. (Wasilla, porcelain dolls and ceramic tree ornaments); Herring Bay Mercantile (Seldovia, fish-shaped drawer pulls); Kimura Art Gallery, UAA Arts Building (Anchorage); Neill Andersen's (Sitka); North Wind Home Collection (Homer); Morning Wind Pottery (Anchor Point); Northcountry Fair (Soldotna); SITE 250 Fine Art (Fairbanks); Tenderfoot Pottery (Delta Junction); Town Square Art Gallery (Wasilla); Tundra Arts and Gifts (Anchorage).

Referrals: Anchorage Clay Arts Guild and their newsletter, Fired Up!; 907 349-4039.

An assortment of cloisonne´ pins: "Basket Weaver," 1.33 x 1.14 inches, blue kuspuk with pink flowers, Barbara Lavallee. Produced by Northern Images (Artique Ltd. Publishing); made in China. Based on a 1983 watercolor in which the kuspuk has a different pattern. "Alaska at War" (commemorating a 1993 history symposium in Anchorage), red, white and blues. "Petropavlovsk-Kamchatskiy, Sister Cities," 1991 (commemorating the 250th anniversary of Bering's 1741 voyage of discovery); made in Taiwan. "Alaska Department of Fish & Game Volunteer" (with loon; blue background, black and white bird). Orthodox churches, imitation of cloisonne plastic, orange, red, turquoise, white; made in USSR.

CLOISONNE´

Cloisonne´ is an enamelwork in which colored areas are separated by thin metal bands which act like dikes; related to "cloister," the English word derives from the Old French *cloison* or "partition."

Especially in the last decade, the work of several Alaskan artists has been repro-
duced in the form of inexpensive cloisonne´ pins. Barbara Lavallee is one of the most
notable. Her popular pins take the form of Native dancers, berrypickers, basket
weavers, fisherwomen, etc. Bill Spear of Juneau has designed dozens of pins, some
with slightly naughty or provocative messages — the perfect accent for the gray flan-
nel lapel. Eskimo artist/dancer Chuna McIntyre is also experimenting with this art
form.

See also JEWELRY.

Sources: Anchorage Museum of History and Art gift shop; Annie Kaill's (Juneau);
Elaine S. Baker (Anchorage). Most Alaska gift shops and even the souvenir sections
of supermarkets carry such pins.

Practitioners: Barbara Lavallee; Chuna McIntyre; Bill Spear.

COTTONWOOD BARK

Cottonwood *(Popular balsamifera)* or balsam poplar, a member of the willow fam-
ily, has thick, deeply fissured, grayish bark. Black cottonwood *(Populus trichocarpa)*
bears the same bark, and is the fastest-growing tree in North America. The tradi-
tional Athabascan objects carved from this buoyant bark were fishing net floats, sun
goggles (sun shades with eye slits, blackened with soot on the inside), spoons and chil-
dren's toys. Eskimos also found the wood of use for carving slit-eyed goggles and fish-
ing floats.

In the last decade or so, cottonwood bark has increasingly been used as a light-
weight "wood" for small carvings and masks as well as the faces of dolls. Chunks are
readily stripped from fallen trunks. The easy-to-work bark is marked with concentric
ring patterns as if it were wood, and it takes an attractive brown finish.

See also BIRCH BARK, CARVINGS.

Practitioners: Robert C. Johnson (Eagle River; works in cottonwood, baleen, soap-
stone).

Sources: The Yankee Whaler (Anchorage)

CRIBBAGE BOARDS

Boston whalers first entered the Bering Sea in the 1840s. They introduced the
game of cribbage to Alaska's Eskimos, who quickly grasped the notion of a new sou-
venir item to carve for trade. Ivory carvers use an entire walrus tusk to create a crib-
bage board about two feet long, but sometimes pocket-size boards are carved. The
heyday of this art, according to Dorothy Jean Ray's *A Legacy of Arctic Art*
(University of Washington Press, 1996), took place before the 1918 Spanish flu epi-
demic, when 200 of the 250 Eskimo residents of Nome perished.

See also IVORY, WALRUS IVORY.

Museums: Anchorage Museum of History and Art; UA Museum (Fairbanks).

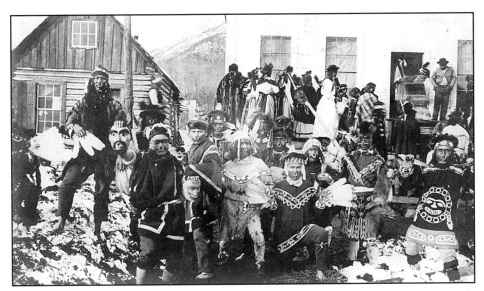

Tlingit dancers at a winter potlatch in Chilkat, AK. Some of the dancers are wearing trade items — Athabascan garments decorated with fringe, beads and quillwork. The dancer at the far left holds dance fans. The dancer standing second from left holds two masks and wears a button blanket. The man second from right is wearing a beaded octopus bag around his waist. The man standing dramatically far right holds two daggers to his throat, and wears a beaded tunic and beaded gauntlet gloves. Photo copyright 1895 by Winter and Pond.

Historic Practitioners: Happy Jack (Little Diomede Island, d. 1918 in the Spanish flu epidemic); Guy Kakarook (also known for drawings in watercolor, ink and crayon on paper); Billy Komonaseak (Wales, d. 1943).

Practitioners: Joseph Iya Sr. (Savoonga); Bernard Katexac (King Island, Nome); John Killarzoac (King Island); Cecil Seppilu (Savoonga); Melvin Seppilu (Savoonga).

Sources: Boreal Traditions (Anchorage); Alaska Ivory Exchange (Anchorage).

DANCE FANS

Dance celebrations which honored the spirits of people and animals were typical of Alaska's indigenous peoples. After the purchase of Alaska from Russia by the U.S. in 1867, early missionaries did not understand or appreciate dance tradition and many stifled it. However, dancing was approved by the priest in residence at St. Marys in 1964, and festivals revived in that area.

Torin Kuiggpak Jacobs of Bethel describes the importance of dancing to the Yupik Eskimo people: "I take so much pride in dancing to songs that my grandparents have danced and sang, and their grandparents and their grandparents before them. Not only is it the pride, but the extreme spiritual feeling I receive. At dance festivals when a member of the audience yelled 'pumyaa' (bum-e-yaw; i.e., "encore") I would glad-

ly repeat the dance with all the energy I had left, to please the audience, myself and my people."

Dance fans are a traditional part of Yupik dance regalia. Yupik dance fans are circular mats woven of grass, with a handle loop woven into the final ring; they are framed with caribou hair from the throat of the caribou, long, pale gray strands that sway as the dancers move. Many are produced today for sale to private collectors.

Yupik dance fans from Bethel, Stebbins and Tooksook Bay have a somewhat different form: wooden hoops in which feathers have been inserted. At the bottom, where they are gripped, the hoops lie together; at the top, where the feathers are inserted, the hoops leave space so that the quills of the feathers can pierce both rounds of wood and be securely held.

Rather than fans, Tlingit dancers often carry dance paddles (AKA "wands" or "staffs"). Such staffs were also used to punctuate oratory.

Dance headdresses, which may be topped with wolverine or wolf fur, are generally made only for dancers and not for sale. The bands of these headdresses may be beaded.

For the full story of Nick Charles and details about the symbolism of dance fans, see *The Artists Behind the Work* (University of Alaska Museum, Fairbanks, 1986).

See also FEATHERS, FINGER MASKS.

Alaska Live: During the summer tourist season, Alaska's Native dancing may be viewed live at several locations: the Anchorage Museum of History and Art, Metlakatla Native Reserve (a floatplane flight out of Ketchikan), and in the Saxman Beaver Clan House. Russian dances are recreated by a Sitka troupe, and Alutiiq dances by a Kodiak troupe.

Practitioners (fans): Nicholas Charles, Sr. (Yupik, Bethel); Carol Hoelscher (Anchorage); Mary Ann Hoelscher (Anchorage); Kathi Mathis (Anchorage); William Trader (Emmonak); Tamara Mosier (Anchorage).

Practitioners (paddles): John J. Burr (Ketchikan).

Sources: Alaska Native Arts & Crafts (Anchorage); Alaska Native Medical Center gift shop (Anchorage); Anchorage Museum of History and Art gift shop; J.C. Penney (Anchorage); Portfolio Arts (Juneau); Saxman Village's carving shed; Yankee Whaler (Anchorage).

Resources: Cape Fox Native Corporation (Ketchikan); Johnson-O'Malley Program (Anchorage); Ben Snowball (Anchorage); NANA Museum of the Arctic.

DENTALIA

Dentalia or "tusk shell" are the empty houses of certain sea snails; they do not coil, but are shaped like a straight walrus tusk. The Athabascans strung them on belts and necklaces to show prestige, sometimes combining them with beads in "chief's necklaces." The Tlingit sewed them into crest designs to adorn woolen dance

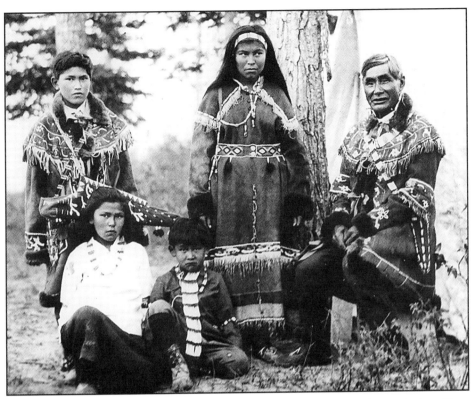

Formally posed Athabascan group including Chief Thomas of Tanana and several other village residents. Both the chief and the two children kneeling are wearing dentalium necklaces. Thomas is also wearing a knife sheath decorated with dentalia. The boy standing at far left wears a quiver around his neck, suspended from a band of woven quillwork. His parky and the chief's both have shawl collars decorated with beadwork and fringe. Circa 1920, Cann, Fairbanks.

shirts/tunics, using them as an alternate to mother-of-pearl buttons from China. Use of this ornamentation is rare today.

Museums: Anchorage Museum of History and Art; Burke Museum (Seattle).

Practitioners: Shirley Holmberg (originally from Tanana).

Resources: Black Elk Leather (Anchorage).

DIAMOND WILLOW

Diamond-shaped patterns of reddish heartwood infiltrate the pale sapwood of some Alaskan willow trees, apparently as the result of a fungal infection. These trunks average three and a half to four inches in diameter, but may exceed 10 inches. (Because many Alaskan trees grow slowly, a trunk four inches in diameter may be 50 to 100 years old.) Diamond willow is harvested, stripped of bark, and made into walk-

SYDNEY LAURENCE

Sydney Laurence (1865-1940) came to Alaska during the waning years of the Klondike and Alaska Gold Rush era, prospecting for ore rather than art.

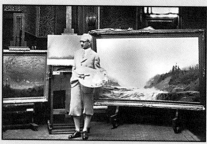

Thirty-eight years old, Laurence arrived in Juneau in 1903. Before this passage north, he had lived, studied and painted in New York, Cornwall, Paris, Venice and North Africa. Lawrence prospected for nine years around Valdez, and nearly lost his feet to frostbite after a mishap with a boat in Cook Inlet.

Painter Sidney Laurence poses in his Anchorage studio.

After his recuperation, he secured a grubstake — all the necessities he needed to mush 300 miles to the Tokositna River and set up camp. Intrigued by Mt. McKinley, he hiked to a remote knoll with a good view of "the great one." In less than a year he completed 40 oil sketches of this magnificent peak. His other subjects included Alaska's "vanishing races" of indigenous peoples, cascading rivers, storage caches, and flimsy canvas tents dwarfed by the wilderness. The Block and Kuhl department store in Peoria took on consignment all the paintings he sent.

However, Laurence never managed his money very well. Although his paintings were often romantic, he supported himself by photography dealing with the mundane details of Anchorage life.

"Like all the other suckers, I went broke mining gold," Laurence said. "But I found enough painting material to keep me busy for the rest of my life."

Laurence painted many oils measuring less than a foot square, but in his studio in Anchorage he created huge, awe-inspiring canvases grand enough for the Louvre. In 1914, two of Laurence's huge landscapes were exhibited at the Smithsonian. The resulting national publicity and demand for his blend of skillful brushwork and masterful composition allowed Lawrence to dream of being a full-time artist.

In 1925 his declining health forced him to move to Los Angeles, but Alaska continued to bloom on his easel.

A number of Laurence's works may be seen in the collections of the Anchorage Museum of History and Art and Alaska National Insurance Co. "Laurence of Alaska," a video dramatization of his life, is available from television station KAKM.

ing sticks and rustic lamp bases.

See also BURLS, CEDAR, COTTONWOOD BARK.

Practitioner: Leland Alexander (Nenana, diamond willow lamps, canes); Evelyn Beeter (Chistochina).

Sources: Grizzly Gifts (Anchorage); House of Diamond Willow (Seward); Once in a Blue Moose (Anchorage); Rika's Roadhouse (Delta Junction); Westco (Anchorage).

DOLLS

Dolls have been created in Alaska for at least 2,000 years. Prehistoric Eskimo dolls were carved of ivory and bone. They were probably created for ceremonies rather than as playthings. Many lacked arms and legs. Dolls to be used as playthings for children might be wrapped in buntings of Arctic ground squirrel, reindeer fawnskin, caribou or sealskin.

During early historic times, bone and ivory dolls were common. Some were used by shamans. Among both Alaska's Eskimos and Indians, dolls dressed in fur clothing were employed in Doll Festivals to divine the location of prey animals and insure success for future hunting trips.

Contemporary Eskimo dolls may be subdivided into several types: dolls with ivory faces, dolls with leather faces, dolls with wooden (often cottonwood bark) faces. Some are dressed completely in fur; some are dressed in colorful cloth kuspuks (parky covers). Covet those rare examples wearing feather parkys and fish skin boots.

Dolls created by Native artists generally are not articulated but stiff in all their joints. Some, however, are shaped so that they sit —and are shown engaged in traditional pursuits, such as fishing, weaving a grass mat, making Eskimo ice cream, carrying buckets of berries or bundles of firewood, or weaving baskets. These have been dubbed "activity dolls." Girl dolls may be storytelling with a story knife. Female dolls sometimes carry babies in their enlarged parky hoods. Male dolls may be cutting seal meat or carrying sealing spears attached to retrieval lines. Rosa Francis of Kotzebue has created lady dolls carrying spoons and tiny birchbark baskets, and gentleman dolls carrying bows.

For detailed information about 18 contemporary Eskimo dollmakers, consult *Eskimo Dolls*, edited by Suzi Jones with an essay by Susan W. Fair (Alaska State Council on the Arts, 1982). And peruse Dorothy Jean Ray's *A Legacy of Arctic Art*.

See also FEATHERS, FUR, OKVIK, PARKY, REINDEER HORN.

Teacher Alert: Young students learning about new cultures will be charmed if some of their instruction comes from dolls — from Inuit hunter dolls through Iroquois cornhusk dolls; see *Dolls and Toys of Native America* by Don and Debra McQuiston (Lark Books, 800-284-3388).

Museums: University of Alaska Museum (Fairbanks); Anchorage Museum of History and Art.

Historic practitioners (Eskimo dolls with ivory faces): Ruth Keszuk Kugzruk Mosquito (d. 1997 at age 85; born in Marys Igloo); Jeanette Noongwook (Savoonga, d. 1981); Flora Tungiyan (Gambell).

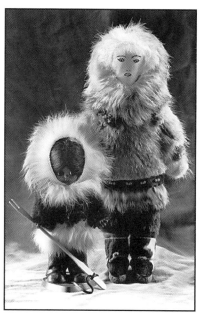

Eskimo doll, 10.75 inches tall, calfskin and other furs, leather, beads, felt, yarn, features sewn in black thread, by Rose Kozeuna, originally from King Island, 1995. Private collection. On left, mass-produced Arctic Eskimo doll, 6 inches tall, rabbit fur, rickrack, leather boots, artificial hair, plastic body, opening eyes, wooden fishing spear, plastic stand, Arctic Circle Enterprises (Anchorage), 1992.

Historic practitioners (Eskimo dolls): Emma Black (Anchorage); Irene Hawley (Kotzebue); Alice Moore (Twin Hills); Ethel Washington.

Practitioners: Margaret Ahlalook (Wainwright); Annie Alowa (Savoonga); Lucy Berry (Napakiak; activity dolls); Mary Black (Kongiganak); Susie Brown (Eek); Helen Slwooko Carius (Anchorage; Siberian Yupik, formerly of Gambell); Juanita Cowdery (Anchorage); Norma Daniels (Kasilof, Alaska Doll & Ornament Co.); Lynora Eichner (Ketchikan); Rosa Francis (Kotzebue); Eva Heffle (North Pole); Rose Koezuna (King Island, dolls with leather faces, stitched features); Steven Kiyutelluk (Shishmaref); Dorothy Komakhuk (Anchorage); Maggie Komonaseak (Wales); Margaret Konukpeok (Fairbanks); Frank Kuzuguk (Shishmaref); Fanny Kuzuguk (Shishmaref, beaded dolls); Janice Latta (Whittier); Okalene P. Lekanoff-Gregory (Unangan, Unalaska, Aleut dolls); Iva Lisbourne (Tok); Mary Nash; Helen Okpealuk (Wales); Hazel Omwari (Siberian Yupik, St. Lawrence Island); Martina Oscar (Bethel); Rosalie Paniyak (Chevak); Caroline Penayah (Siberian Yupik, born on St. Lawrence Island, lives in Anchorage); Fern Potts (Anchorage, dolls with kuspuks, furs, mukluks); Janette Ramberg (represented by Elaine S. Baker & Assoc., Inc.); Margaret Slats (Chevak, hunter dolls holding small stuffed weasels or squirrels); Rachel Smart (Yupik Eskimo, Hooper Bay; some of her dolls stand alone and wear birdskin parkas); Helen H. Smith (Hooper Bay); Dolly Spencer (Inupiat; Homer, originally Kotzebue; exquisite portrait dolls with carved birch faces); Nellie Swan (Kivalina); Louise Talloff (Hooper Bay); Josephine Ungott (Siberian Yupik, Gambell); Judy Bowers (Big Lake).

Doll Trivia: Dolls by Esther Norton (b. 1913 in Selawik) have been sent worldwide, including to the People's Republic of China. Norton learned skinsewing at age

nine from her Inupiat grandmother. Ursula Penyiak (Chevak) created skin-faced dolls for a Nativity scene exhibited each December on the main floor of the Alaska Native Medical Center.

Practitioners (one-of-a-kind activity dolls): Lucy Berry (Napakiak); Marile Dupree (Homer); Eva Heffle (Fairbanks, originally Kotzebue; creates several dozen activity scenes featuring multiple dolls and props, such as a blanket toss); Anna Kungurkak (Tooksook Bay, Eskimo hunter dolls in eider duck parkys); Martina Oscar (Bethel, originally Nelson Island).

Practitioners (dolls with porcelain faces): Juanita Cowdery (Anchorage); Arlene LaCoss (Anchorage); Fern Potts (Anchorage); Louise Ridinger (Fairbanks); Renee Scully (Anchorage); Jean Starkey (Anchorage); Bobbie L. Sublett (Sterling); Eleanor Wilde (Wasilla).

Practitioners (dolls of coiled basketry): Mary Black (Kongiganak); Viva Wesley (Mekoryuk, Nunivak Island).

Practitioner (moose dolls): Karen Fett (Delta Junction); Molly A. Pease (Anchorage).

Practitioner (doll parkas of sealskin): Margaret Johnsson (b. 1897 in Unalakleet; later lived in Mukilteo and Edmonds, WA.)

Sources: Alaska Doll & Ornament Co. (Norma Daniels, Kasilof); Alaska General Store (Anchorage and Juneau); Dillingham Heritage Museum (Dillingham); Alaska Native Medical Center gift shop (Anchorage); Alaska Fur Exchange (Anchorage); All Alaska Gifts & Crafts (Tok); Alaska Native Arts & Crafts Coop. (Anchorage); Billikin Gift Shop (between Anchor Point and Homer); Dolls A Timeless Treasure (Anchorage, Jean Starkey); Creation Enterprises (Homer, Mark & Linda Stadler); The Doll Shop (Wasilla); Elaine S. Baker & Assoc. (Anchorage); Forget-Me-Not Antiques & Accents (Juneau); Flowers in the Snow (Healy, Karin Nierenberg); Great Alaska Tourist Co. (Wasilla); Juanita's Dolls (Juanita Cowdery, Anchorage); Juneau General Store; Memeluck Fur Doll Co. (Juneau, Manuel Hernandez); Molly's Moose Etc. (Anchorage, Molly Pease); Northern Handcrafts (Juneau); Originals by Von (Vonna Baehm, Anchorage); Princehouse Furworks (Homer); The Raven's Journey (Juneau); Reflections of Alaska (Eagle River, Terri Fors); Ship Creek Center (Anchorage, Ship Creek Hotel); The Yankee Whaler (Anchorage, Hotel Captain Cook) and many gift other shops throughout the state. Doll collections occasionally turn up at auctions.

Insider Tip: Dolls priced under $100 are rarer and rarer.

DRAWINGS

In the 1890s, Eskimos in northwestern Alaska were introduced to paper, watercolors, crayons and pencils by teachers from mission and government schools. The drawings produced as a consequence of this cultural fusion derive from the aborigi-

nal traditions of pictographs, petroglyphs ("rock art") and scrimshaw.

In the 20th century, many Native artists who, in centuries past, would have drawn in snow or incised hunt tallies or calendars on bone, have adopted mediums such as reindeer skin, paper and canvas. One of the first observers to focus on Eskimo drawing and painting as part of a narrative process instead of as artifact was Hans Himmelheber, who did fieldwork among the Yupik of southwestern Alaska from June 1936 until April 1937. Himmelheber was a physician and ethnologist as well as an art

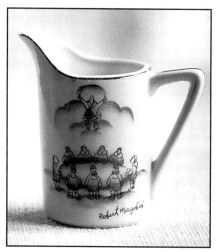

Cream pitcher, 2x3.5 inches, ceramic, with drawing of Eskimo blanket toss by Robert Mayokok, c. 1978. The blanket toss was one of Mayokok's favorite motifs.

historian; see his book *Eskimo Artists* (University of Alaska Press) for details of the cultural and artistic heritage of the Yupik.

For additional examples of Eskimo drawing, see *Alaskan Eskimo Life in the 1890s, As Sketched by Native Artists* by George Phebus, Jr. (University of Alaska Press, 1995) and Dorothy Jean Ray's *A Legacy of Arctic Art* (1996). Consult also *Artists of the Tundra and the Sea* by Dorothy Jean Ray (University of Washington Press, 1961), Walter Hoffman's "The Graphic Art of the Eskimos" (United States National Museum Annual Report for 1895, Washington, D.C., 1897), and Kesler Woodward's *Painting in the North*.

Many non-Native artists who shine as painters also put their talents onto paper or in collages or even onto fabric which becomes pillow covers or wall quilts. Contemporary Alaskan artists whose drawings are available for sale include Carol Crump Bryner (Anchorage), JoAnn Wold (Anchorage), Mindy Dwyer (Anchorage), and Pat Austin (formerly of Anchorage; now living at Port Townsend, WA). Branching out from drawing per se, Sitka soapstone carver Dale Hanson creates castings of hand-made paper, then frames them in shadow boxes. Anchorage artist Marianne Wieland embosses her paintings to help them stand out from their backgrounds; and she has created a series of sand-blasted mugs to benefit public television station KAKM. Carollee Pollock has been known to create dog quilts!

Insider Tip: Todd Co. distributes Doug Lindstrand's "Alaskan Matted Sketches" and other assorted art prints.

Alaska Alive: Anchorage artist Suzanne Bach periodically gives lessons in drawing, watercolor and sculpture to kids ages 6 and older at Creative Design Studio.

Museums: Anchorage Museum of History and Art; California Academy of

Sciences; United States National Museum; University of Alaska Museum (Fairbanks).

Some of Webber's original watercolors can be seen in the Edward W. Allen Collection, University of Washington Libraries. Some of Cardero's wash drawings can be seen in the Museo de America, Madrid.

Historic Practitioners: George Ahgupuk (paper and bleached reindeer skin; illustrations for Edward L. Keithahn's book *Igloo Tales*, 1945); Bill Berry (Fairbanks); Lt. Blondela (who accompanied La Perouse); Jose Cardero (Alejandro Malaspina expedition, 1791); Jane Hafling (cartoonist); Guy Kakarook (crayon); Sofron Khitrov; Mikhail Levashov; Florence Nupok Malewotkuk (1906-91, Siberian Yupik; ink on sealskin, especially large compositions about subsistence Eskimo life on St. Lawrence Island); Lt. R. Maschin; James Kivetoruk Moses (1900-1982; brother-in-law of George Ahgupuk; ink, oils, watercolor, colored pencil and oil pencil on paper or board); Robert Mayokok (Anchorage, ink, acrylic, watercolor, oil and magic marker, on paper, canvas and various animal skins); Eliot O'Hara; James Shields (an English shipwright and navigator in Russian service); Tomas de Suria (official artist with Malaspina expedition); Mikhail Tikhanov; Luka Voronin (Billings-Sarycev expedition); Sven Waxel; John Webber (official artist for James Cook's 1778 expedition).

"Self-Portrait in a Mother's Day Apron," 48 x 60 inches, oil on linen, by Carol Crump Bryner.

Practitioners: George Aden Ahgupuk; Betty Atkinson (Anchorage; also works in prints); Pat Austin (often entered All Alaska Juried Art Exhibition); Suzanne Bach (Anchorage); Julie Baugnet (Chitina, Anchorage); Susan Bremner (also works in prints, painting); Carol Crump Bryner; Richard Carstensen (Juneau); C. Lee Clapsaddle (also works in mixed media, prints); Steven E. Counsell (also works in watercolor); David Dapogny (Fairbanks, Juneau); Jim Dault; Tara Davies (Tlingit- and Haida-influenced); Belle Dawson (Anchorage); Nancy DeWitt; Catherine Sabra Doss (also works in prints, mixed media); Claire Fejes (Fairbanks and California); Vickie Fish; Ayse Gilbert; James Grant Sr. (Athabascan, from Tanana, now living in Fairbanks); Spence Guerin (reared in Melbourne, FLA; also paints); Kay Haneline; Sandra Harrington (also works in mixed media); Mary Kondak (Unalaska, pencils, pastels); Marvin Oliver (works in metal, glass wood, and on paper); David Rosenthal; Wanda Seamster (Anchorage); Jan Terzis; Diana Tillion (Halibut Cove, octopus ink); Amelia Katherine Ahnaughuk (Barr) Topkok (colored pencil drawings); Ray Troll

(Ketchikan); Charles Tuckfield, Jr. (Anchorage; greeting cards, prints, often with inspirational links to Bible verses); Richard Tyler (Homer; plants and wildflowers); Shannon Service Wilks (gold dredges, birch trees); Robert Dennis Willard (Anchorage); JoAnn Wold (Anchorage, originals in the collections of Alaska Airlines, Hickel Investments, Ribelin Lowell, etc.); Evon Zerbetz (Ketchikan; the stations of Raven, octopus, dragon flies, autodidact bears and others; illustrations for *Lucky Hares* and *Itchy Bears*).

> "It's strange to me that a few marks on a piece of paper have so much power over people. They laugh, cry, become embarrassed or angry. Even Congress gets involved. Laws are passed. Money is given or withheld. All for the sake of a few molecules of color that would be ignored if they were spilled on a sidewalk."
> --Mary Beth Michaels, *Expressions: Art by Interior Alaskans* (1994)

Sources: Artique Ltd. (Anchorage); Bunnell Street Gallery (Homer); Creative Design Studio (Anchorage); Soho Coho Gallery (Ketchikan); Decker/Morris Gallery (Anchorage); Fireweed Gallery (Homer); Nicky's Place (Unalaska); Rainbow Art and Frame (Anchorage); Reluctant Fisherman gift shop (Cordova); Paper Nose Charlie's (Ketchikan); Kaye Dethridge (Sitka, historic examples); University of Alaska Fairbanks Fine Arts Gallery. A portfollio of Ahgupuk's paintings was issued by Deers Press of Seattle in 1953.

DRUMS

Yupik peoples beat shallow drums with heads of seal gut stretched across the top of a circular frame about an inch deep. Inuit people sometimes use caribou hide for their drum heads. The hide is sewn onto the bentwood frame with babiche or with sinew. The typical Eskimo drum is 2 to 4 feet in diameter, shaped like a huge pancake or pizza. This style is sometimes termed the "tambourine drum." Traditionally only men drum, although both men and women dance to the drum.

To play his instrument, an Eskimo drummer (usually a man) wets the middle of the head a bit by throwing on water from his fingertips (or, more recently, using a spray bottle). If the head gets too dry and shrinks, the frame may warp. The drum is held by its handle with the left hand, with the head of the drum facing the player; the drumstick is held in the right hand and used to beat the frame of the drum from beneath. If a long willow drumstick is used, a stick longer than the drum is wide, both sides of the frame may be beaten simultaneously.

Drumming occurred at annual ceremonies and seasonal festivals, such as the Messenger Feast, an Inupiat festival of fall or winter. The Messenger Feast was an

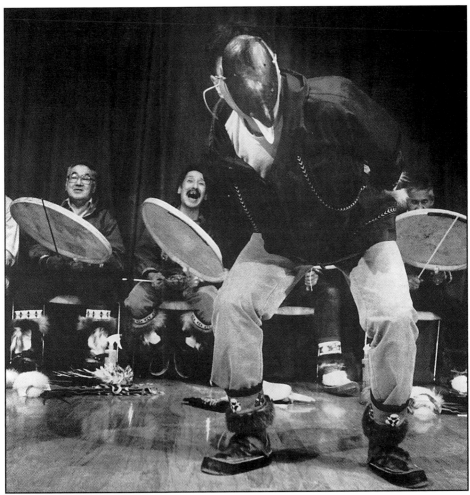

Beating an insistent rhythm on skin drums, the King Island Dancers accompany a masked dancer during a performance at the Anchorage Museum of History and Art. The dancer's mukluks are beaded with pansies.

occasion for inviting residents of another village to several days of feasting, dancing and competitive games. The Feast helped to cement vital trading relationships. The Bladder Feast, held in winter, involved five days of dancing. The American holiday of Fourth of July has now become an accepted dancing occasion among Alaska's Eskimos; dancing may go on all night in villages like Gambell on St. Lawrence Island.

In 1937, Hans Himmelheber was able to obtain drums with painted heads which illustrated stories told to him during his study of the artists of the Kuskokwim River and Nunivak Island. Such objects should be considered rare today, because they are chiefly made for drummers rather than for sale.

ALVIN ELI AMASON

Born April 6, 1948, on Kodiak Island. Amason graduated from Kodiak High in 1966, and later received Bachelor of Arts and Master of Arts degrees from Central Washington State College and a Master of Fine Arts degree from Arizona State University.

Of Aleut heritage, Amason is widely known for his unusual choices of color for wildlife, the appendages he makes to his canvases, and his sense of humor. Many of the titles he chooses for his work come from things his Grandmother Lena said to him, or from popular songs.

Amason has lived in California and Washington state, but often returns to his northern island roots, and is never happier than when he is watching foxes and sea otters from a Kodiak beach.

His work in paint, wood and mixed media has been exhibited at the Anchorage Museum of History and Art. He is represented in collections at the National Gallery of Fine Arts, Alaska State Museum, the University of Alaska (Fairbanks), Baranof Museum (Kodiak), Museum of the Northland in Aalborg, Denmark, and the Bureau of Indian Affairs (BIA) office in Washington, D.C.

Aleut artist Alvin Amason poses before one of his "Alaskan animals of the 20th century."

Look for large examples of his work in the Anchorage Federal Building and Anchorage International Airport. His infrequent shows at Decker/Morris in Anchorage sell out quickly.

A buyer for Alaska Fur Exchange (Anchorage) told me, "It's almost impossible to get them; a man may come in with one — but when I ask him to make me two or three, I just don't see him again!"

In centuries past, box drums were common among the Tsimshian and Tlingit. Squarish in shape and open on the bottom, this drum is very similar in construction to the bentwood box. Played with a clenched fist or a skin-padded beater (drumstick), the box drum has a resonating, echoing sound that compliments the sound of the skin drum.

Thunderbird or eagle painted on a Tsimshian drum head. Rendered by Paul E. Kennedy.

Practitioners (skin/Eskimo drums): Titus David (Athabascan, Tetlin), Donald Adams; Gertrude Svarny (Unangan/Aleut, Unalaska); Edward O. Muktoyuk Jr. (Nome); Alex Weyiouanna (Shishmaref); Kenneth Decker (Ketchikan).

Practitioners (box drums): David Boxley (Tsimshian); Wayne Hewson (Metlakatla).

Practitioners (round drums with painted heads): H. L. Adams; Greg Colfax (Makah, Neah Bay, WA.); Ben Snowball (Anchorage).

Sources: Alaska Fur Exchange (Anchorage); Alaska Native Arts & Crafts (Anchorage); Anchorage Museum of History and Arts; Main Street Gifts & Curios (Ketchikan); Mt. Juneau Artists (Juneau); The Raven's Journey (Juneau); Trapper Jack's Trading Post (Anchorage).

ELEPHANT IVORY

"The wanton destruction of the African elephant has been one of the 20th century's grimmer monuments to human stupidity and greed ... (in the 1980s) the number of these majestic creatures dwindled from 1.3 million to less than half that."

— An editorial in *The New York Times,* June 20, 1997

Elephant ivory is a type of dentine, composing the tusks of African or Indian elephants. This material, with its lovely creamy gleam, has been used for marquetry (veneer inlays on the surface of furniture) for at least 6,000 years. Statuettes two inches high of this age survive from ancient Egyptian tombs. In the Assyria of 5,000 years ago, craftsmen created furniture to which ivory plaques were affixed. Although the

woodwork itself crumbled to dust over the centuries, some of the durable ivory plaques have survived, recovered in excavations of the sites of Nineveh, Minrud and Babylon in the mid-nineteenth century.

Ivory was carved into chess and draught sets and drinking horns in the Europe of the Middle Ages.

In pre-Renaissance Europe, elephant ivory was also used in marquetry, as were bone, ebony, tortoise shell and brass; and it was prized for crucifixes, caskets (boxes) to enshrine saints' relics and religious statuary. Ivory was considered the best material for a bishop's morse, the clasp used to hold shut a cope, the ecclesiastical vestment/cape worn at important ceremonies.

In the late 1700s, elephant tusks were imported to the U.S. from Africa. In 1789, the first ivory combs were laboriously hand-sawed by Andrew Lord, a craftsman of Essex, CT. Soon a small company, Pratt, Read & Co., began to make piano keys for piano manufacturers. For decades, more elephant ivory was used for piano keys than for all other purposes combined. Elephant ivory was said to possess a density, a permanence, a color and a suitability for keys that no other substance could equal. (Pratt, Read & Co. made so many keys in the little village next to Essex that the village took the name Ivoryton; the company is still there.)

When the tough thermoplastic compound, celluloid, was invented around 1880, the demand for ivory for piano keys and billiard balls fell off for a time. The price of elephant ivory soared again in the early 1970s, from 45 cents a pound to $6 a pound by 1976. This made poaching of elephants irresistible to impoverished Africans, and the carcasses of elephants were left to rot, while their tusks were hacked out with axes.

On Dec. 12, 1977, Kenya's President Kenyatta announced a total ban on private trade in wildlife trophies, skins and ivory, to take effect three months later. Other countries followed suit. Still, in the 1980s the kill rate reached 200 a day. The public reacted to this slaughter, and in the1980s and '90s, many American shops refused to stock elephant ivory products. The U.N. Convention on International Trade in Endangered Species put the African elephant on its "most endangered" list and banned worldwide commercial trade in elephant ivory.

A recent development in African ivory exports occurred in June, 1997, when, after four days of bitter debate in Zimbabwe, members of the U.N. Convention on International Trade in Endangered Species amended the 1989 agreement to allow three South African states (Zimbabwe, Botswana and Namibia) to sell half their stockpiles of 120 tons of ivory to Japan in 21 months. Sixty tons of ivory are expected to bring in needed millions.

Both male and female African elephants sport tusks, which range in weight from 18 to 200 pounds. (Indian elephants have much smaller tusks.) Ivory is an elastic, flexible gelatin, and in the 1880s even the ivory dust leftover from carving was not wasted. It was used in molded desserts, and it was burned and then crushed into ivory

black for painters.

Elephant ivory can be recognized in section by the presence of criss-crossing lines of different colors which form minute curvilinear, lozenge-shaped spaces. (In section, walrus ivory, in contrast, reveals rings, like a tree trunk.) Elephant ivory lacks a hard enamel outside coating. It has a small hollow in the center, and it is transparent.

Hippo teeth, a lesser known but very durable form of ivory, were once used in making dentures. Such appliances were made from ancient Roman times up through the 1870s.

See also IVORY, WALRUS.

Museums: Reliquaries may be seen in the Victoria and Albert Museum (London), which has one of the world's finest ivory collections. Ivory carved by Eskimos has a place in numerous Native American collections all over the United States, including the collection of the New Bedford Whaling Museum (Massachusetts), the Field Museum of Natural History (Chicago), the Anchorage Museum of History and Art and the NANA Museum of the Arctic (Kotzebue). In 1996, Dorothy Jean Ray gave her ivory collection to the University of Alaska Museum (Fairbanks).

Practitioners: None are known to work in Alaska.

EPHEMERA

To collectors, ephemera are short-lived objects (pamphlets, notices, tickets, labels, banners, badges, lapel ribbons), typically made of paper. In Alaska, they include miners' certificates, stock certificates (especially from defunct gold mines), cruise line menus, cruise line stationery, liquor revenue stamps, chewing gum wrappers, Gold Rush issues of Frank Leslie's illustrated newspaper, Alaska Steamship menus, Klondike sheet music, personal diaries or log books, movie lobby cards, territorial bills of lading, first day covers, envelopes carried and autographed by Iditarod mushers, stamps, Fur Rendezvous buttons, coins, stamps, beer/wine/ale labels, maps, movie posters, limited-edition guidebooks, cigarette cards with Arctic scenes, and propaganda leaflets.

Maps and globes are so popular as to constitute a separate class in themselves.

Special editions of board games qualify as ephemera. For example, just in time for the 1997 holiday season, an Alaska edition of the Monopoly® game was released. The game features state wildlife and scenery from the photographic stable of the Ken Graham Agency. Photographers featured were Cary Anderson, Robin Brandt, Mathias Breiter, Kathy Bushue, Ken Graham, Kim Heacox, Rolf Hicker, Dicon Joseph, Kent Kantowski, Didier Lindsey and Sharon Walleen.

Although made of a somewhat more durable material than paper, mouse pads should probably be considered ephemera. In late 1997, Barbara Lavallee introduced a line of mouse pads bearing her paintings.

For details, see "Alaska's History in Postage Stamps" by Kenneth J. Green, *The*

Baranov anniversary first day cover.

Alaska Journal, I, 1:16-19.

See also FUR RENDEZVOUS, WEB SITES.

Insider Tip: One of the more unusual paper works available to collectors is Vanessa Summers' "Iditarod Trail Art Map Postcards," distributed by Todd Co. (Anchorage).

Museums (maps and globes): Heritage Map Museum (Lititz, PA.); Mariners' Museum (Newport News, VA.).

Sources: Alaska Mint (Anchorage); Alaska Rare Coin Investments (Fairbanks); Alaskan Brewing & Bottling Company (Juneau); Alaska General Store (Anchorage, Juneau); Ann's Tiques (Sitka); Antique & Specialty Mall (Anchorage); Arctic Travelers Gift Shop (Fairbanks); Bosco's Comics, Cards & Games (Anchorage, Eagle River); Kaye Dethridge (Sitka); George D. Glazer Gallery (NYC); Paper Tigers (Anchorage); Excalibur Cards & Collectibles (Anchorage); Duane's Antique Market (Anchorage); Forget-Me-Not Antiques (Juneau); The Map Place (Anchorage); Mike's Coins (Sitka); Oxford Assaying & Refining (Anchorage, Fairbanks); Pack Rat Antique Coop (Anchorage); Rhyne Precious Metals Inc. (Seattle); Robert Ross Antiquarian Maps, Globes, Views, and Related Books (Calabasas, CA.); Roy Brown Coins & Collectibles (Anchorage); Saturday Market (Anchorage, May to September).

FEATHERS/BIRD SKINS

A mallard sitting comfortably in Anchorage's October slush is a tribute to the effi-

ciency of feathers as an insulator.

Charles Clerke, Cook's second-in-command, saw the efficiency of feather parkys in May, 1778, when the *Resolution* and *Discovery* anchored at Snug Corner Cove in Prince William Sound. The two British vessels were soon surrounded by skin boats manned by singing paddlers. The friendly Chugach Eskimo kayakers wore feathered parkys, wrote Clerke, "Made of water fowl skins, and exceedingly well calcu-lated, to keep out both Wet & Cold."

Bird feathers and skins have been used by Eskimos and Aleuts for parkys and ornamentation since at least the Birnik culture period (500-1000 A.D.) and into the early twentieth century. Clothing was sewn of loon, cormorant, murre, puffin and guillemot skins. Arvid Adolph Etholen of Finland, Rear Admiral in the Imperial Russian Navy, collected a puffin skin "gown" from the Koniag on Kodiak Island before 1847.

Bird skin parkys are lightweight, waterproof and very warm. The maxillae and topknots of crested auklets were used as decorations, most notably on gut raincoats meant for special occasions such as dancing or visiting.

> "Striking the sheet with the dauber is like harpooning seals. Opening rip-pies is like plucking feathers from a bird. And when I go home and tell my family I caught a whale, they know that means I won a $1,000 payout."
> — Dollmaker Caroline Penayah compares playing bingo with the subsistence lifestyle of her youth on St. Lawrence Island, "The Bingo Subculture" by Kenneth Howe, *Anchorage Press*, Nov. 6-12, 1997.

Anthropologist Dorothy Jean Ray notes that the mask makers of northern Alaska used feathers from eagles, geese, ducks, gulls, swans, horned owls, ptarmigan, terns and old squaw ducks, as well as swans'-down and stripped feather quills.

Among the Tlingit of Southeast Alaska, white bald eagle feathers (that is, feathers from mature eagles of four years and up), green feathered skin from the head of the male mallard duck, and flicker tail feathers were traditional appendages for dancing headdresses. As a final fillip, the crown of the headdress was filled with loose eagle down, which wafted into the air as the dancer nodded his head and moved his body from side to side.

For details about the use of feathers in Tlingit art, see Aldona Jonaitis' *Art of the Northern Tlingit.*

Much avian raw material is now restricted by the U.S. Fish and Wildlife Department, because of regulations protecting endangered and/or migratory species. For example, it is illegal for non-Natives even to have bald eagle feathers in their pos-session. However, on special occasions, such as the assembling of a museum show, special permits to Native craftspeople may be granted by Fish and Wildlife.

As a consequence of current laws, most artisans, whether Native or non-Native, use commercially dyed turkey feathers or feathers dropped by moulting geese in their crafts.

See also DANCE FANS.

Insider Tip: Fans of bald eagles should look in on the fall gathering of bald eagles at Haines at least once in their lives. The gathering begins in October, fed by a late spawning run of salmon, and continues because of hot springs in the area. Call the Haines Visitor Bureau at 800 458-3579 for details.

Museums (feather parkys): National Museum of Finland; Deutsches Ledermuseum.

FINGER MASKS

Not all masks are worn upon the face. Some are held in the hands. Some are so large and heavy they can only lean against walls or hang suspended from the ceiling/roof.

Eskimo finger masks are worn on the fingers, in the bend of the first joint, and used to accent dance motions in the same manner that dance fans do. According to Alaska Native art expert and author Dorothy Jean Ray, they were used mainly between St. Michael and the Alaska Peninsula. Edward Nelson collected a representative number during his research trips along the Bering Strait in the late 19th century. Although common in Nelson's day, finger masks are rare today.

Finger masks are carved of wood; one or two circular holes are carved at the base to permit insertion of fingers. The mask centers on a face (sometimes round, sometimes square), occasionally decorated with a halo of feathers which sways with the dancer's movement.

Museums: Lowie Museum (University of California, Berkeley); Smithsonian.

See also DANCE FANS, MASKS.

FISH SKIN

The tough skin of salmon and halibut has been used for centuries by Eskimo skin-sewers to create knee-high waterproof boots. In the last decade or so, Alaskan salmon skin has been tanned into an attractive leather used to create wallets. Just think eel skin. Shark skin doubled as sandpaper for totems.

See also CHRISTMAS ORNAMENTS, MUKLUKS.

Source: The Trading Post, Inc. (Ketchikan; salmon and reindeer skin wallets, beaver moccasins).

FORM LINES

Right angles are rare in Northwest Coast graphic arts. Lines curve and flow and circle. These undulating lines are called "form lines." They vary in thickness and

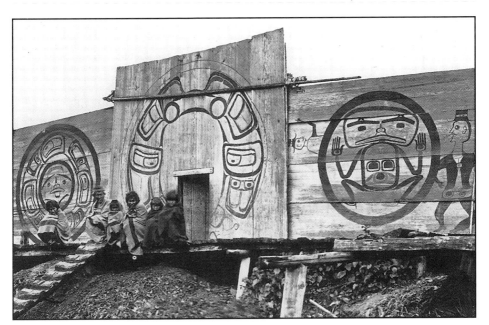

"The First People: Big House," a Bella Coola cedar planked dwelling that housed numerous members of an extended family. Traditional formline paintings on the facade have been amended to include two figures of newcomers, perhaps as a sign of welcome to traders. Photographed by Edward Dossetter, 1898.

direction.

Curvilinear formline designs can be found on totem poles, masks and bentwood boxes by Tlingits and other Northwest peoples. The figures adorning house fronts, Chilkat blankets, silver cuff bracelets and other objects, both functional and decorative, typically interlock or overlap or crouch in contorted postures. Furthermore, smaller decorative figures may be used as "filler," tucked into ears or chests. An octopus, for example, might be tucked into the body cavity of a halibut, because octopus is a favorite food of and bait for halibut. But the octopus will appear stylized, a series of cultural clues — perhaps a face, a slug-like body and single hand.

Animal joints may be rendered with faces in them, a symbolic reminder of the muscular power seated in the joint.

Over time, conventions and stylizings have accumulated within the culture — conventions that it is hard to "read" if one is from another culture.

For example, the bear has erect ears (on top of his head) and may have a protruding tongue. Raven is distinguished by a long, straight beak, while Eagle's beak is short and bent. Beaver wears a cross-hatched tail. Wolf's tail coils in a circle. Killer whale has a blow hole and may be portrayed with as many as five dorsal fins; his tail may be exaggerated to fill space.

In addition to contorted attitudes assumed to fit available space (as on a blanket), figures may strain against the confines of their realistic forms to portray transformations into other beings or spirits. Raven could become a human child. Men transformed into cod fish. Dancers imitating mythical serpents might seem to turn into the serpents; in a painting (on a one-of-a-kind house front) or a modern limited-edition print, the dancer would evince both reptilian and human aspects. Sometimes the head is placed in the center of the representation, and the body splits into symmetrical halves flanking it.

One of the most characteristic shapes used in NW Coast art is an "ovoid," a rounded rectangle. As Hilary Stewart explains in *Looking at Indian Art of the Northwest Coast,* ovoids may indicate heads, eye sockets, major joints, flukes or fins, blow holes or ears. Ovoids, U forms and S forms may be used as fillers.

For in-depth information on this subject, read Stewart's book and/or consult *Northwest Coast Indian Art: An Analysis of Form* by Bill Holm (1965).

The contemporary collector will find that formline designs have wandered away from wood onto more portable items, such as silk-screened prints and silver bracelets.

See also, CHILKAT BLANKET, OVOIDS, TOTEMS.

Practitioners: Will Burkhart (Tlingit); Marvin Oliver (Quinault/Isleta-Pueblo); Roy Henry Vickers (a Tsimshian artist who works with formlines in computer graphics); Kathy Kato Yates ("Love Birds"); Linda Schrack (Ketchikan).

Sources: Raven-Eagle Gift Shop (Juneau, on the second floor of the Mount Roberts Tramway sky terminal); Marvin Oliver Gallery (Seattle); Native Artists Market (next to Naa Kahidi Theater, Juneau); Southeast Alaska Indian Cultural Center; The Reluctant Fisherman Inn gift shop (Cordova); Saxman.

FOSSIL IVORY

Fossil ivory is sometimes defined as prehistoric walrus ivory dug on St. Lawrence Island. This type of ivory is 500 to 10,000 years old. It is desirable for its wide range of color — metallic, often marbleized, browns, greys and blues. The coloration depend on how long a particular tusk has been buried and the specific blend of minerals in the soil that encased it. Fossilized ivory also comes from tusks of the extinct mastodon.

Contemporary carvers use this elegant material to create objects like pins, pendants and bracelets, as well as scrimshaw.

Fossilized objects such as seal and bird darts, needle cases, wrist guards, box handles, workbag fasteners, harpoon sockets and harpoon heads are frequently unearthed at prehistoric village sites on St. Lawrence Island and Punuk Island and may be shown for sale in Anchorage and other locations. The pieces are typically engraved with circles, dots, and Y's as well as straight and curved lines. These objects were carved hundreds or thousands of years ago and should be considered artifacts. Chunks of fos-

silized sled runner may be used as bases to mount walrus ivory carvings such as puffins or Canada geese.

See also ARTIFACTS, IVORY, MASTODON IVORY, SCRIMSHAW.

Practitioners: Cha (Juneau; a native of New Mexico who moved to Alaska in 1974, works in fossilized bone, such as mammoth bone, walrus femur, walrus tooth, whale ear drums;

Whale ear drum (tympana bula of a baleen whale), 5.5 x 3.5 inches, carved by Cha, 1997. Mounted on a walrus femur. Both bones are fossilized.

in 21 years in Alaska, she has carved 44,000 pieces of fossil walrus ivory); Scott Douglas (Kenai, born in California, works in mammoth tusk); Henry Mark (Quinhagak); Harry Ningealook (Shishmaref); Judith Travlos (Anchorage); Jim Lee (Juneau).

Sources: Alaskan Fossil Products (Fairbanks); Cha (Juneau; 800 453-5995); Inu Craft (Kotzebue); J.C. Penney (Anchorage); Rainsong Gallery (Juneau); Ice Age Arts.

FRONTLETS/HEADDRESSES

Also called "forehead masks," frontlets are carved ceremonial headdresses worn tied to the forehead or perched above the brow in the manner of royal crowns. They vary greatly in size. Frontlets are usually carved of wood (alder, cedar, etc.) and may be inlaid with abalone or other sea shell as well as painted. In *Spirit and Ancestor*, Bill Holm describes the frontlet as a "sculptural plaque...sewn to a frame — usually of whale baleen covered with cloth — from the top of which rises a circlet of the long, flexible whiskers of Steller's sea lion. On many northern headdresses, these whiskers are interspersed with flicker tail feathers. The back of the frame is covered with swan skin with its thick mat of white

"The first Eagle headdress I carved didn't fit on anybody's head. It wasn't until I learned how to dance that I understood the art (of carving). Next time I did an Eagle headdress, it had a purpose; it could fit on a person's head and be used for dancing."

— Haida carver Reg Davidson, quoted in Ulli Steltzer's *A Haida Potlatch.*

down....The forehead rims of Tlingit headdresses are often bound with the iridescent green-feathered skin of a mallard drake's head....Many of these frontlets stand among the masterpieces of Northwest Coast sculpture."

To add movement to the frontlet, it is often adorned with ermine skins or strips of

red blanket which can bounce about during dancing. Sea lion bristles sometimes sway above the crown.

The frontlet is part of a dancing regalia worthy of a chief. The complete regalia would include a Chilkat blanket, a painted or woven apron and leggings, and a carved rattle. The inner cavity of the frontlet would be heaped with loose eagle down, so that, as the dancer moved from side to side, the down would waft into the charged air and over the guests, in what Holm calls "a sacrament of peace."

Among the Tlingit, both men and women wore these headdresses at potlatches. Shamans donned such headdresses when performing curative rituals.

See also ABALONE, MASKS, SEA LION WHISKERS.

Museums: Burke Museum (Seattle); Denver Art Museum.

Practitioners: Gerry Dudoward (Coastal Tsimshian, Port Simpson, British Columbia); Chuck Heit (Tsimshian, Kispaiox, British Columbia); Nathan Jackson (Ketchikan). Jackson's "Raven Frontlet" won a merit award in the contemporary wood category of the 1981 Native Art Competition, "Wood, Ivory and Bone," sponsored by the Alaska State Council on the Arts and the Alaska State Museum.

Sources: Anchorage Museum of History and art gift shop; Sheldon Jackson Museum gift shop (Sitka); Portfolio Arts (Juneau); Northern Nook (Juneau); Southeast Alaska Indian Cultural Center (Sitka).

FUR

Fur is the fine, soft, thick, hairy coat on the surface of a mammal's skin; the English word derives from an Old Norse term meaning "sheath."

The fur of fox, seal, ground squirrel (AKA "parky squirrel"), marten, beaver, rabbit, wolf, wolverine, sea otter and muskrat have been harvested for untold centuries by Native Alaskans. Polar bear fur was traditionally used for men's winter hunting trousers. Ground squirrel skins were used for dress parkys. Arctic hares were used for children's parkys. Clothing is decorated with many materials, from ermine tails to red yarn to bands of imported calfskin.

Coarser pelts, such as caribou, black bear and grizzly, were usually not worn, but used as mattresses and comforters.

The harvesting of some furs is limited to enrolled members of Native corporations, and governed by strict regulations. Sea otter, once nearly extinct, is a case in point.

Fur slippers, hats, mukluks and other clothing are available chiefly by personal contact with skin sewers. The Eskimo village of Unalakleet (145 miles southeast of Nome) is one good spot to visit for mukluks, slippers, hats and authentic Native clothing. Collectors should call the Unalakleet Native Corporation well in advance of arrival. Kobuk (300 miles west of Fairbanks) is known for its beaver hats and fur mittens.

JON VAN ZYLE

Like writer Jack London, painter Jon Van Zyle of Eagle River lives the things he limns. London knew cold and overflows and dog teams. Van Zyle, too, has experienced these northern phenomena.

In the book about his life and work, *Best of Alaska: The Art of Jon Van Zyle* (1990), Van Zyle stated, "I always have made it a practice to paint only the things that I've actually experienced or know. But I also like to do historical paintings because of the research we have to conduct and the understanding that it rings to familiar things. I hope I convey the Alaskan mystique in all these works."

For Van Zyle, the Alaskan mystique is in things: a remote log cabin, wood smoke from a campfire on the shore of a lake, a husky encrusted with snow as it sleeps, the piercing cry of a loon, a wolf warily observing an Iditarod musher from the edge of the forest, a musher taking a tea break at 30 below zero. He's been to Anvik and Kaltag and Nome and seen and heard all these things for himself.

"While working on this large painting ("All the Better to See You With, My Dear"), I remembered what my mother had told me many years ago. 'Just remember, Jon, that the eyes can tell a lot about a person or an animal.' So I started with the eyes. The eyes of a wolf are haunting, and seem to be a part of that mystical thing that they have become.

"I love this painting. It started out and finished exactly how I had pictured it in my mind's eye. It told all the stories I wanted to tell."

— Jon Van Zyle, *Best of Alaska*

Born in Michigan in 1942, Van Zyle inherited his talent from his mother and shares it with a twin brother, Daniel, who lives in Hawaii. He ran the Iditarod Trail Sled dog race twice in the 1970s and holds the title of "official Iditarod artist." Jon's work takes the form of acrylics or stone lithographs. Alaska Limited Editions publishes and distributes his posters. His work appears in collections such as the Frye Art Museum (Seattle), Princess Tours, Anchorage Museum of History and Art, Alaska Natural History Association, the Juneau Empire/William Morris III Collection, Alaska Airlines, and the Soviet Union Government. He has exhibited throughout the U.S. and in Canada.

Alaska Live: Demonstrations of skin sewing are given from June to September at the NANA Museum of the Arctic (Kotzebue); call for schedule, (907) 442-3304. Demonstrations are also probable at the Annual Festival of Native Arts (UA Fairbanks) and the Anchorage Museum's annual Native Arts Festival in March.

Insider Tip: The Dillingham Arts Council holds a Christmas Bazaar early in December, where Native crafts, furs, art, jewelry and unique gifts abound (907 842-5115). The Homer Council on the Arts holds an annual Arts and Crafts Fair about the same time of year (907 235-4288).

> "From the earliest times, Native Americans maintained a unique aesthetic vision of the universe and never was the vision separated from the functional aspects of their culture."
> --Anna Lee Walters, *The Spirit of Native America: Beauty and Mysticism in American Indian Art* (Chronicle Books, 1989).

For additional information, see *From Skins, Trees, Quills and Beads: The Work of Nine Athabascans.*

See also FUR REN-DEZVOUS, MUKLUK, PARKY, SEALSKIN, YO-YO.

Museums: Alaska State Museum (Juneau); Anchorage Museum of History and Art; Samuel K. Fox Museum (Dillingham); Anchorage Museum of History and Art; NANA Museum of the Arctic (Kotzebue); a permanent exhibit on the walls of Gary King's Sporting Goods (Anchorage).

Insider Tip: During March, the village of Akhiok celebrates the revitalization of the Alutiiq culture with "Alutiiq Week," which includes traditional craft workshops and events including beading, grass weaving and fur sewing. For details about this event, consult the Kodiak Island Convention and Visitors Bureau.

Historic Practitioners: "Big Susie" King (Ahtna, Chitina).

Practitioners: Katherine Barr (Inupiat, Shishmaref); Julie Biddle-Attla (Fairbanks); John K. Boone (Valdez; sea otter coats and vests); Alice Brean (Delta Junction); Hulda Conley (Anchorage); Keith Curtis (Arctic Midnight Furs, Anchorage); Liza DeWilde Pitka (Huslia); Sally Hudson (Rampart, fox skin mittens, rabbit skin blankets, parkys); Kimberly Mosquito (Anchorage; finger puppets, doll-shaped Christmas tree ornaments, yo-yos); Faye Ongtowasruk (Wales); Anna Pootoogooluk (Shishmaref); Diane Potoogooluk (Inupiat, Shishmaref); Ellen Pootoogooluk (Shishmaref); Gloria Pootoogooluk (Shishmaref); Johnee Seetot (Brevig Mission, beaver hats, sealskin mittens); Helen Seetot (Brevig Mission, beaver hats, sealskin Christmas ornaments); Barbara Smart (Alaska Fur & Leather, Anchorage; fur hats, leather pants, chaps, jackets); Monica Riedel (Cordova, fur hats, coats, mittens, vests, slippers, pillows); Renita Reader (Nome, beaver skin hats, mittens, slippers); Jean Marie Pungowiyi (Anchorage); Daisy Rock (Brevig Mission, slippers, hats); Clara Ross (Anchorage,

beaver hats, baby mukluks); Willa Seetamona (Shishmaref, slippers, Christmas ornaments); Brenda Tolman (Fish Hawk Canvas Co., Whittier; leather and fur novelties); Edna Wilder (Fairbanks).

Sources: NANA Museum of the Arctic gift shop (Kotzebue); Alaska Fur Enterprises (Anchorage); Alaska Fur Exchange (Anchorage); Alaska Fur Factory (Anchorage); Alaska Fur Gallery (Anchorage); Alaska Fur & Leather (Anchorage); Alaska Professional Fur (Anchorage, Bob Pate, custom beaver hats); Alaska Raw Fur Co. (Fairbanks); Anchorage Fur Factory (Mr. Hernandez); The Arctic Goose (Kotzebue, Wyn Huss, fur hats); Arctic Rose Custom Furs (Soldotna, Jan Tall Chief); Bare Island Furs (Port Bailey, Susan Scanford; fur hats, mukluks, jackets); Beads and Things (Fairbanks, slippers, hats); Black Elk Leather (Anchorage, Stephen Loeck); Chilkat Valley Furs (Haines; fur wraps, earmuffs and hats in fox, beaver and sable; shearling lamb slippers and hats); City Fur Fashion (Anchorage, Felicia Tagle, fur garments and gifts); Custom Creations (Sitka); David Green Furs (Anchorage, custom fur coats); Fields House Alaskrafts/The Fur Shack (Delta Junction); Fur Traders of Alaska (Anchorage, Roberto Cuautle); Gerald Victor Furs (Fairbanks); Great Alaska Train Co. (Anchorage, Charlie and Shirley Powell, fur-trimmed leather gloves and fur mittens); John's Taxidermy & Furs (Ketchikan, John Palmer); Kimberley's Kreations (Anchorage); Laura Wright Alaskan Parkys (Anchorage); Lorraine Larsen Furs (Kasilof, fur hats, mittens and booties); Reindeer Shop of the Arctic (Fairbanks); Shishmaref Tannery (Shishmaref, slippers); Slide Mountain Company (Palmer, Mary Odden, musher mitts, fur hats); The Tanana Trading Post (Delta Junction); Rika's Roadhouse gift shop (fox furs; Delta Junction); Skwentna Roadhouse (Skwentna); Whitestone Furs of Alaska (Delta Junction); Wilderness Creations (Tok, Frank Entsminger).

Referrals/Classes: Athabasca Cultural Journeys in the village of Huslia, home to about 250 Athabascan residents of the Koyukuk National Wildlife Refuge, offers classes in skin sewing and beadwork. Inquire via Box 72, Huslia, AK 99746; 800 423-0094 or 907 829-2261. Tours/classes operate from June through August.

In Anchorage and other cities, classes in traditional Native crafts are offered by the Johnson-O'Malley program, a federal program founded in the 1930s to preserve Native American lifestyles.

Insider Tip: Occasionally Edna Wilder-Cryan, author of *Secrets of Eskimo Skin Sewing,* teaches skin-sewing classes at UAF.

FUR RENDEZVOUS

Fur Rendezvous is an annual winter festival held in February in Anchorage. It is based on a historic winter gathering of trappers, who would come to town to sell their prime furs. A number of collectibles are associated with this event; pelts are auctioned off; and craftsmen exhibit and sell their wares. Belt buckles big as wagon wheels, fur

hats fit for Stephen Seagal films, fringed jackets and blackpowder gear are in ample supply.

See also EPHEMERA.

Sources: Kaye Dethridge (Sitka); Excalibur Cards & Collectibles (Anchorage).

GARNET

The garnet is a semi-precious mineral sometimes used as a gem stone; garnet has a deep red, brownish or green color.

A deposit of garnets in Wrangell was willed to children who mine them and sell them to tourists.

Source: The Monticello catalog. See other sources under JEWELRY

Insider Tip: As you get off the Alaska ferry at Wrangell, keep an eye out for local kids and their muffin pans of uncut gems.

GLACIER ICE

Blue topaz, a local gem, is sometimes marketed in Alaska as "glacier ice."

Source: Julie's Fine Jewelry (Ketchikan).

GLASS

Glass is a hard, brittle substance made by fusing silicates with soda or potash, lime, and (on occasion) various metallic oxides. These components fuse into a molten mass with the consistency of warm taffy. The molten mass is cooled rapidly to prevent crystallization and blown or molded or pulled into a final shape. Lines or swirls in a contrasting color may be applied while the shape is still warm. When the object has cooled, designs may be cut or etched into the surface.

Glass is characterized by shine, smoothness and transparency but may also be opaque, or consist of layers of opaque glass blown into a transparent layer.

Functional glass, like Waterford crystal, achieves its degree of transparency by incorporating a high proportion of lead.

Glass forms in nature under volcanic conditions. Man discovered how to melt silica and create glass artificially 4,000 years ago. Glassblowing was invented by Syrians in the first century B.C.; blown vessels produced in Syria were exported to all corners of the Roman Empire.

Contemporary art glass may appear as freeforms, lamps, bowls, vases, paperweights, jewelry and even (as in the large-scale work of Dale Chihuly) theater sets. For more about Chihuly's work see his book, *Chihuly: Color, Glass and Form* (Kodansha International Ltd., 1986). In the CIRI collection at the Anchorage Museum, look for Preston Singletarry's "Glass Potlatch Hat."

Norm Hays of Anchorage creates glass ornaments suitable for hanging in a sunny window or on a Christmas tree. He has won blue ribbons for his work, all of which

he certifies "Made in Alaska" and one-of-a-kind. Typical shapes are icicles, bells, teardrops, and balls, each colored by dipping six to eight times in special paint. Some are black light reflective. Look for "Ornaments by Norm" in the Anchorage Visitors Guide.

Practitioners: Tom Carney; Frank Cavas; Dale Chihuly (raised in Tacoma, lives in Seattle; subject of a 1987 retrospective at the Louvre); John Cook; Cynthia Daiboch England; Barry Entner; Norm Hays (Anchorage); West Hunting; Ahna Iredale (Homer); Rebecca Lundberg; Dan La Chaussee; Drew and Sally Malone (stained glass, church windows); Michael Murphy; Caleb Nichols; Paul OBrien; Nina Paladino-Caron; Laura Preshong; Carl Radke; Richard Satava; Preston Singletarry (Tlingit); Michael Sosin; Laurence Tuber; Steve Weinstock; Carol Willsea; Barbara Yawit.

Sources: Alaska Neon Works (Anchorage, custom neon and design); Anchorage Museum; Artique Ltd. (Anchorage); Aurora Fine Art Gallery (Anchorage); Brendan Walter Gallery (Santa Monica, CA.); Bunnell Street Gallery (Homer); Coal Alley Gifts (Fairbanks); Gallery of Earth & Fire (Fairbanks); Lightwave (Anchorage, fused, blown, sandcarved and stained); Paned Expressions Gallery & Studio (Eagle River, art, stained and fused); Blue Frog Art Studio (Anchorage).

GOLD NUGGET JEWELRY

Of all the world's gold, only a minute fraction occurs as natural nuggets. Because of their rarity, natural nuggets have a value higher than open-market gold prices, higher than their weight in ounces; and this value increases with the size of the nugget — as well as any imagined or real resemblance to something, such as Elvis Presley's profile. A nugget has a gold content of 70 to 95 percent. (Ten karat gold contains only 41 percent gold; 14 karat gold contains 58.5 percent gold.) The average nugget is 22 kt (90% pure), and is sold based on size, shape and rarity.

When miners turn their placer gold into spending money, they regularly set aside large, handsome nuggets to use as "appliqueˊs" on watchbands, belt buckles, bolo ties, cufflinks and other jewelry. The nuggets are mounted in their original, unaltered shapes.

> "I charge by the quality of the work I put in, and the size of the piece. I like to take my time and put in lots of detail. My work is very realistic in style; I try to make my work look like real animals."
> —ivory carver George Mayac in a 1981 interview with Ann Chandonnet.

An odd offshoot of nugget jewelry is the "mosaic opal." Fourteen-carat gold is shaped into silhouettes of spruce trees, cabins, etc., and these miniatures are set onto the surface of opals.

Let the Buyer Beware: When purchasing nuggets, be sure they are in their natural state — that neither shape nor color has been altered artificially. Ask for a certificate of authenticity from the Alaska Natural Gold Nugget Jewelers (Anchorage, Ketchikan). For details, call the Jewelers Bench (Sitka) or Arctic Gold (Fairbanks).

Insider Tip: Window shop the booths at the Alaska State Fair at Palmer during the last week in August and the first weekend in September for bargains in arts and crafts, including gold nuggets, vials of fine gold, and gold nugget jewelry.

Alaska Alive: Watch nugget jewelry being made from gold purchased directly from miners at Taylor's Gold-N-Stones, Inc. (Fairbanks).

Practitioners: J.L. Houston (Juneau); Jarvi (Ketchikan); Thomas Tunley (Anchorage).

Sources: Alaska Mint (Anchorage, Gold Rush Centennial medallions); Alaskan Gifts & Artwork (Homer); Allen's Nugget Jewelry (Anchorage); Arctic Wonder Gift Shop (Fairbanks); Bull Moose Gifts (Ninilchik); Christopher's Gold Country (North Pole); Coldfoot Services (Coldfoot, 250 miles north of Fairbanks, 60 miles above the Arctic Circle); Engelhard West Incorporated (Fairbanks); Fire & Ice (Juneau); Gold Mine Jewelry & Gift Shop (Fairbanks); Gold Rush Jewelers (Fairbanks); Hickok's Trading Co. (Juneau); Homer's Gold-Mine Gifts (Homer); Innoko National Wildlife Refuge gift shop; J.C. Penney (Anchorage); Jack Wade Gold Co. (Tok); The Jewel Box (Juneau); The Kachemak Goldsmith (Homer); Larson's Jewelers (Fairbanks); Little Switzerland (Juneau, Ketchikan, Skagway); Madame's House of Gold (Ketchikan); Ninilchik General Store (Ninilchik); Platinum Jewelers (Anchorage; "Alaska Collection" platinum jewelry with gold nuggets); Poker Creek Gold (Ketchikan); Reluctant Fisherman gift shop (Cordova); A Touch of Gold (Fairbanks); The Yankee Whaler (Captain Cook Hotel, Anchorage).

Source: gold charms: J.L. Houston, The Jewel Box (Juneau).

Referrals: Alaska Precious Metals Ltd. (Anchorage); Eagle Historical Society (Eagle); Denali West Lodge (Lake Minchumina); General Refining Corp. of Alaska (Fairbanks); Kantishna Roadhouse (Kantishna); Tacks' General Store (Chena Hot Springs Road, Mile 23.5); Taylor's Gold-N-Stones (Fairbanks); A Touch of Gold (Fairbanks, goldsmiths on staff).

GOLD PANS

To make their work more "Alaskan," some painters veer away from canvas to surfaces such as metal gold pans or masonite squares lashed to miniature snow shoes. Manufactured to pan placer gold from streams, gold pans resemble industrial-strength metal pie plates with wide, inclined edges. The diameter of a gold pan ranges from four inches to 20 inches.

Practitioners: Yvonne Gossett (Trapper Creek; also paints on saw blades made into clock faces); Brenda Hutchens (North Pole); Paul D. League (Anchorage).

BYRON BIRDSALL

"Watercolor," a Seattle art critic once wrote, "is largely a matter of technique, discipline and skill. Byron Birdsall is a master of all three."

Like his distinguished mentors, the Japanese wood block artists, Hokusai and Hiroshige, Anchorage artist Byron Birdsall plays with shapes and contrasts. His gradations of color seem so precise as to have been executed by computer--but Birdsall, a tall man of genteel manner, is no machine.

Since his first solo exhibit in 1967, Birdsall has mounted over 50 one-man shows. Most of them (like Machetanz' first show) have been sellouts. He has won numerous awards, including first place in the All Alaska Juried Representation Show.

Like Winslow Homer, Birdsall favors splendid landscapes--whether tropical, storm-tossed or quietly soothing. Birdsall has painted the narrow streets of Jerusalem as well as the sprawling peaks of the Chugach Range. Cats on windowsills, the ubiquitous moose, moonlight on water, the Oscar Anderson house, slopes of powder without a track, Anchorage street scenes from history--all these and more are his

"That He Sings in His Boat on the Bay," 18x10 inches, Byron Birdsall, 1997.

subjects. His larger works take the forms of triptychs.

In recent years he's turned from watercolor to oils, and to the study of Russian icons, which he decorates with pearls and semiprecious stones from recycled jewelry. Some of his paintings have been reproduced as cross-stitch patterns.

Byron Birdsall is an artist who believes that good work comes from working. "To be an artist you have to be doing, all the time," he says.

And it's wonderful to wait and see what "the master of the mountains" will be doing next.

Sources: The Bear's Lair (Juneau); Pay 'N Save (University Mall, Anchorage).

GUT/INTESTINE

For centuries, hog intestines have been recycled by Western society as casings for sausage. Ahtna Indians of Alaska's Copper River area are known to have used bear intestines to create a bear sausage which they boiled in cauldrons. A meal of such sausage helped save the lives of starving Army explorers Allen and Fickett in the late 1800s.

Confronted with intestines of whales and walrus — intestines of much greater diameter and length — Eskimo and Aleut skin-sewers ingeniously perfected the use of this translucent material for waterproof rain coats and snow shirts as well as sewing bags and windows in sod dwellings.

Similarly, the Tanaina Athabascans used bear gut to fashion raincoats. The Alutiiq used bearded seal gut for their raincoats, or *kamleikas*. Whale bladder and the skin of whale's tongues were occasionally called into service, too.

Aleut women made basketlike containers from strips of seal intestine, cleaned and scraped until thin and translucent. Like the raincoats, these containers were decorated at the seams with feathers, crests of the crested auklet, tufts of down and colored yarn.

An adult walrus can yield 100 feet of large intestine — a great deal of free raw material. To process intestine, the hunter first squeezes out the contents by hand. Then the intestine is repeatedly washed. To make it easier to transport home, it is braided.

The skin-sewer takes over with more washing, and then inflates the intestine and hangs it out to dry in the breeze. The finished material — which slightly resembles a veinous plastic wrap or crinkled waxed paper — is slit down one side to form long panels. Garments made of such material are still occasionally used on Nunivak Island.

See also FISH SKIN, KAMLEIKAS.

Museums: Anchorage Museum of History and Art; National Museum of Finland; Sheldon Jackson Museum.

Practitioners: Larry Matfay (Alutiiq, Akhiok).

Referrals: Athabasca Cultural Journeys (Huslia; 800 423-0094); Nunivak village story; Ounalashka Corporation (Unalaska); Aleut Tours (Unalaska).

GYOTAKU/FISH PRINTS

Gyotaku or fish printing is a traditional Japanese and Chinese art form that is rapidly gaining popularity in the U.S. A fish print is an inexpensive way to make a permanent record of a trophy catch.

Water-based inks, such as sumi inks, are best. The fish used should have all its fins. First, wash the fish with soap and water. Then, ink it with a stiff brush. Next, press a

sheet of handmade rice paper over the fish and rub to take up an imprint of all details. The first impression will usually have too much moisture, and is discarded. A fresh fish can yield three to 10 good prints.

After it has yielded a satisfactory print, the fish may be washed and cooked for dinner.

Alaska practitioners, like Pat McGuire, use several fish, plus seaweeds and shells in their prints. And, of course, they catch the fish themselves.

See also PRINTS.

Practitioners: Jackie Feigon (Aniak); Pat McGuire (Cordova). McGuire's prints appear in museum collections as well as in offbeat places such as the Eyak Packing Company catalog.

Sources: Fathom Gallery (Cordova).

HALO MASK

A halo mask is a mask which is surrounded by a circle or multiple circles of bent wood, to which appendages (flippers, hands, etc.) are attached. The outer rings typically resemble outsize embroidery hoops.

According to a Nunivak legend, this artform originated when a hunter wandered into a cave and saw floating in the air parts of all the game he had killed. He took this as a warning that to continue as a successful hunter, he needed to show additional respect for the game that "gave itself" to him. Therefore, he carved a mask showing the disembodied parts, and the mask became a prototype for other carvers on the island.

The halo mask is also known as the "ring mask" or "spirit wheel mask." Details of how the halo replicates the Yupik view of the cosmos are given in Ann Fienup-Riordan's contribution to *The Artists Behind the Work.*

Originally all wood (driftwood and willow), halo masks are now being made in ivory and soapstone.

See also MASKS.

HEMATITE

Nicknamed "black diamond," or "Alaskan black diamond," this extremely-hard, semi-precious stone was first introduced to Alaska in the 1880s by Russian traders. Hematite occurs naturally in iron ore deposits, and sources have since been found in Alaska. It is considered the most important ore in iron.

Dull black when mined, hematite takes on a silvery sheen and sparkle when cut and polished. It is used in many different jewelry applications, from plain black bands to fancy-dress necklaces.

Native jewelry makers have not taken to this material, but commercial jewelry manufacturers have embraced it. Seek it at gift shops and airport shops aimed at tourists.

See also ARCTIC OPAL, JEWELRY.

Practitioner: Pam Holmquist (Anchorage).

Sources: Alaska Shop (Seward); By Nature catalog (Miami, FL.; 800 938-8811); J.C. Penney (Anchorage); Light in Motion Crystals (Anchorage); Pristine's (Fairbanks); Trapper Jack's (Anchorage); Sheraton gift shop (Anchorage).

HORN DOLLS

Horn dolls, sometimes referred to as "reindeer horn dolls," have armless bodies of caribou antler — a distinctive specialty of the village of Shishmaref. Averaging six inches tall, this minimalist Inupiat plaything is rarely seen in urban shops. It is said to have been invented by Andrew Tocktoo in the mid-1920s, and to have gained popularity when a village store opened in Shishmaref in the 1930s.

Horn dolls are typically created by husband/wife or brother/sister teams. The men shape the horn, and the women sew the clothing. The parky, which pulls off over the head, may be reindeer fawn skin, ground squirrel or seal skin. Trousers are often silky seal skin.

See also ANTLER, REINDEER HORN.

Practitioners: Nora Ann Kuzuguk (Shishmaref); Steven Kiyutelluk (Shishmaref); Elliot and Emma Olanna (Shishmaref); Vincent and Molly Tocktoo (Shishmaref).

Sources: Shishmaref Native Store; Nayokpuk General Store (Shishmaref). A village of about 400, Shishmaref is located on Sarichef Island, 120 miles north of Nome.

ICONS

The word "icon" is from the Greek *eikon* or "sacred image." Icons are stylized figures in small paintings displayed in the Eastern Orthodox Church, the Russian Orthodox Church and in homes of Orthodox believers. They represent Jesus, Mary, or figures of saints (St. Nicholas, the saint of safety on the sea, for example, or St. John the Evangelist) venerated as holy. The saints are often shown in profile. Certain icons themselves are said to have special powers.

Traditional icons were created with several layers of translucent egg tempera one atop the other. The paint was laid on wood or canvas, sometimes ornamented with gold leaf or metal leaf. The gold leaf was burnished by hand, often by rubbing it with a hound's tooth. The image is always labeled and lettered. Some icons are overlaid with a cutout adornment called a *riza*, which may be silver.

Icons are occasionally executed in silk embroidery on banners displayed in the naves of Orthodox churches, in front of the *iconostas* (screen composed of painted icons).

Several Alaskans are creating modern icons. They include Byron Birdsall and Yuri Sidorenko (born near Moscow in 1958).

Sidorenko works in acrylic on wood. What helps to make his icons singular is that

he prepares his own varnish, using lavender oil and natural resins. This formula produces a special warmth and a golden glow. He uses layer upon layer of thin paint to create his images — a technique used by many 16-century masters.

Since arriving in Alaska in 1990, Sidorenko has designed all the icons for the interior of the Chapel of St. Sergius of Radonezh in Eagle River. His icons are available only by commission through Elaine S. Baker Inc.

Detail from icon by Byron Birdsall.

For more about icons, see the exhibit catalog *Heaven on Earth: Orthodox Treasures of Siberia and North America* by Barbara Sweetland Smith, David Goa and Dennis Bell (Anchorage Museum of History and Art, 1994).

Insider Tip: "The Vladimir Mother of God"—an image of the Virgin holding the Christ child — is one of the most popular icons; it is found in nearly every Orthodox church along the Aleutian Chain.

Historic Practitioners: Alimpy, Procopius Chirin, Dionysius, Vasily Kruikov (Aleut, Unalaska); Andrei Rublev, Istom Savin, Nazarius Savin, Nicephorus Savin, Theodore Savin, Theophanes the Greek, Simon Ushakov, Matthias E. Von Reutlinger. For information on some of these painters, see *The Alaska Journal*, II, 1.

Practitioners: Robin Armstrong (Eagle River); Byron Birdsall (Anchorage); Yuri Sidorenko.

Sources: Arctic Rose Galleries (Anchorage); Artique Ltd. (Anchorage); Elaine S. Baker (Anchorage); Orthodox cathedral (Sitka).

IVORY

Ivory is the hard, white substance — a form of dentine — composing the bulk of the tusks of the elephant, walrus and other animals.

For centuries upon end, early peoples carved miniatures of prey animals valuable to them or spirit animals that might bring them luck. Among Alaska's Eskimos, these animals included whales, seals, walrus, polar bears, caribou, swans, snowy owls, ducks, loons and other waterfowl. In the Eskimo village of Savoonga, which the residents have dubbed the "Walrus Capital of the World," the figures lean heavily toward animals harvested there: bowhead and gray whales, walrus, seals, crabs and polar bears. The figures were carved in whatever material was handy — bone, shell, bark, wood or soft stone; in Eskimo country, ivory was often more common than wood.

The ivory traditionally worked in Alaska comes from the tusks of walrus and from the teeth of toothed (i.e., non-baleen) whales such as the sperm whale. It should not be confused with elephant ivory or with the spirally twisted tusk of the male narwhal (*Monodon monoceros*). Feel free to question carvers/shop keepers when in doubt.

Elephant ivory is cross-hatched. (For a more extensive description, see ELEPHANT IVORY.)

Walrus tusk ivory has a mottled core (a deposit of dentine) and a tendency to split. When viewed in cross-section, it shows a radiating pattern. To minimize splitting, tusks are usually allowed to dry for at least two weeks before carving is attempted.

Sperm whale teeth, of which there are dozens on the whale's lower jaw, is homogenous, and lends itself to small figurines and rings. A sperm whale tooth, which can weigh two pounds, is tough and resists splintering.

Walrus teeth are also considered ivory, but their small size limits their use by carvers to bracelet links and tiny animals and birds.

> "In those years [pre World War II in Nome] almost everybody did it [ivory carving]. But it wasn't done to make money. It was mostly done for their own use like buttons on harnesses for pulling seals, seal skin floats and all that. Craft items didn't come into existence until 1940, during the war. Almost everything I know I learned from experience. A lot of frustrations in it. The one bad thing about ivory is you can't make a mistake...."
> — Lincoln Milligrock, *The Great Lander,* April 2, 1980.

Native carvers obtain ivory by participating in twice-yearly walrus or whale hunts, bartering with relatives who hunt or buying from carvers' co-ops in their villages. "Old ivory" is tusks that have been buried in soil or beach sand for decades or centuries; this ivory is uncovered by excavation or the action of arctic storms.

Traditionally, Eskimos worked ivory with a mouth bow, a tool powered by human muscle. In the past few decades, Eskimo carvers have commonly employed dental drills, hacksaws, files and sandpaper. In centuries past, only men carved walrus ivory. Today some women are trying their hand at it.

The best ivory carvers don't just hack a form out of any blank. They use the varied colors of the ivory to delineate specific body parts of the walrus or loon or polar bear they create. Even cracks and imperfections will be used to good advantage, as in sea bird rookeries where the core of a tusk simulates crags used for nesting.

Villages such as Mekoryuk, Nome, Gambell and Savoonga are known for their talented ivory carvers. King Island men were particularly known for their work, and some carvers still identify themselves as from King Island — although no one lives

there today because the island lacks a school; many carvers born on King Island live in nearby Nome or have migrated to Anchorage. Work from all over the state can be seen at an important co-op, Alaska Native Arts & Crafts (Anchorage).

Alaska Alive: Demonstrations of ivory carving are given during the summer in some gift shops in Anchorage and Juneau, and between June and September at the NANA Museum of the Arctic in Kotzebue. Some carvers specialize in one bird, such as an eagle. Some specialize in assemblages, such as a men's community house with a dance in progress or a blanket toss. Some create ivory jewelry. (A particularly collectable form of jewelry is the bracelet made of lozenges of ivory attached one to the other with elastic thread; lozenges of baleen may alternate with ivory in a striking black-white arrangement, with the ivory featuring scrimshaw.) Cecil Seppilu of Savoonga shapes ivory into whales, polar bears, seals, walrus, birds and cribbage boards, while David Seppilu of Savoonga creates ivory dog teams. Meanwhile, Mabel Smith of Barrow is carving seals and owls.

Puffin by R. Mayac, walrus ivory, 1976, 2.25 inches tall. Orange and yellow beak, orange feet.

Possession of raw ivory and walrus tusks is restricted by Alaska law to Native walrus and whale hunters and their families. For details, consult the Agent-in-Charge, U.S. Fish and Wildlife Service in Anchorage or Fairbanks. Other laws govern the export of carved or scrimshawed walrus ivory. (See SHIPPING COLLECTIBLES HOME.)

For more information, consult Dorothy Jean Ray's *Aleut and Eskimo Art* (University of Washington Press, 1981), as well as her *Artists of the Tundra and the Sea* (UW Press, 1961, 1980). See also Geoffrey Wills' *Ivory* (1968). See also Darroll Hargraves' "Eskimo Ivory Carvings of the Human Figure," *The Alaska Journal*, IV, 3. Another worthy source, which deals with many materials in addition to ivory, is Susan W. Fair's *Alaska Native Arts and Crafts* (1985). Vol. 12, No. 3, of *Alaska Geographic*.

Note: The kernel of a certain tropical nut, the ivory nut, is now being marketed as "vegetable ivory." This durable nutmeat is shaped into buttons and charms.

See also ARTIFACTS, BRACELETS, CRIBBAGE BOARDS, ELEPHANT IVORY, FOSSILIZED IVORY, IVORY, MASTODON IVORY, NUNIVAK TUSK, SCRIMSHAW, WALRUS IVORY.

Insider Tip: When visiting Skagway, be sure to tour the ivory museum at

Corrington's.

Insider Tip: Native carvers can purchase ivory by the pound at Ivory House (Anchorage).

Museums: American Museum of Natural History; Anchorage Museum of History and Art; Historical Museum, Mystic Seaport (CT); Museum of Anthropology, Soviet Union Academy of Sciences; NARL (Barrow); Smithsonian (Washington, D.C.); U.S. National Museum; University of Alaska Museum (Fairbanks, Dorothy Jean Ray Collection); University Museum, University of Pennsylvania (Philadelphia).

Historical Practitioners: Melvin Olanna (Shishmaref); George Washington (Nome, St. Lawrence Island); Happy Jack (Nome); Paul Tiulana (King Island, Nome, Anchorage).

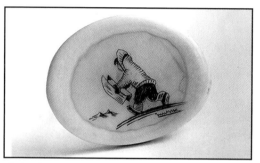

Scrimshaw ivory pin, Kodiak, 1965. Private collection.

Practitioners: Rolin Allison (North Pole); Francis Alvanna (Nome); Byron Amos (Anchorage); Shirley Anungazuk (Nome); Bellarmine Alvanna (Nome); Alexander Akeya (Savoonga); Julius Alowa (Savoonga); Cha Rnacircle (Juneau); Thomas Coates (Barrow); Sipary Cuukvak (Nightmute); Lloyd Elasanga (Anchorage); James Grant Sr. (Athabascan, born in Tanana, now living in Fairbanks); Dale Hanson (Sitka, grizzlies); Jim Immingam (Savoonga); Walton Irrigoo (Nome); Truman Kava (Siberian Yupik, Savoonga); Floyd Kingeekuk Sr. (Savoonga); Kenneth Kingeekuk (Savoonga); Larry Kingeekuk (Savoonga); Franklin Kiyuklook (Savoonga); John Kokuluk (King Island, Nome); Earl Mayac (Inupiat, King Island; human-animal transformation carvings); George Mayac (Inupiat); R. Mayac; Davis Menadalook (Little Diomede); Lincoln Milligrock (originally from Little Diomede, sea mammals); Herbert Nayokpuk (ivory and bone, Shishmaref); Wilson Okoomealingook (Siberian Yupik, Savoonga, polar bears, walrus); Karen Olanna (Juneau); Carson Oozeva (Siberian Yupik, Gambell, puffins); Wilson Oozeva (Siberian Yupik, Gambell, bears); Bert Oozevesuek (Siberian Yupik, Gambell; owls and puffins); Aaron Oseuk (Siberian Yupik, Gambell; otters, walrus and ptarmigan); Louis Ozenna (Little Diomede); John Penatac (Inupiat, originally of King Island, human-animal transformation carvings); Aloysius Pikongonna (originally from King Island); Charlie Post (Tununak); Edith J. Rivera (Anchorage); Lane Rookok (Siberian Yupik, Savoonga, ivory kayaks); Raphael Sebwenna (Inupiat, Nome); Daniel Seetok (Wales); Suzi Silook (Siberian Yupik, Anchorage/Gambell); Levi Tetpon; Justin

PAUL TIULANA

Ivory carver Paul Tiulana was born at King Island in 1921. Although no one lives on King Island today, it is the cultural and artistic home of many noted ivory carvers. Tiulana began carving at age 11 or 12, he told me in 1981, when he was Projects Coordinator for Native Culture at Cook Inlet Native Association.

"When I got up to 18 or 20 I started to carve constantly, and I have been carving since then-- and still improving." He carves "mostly the animals I hunt: seal, polar bear, walrus and sea birds I see coming through King Island: puffin, murre, auklets, sea duck. Sometimes the bird has a little story behind it, and this makes it more interesting to carve," he adds.

By "a little story," Tiulana means not only a legend but also a functional use in the Eskimo culture. He explains, "We hunt the walrus for food, and this makes it more interesting for me to carve. We use the female walrus skins for umiaks [large skin boats]. We use the common seal skin for binding kayaks, for binding almost anything; and I like to carve the seal. The polar bear is our, I would say, prize game at King Island because it is very hard to get; you have to compete with the animal--it is either you or him. You put a little fresh water on the mouth of the seal or bear or whale when you kill him to show you respect him, and you give the fur and meat of the bear away to the hungry people in the village and celebrate with an Eskimo dance."

Tiulana's four sons, Eugene, Tommy, Matthew and Justin, are all ivory carvers. "Justin, my oldest boy, is a real master now; and Eugene is pretty good. Simon Pushruk is doing pretty good, too. Mostly the old-timers are the best, but they are mostly living in Nome."

Tiulana often felt homesick for King Island: "Living in an urban center is completely different from the rural villages, and I just hate to come down here from Nome. But there is a lot that has to be done," said this renaissance man who oversaw the creation of a full-size umiak launched on Mirror Lake, who restored several dances that had not been performed for years as well as the polar bear feast held on the occasion of a young man's taking his first nanook.

"Often I think, 'Let me go back to King Island where I know Alaska best: no traffic, no regulations; where all you have to compete with is Mother Nature.

Tiulana was aware that he was trying to reconcile two worlds: "The old folks used to say, "Do whatever is the best.' It is hard for us to compromise. Even when we see something we don't agree with, even if we see it two or three times, we hold in our reactions, and we say, 'Yes.' The old folks didn't understand what it meant to say 'Yes.' "

Tiulana (Inupiat, Anchorage).

Sources: A Alaska Old Ivory Dealer (Fairbanks); Alaska Auction Company (Anchorage); Alaska Commercial Co. (Unalaska); Alaska Fur Exchange (Anchorage); Alaska Gold & Ivory (Ketchikan); Alaska Ivory Exchange (Anchorage); Alaska Ivory Outlet (Anchorage); Alaska Native Medical Center gift shop (Anchorage); Alaskan Gifts & Artwork (Homer); Alaska's Best (Anchorage); Arctic Trading Post (Nome); Aurora Fine Art Gallery (Anchorage); B Merry Studio (Anchorage); Bull Moose Gifts (Ninilchik); Burke's Jewelry (Northway Mall, Anchorage); Cape Smythe Trading (Barrow); Cha's Studio (Juneau); Corrington's (Skagway); The Cracker Box (Dillingham Airport); Elim Native Store (Elim); Franklin Arts (Anchorage); Frontier Art Gallery (Anchorage); Gambell ivory carvers' cooperative; Inu Craft (Kotzebue); The Ivory Broker (Anchorage); Ivory House (Anchorage); Ivory Jim's (Nome); J.C. Penney (Anchorage); King Salmon Airport gift shop; Kobuk Valley Jade Co. (Girdwood); Kowak Ivory (Fairbanks); Lynd's Alaska Ivory (Anchorage); One People (Anchorage); Portfolio Arts (Juneau, owned by Karen Olanna); Rose's Ivory and Native Crafts (Anchorage); Savoonga ivory carvers' cooperative; Savoonga Native Store; T.C.R.'s Ivory (Fairbanks); Top of the World Hotel gift shop (Barrow); Wayne Penaya's Grocery Store (Savoonga); gift shop of the Sheraton Anchorage Hotel; gift shops in the Captain Cook Hotel and Anchorage Hilton; TCR Ivory (Fairbanks).

> "The public has become accustomed to purchasing ivory by its volume — the size of the piece — rather than the quality of the work on it. Ivory is becoming more expensive now, in its raw state, and I think there has to be more quality to the work to justify the cost of it."
> — Carver Joe James in an interview with the author in Eagle River, 1981.

Note: A cream-colored polymer resin is being used by museums to reproduce priceless ivory carvings in their collections. These items are marked on their bases as to their composition. (They may also be marked with the initials of the museum, such as MMA for Metropolitan Museum of Art.) When in doubt, ask.

JADE

Jade is any of various hard greenish gemstones used in jewelry and artistic carvings, including jadeite and nephrite. Jadeite, $Na(Al, Fe)Si_2O_6$, found chiefly in Burma, is considered the most precious type of jade. The ancient Romans believed that wearing jade cured pains in the side.

Known for its hardness and its variety of colors and shadings, jade is Alaska's state gem. It must be cut with diamond and Carborundum tools. Formerly, some of the jade in Alaska shops originated at "Jade Mountain," near Kotzebue. However, that

area is no longer mined, and more and more of the jade for sale here is now mined in British Columbia and in the Orient. Jade is fashioned into jewelry, sculptures, book-ends, table tops, clock faces, lamp bases and more.

Sources: Alaska Shop (Seward); All Alaska Gifts & Crafts (Tok, AK.); Arctic Art (Anchorage); Aurora Arts & Crafts (Anchorage); Burke's Jewelry & Gifts (Northway Mall, Anchorage); Commack Lodge & Store (Shungnak); Inu Craft (Kotzebue); J.C. Penney (Anchorage); The Jade Shop (Fairbanks); Kobuk Valley Jade Company (Girdwood; jade jewelry, raw jade, jade carvings); Norman's (Kodiak); Nullagvik Hotel (Kotzebue); Ootukahkuktuvik Museum gift shop (Kotzebue); Pristine's (Fairbanks, earrings, and earring wardrobe); Stewart's Photo (Anchorage); Taylor's Gold-N-Stones (Fairbanks); White Nights Siberian Stone (Anchorage); The Yankee Whaler (Anchorage, black and white jade necklaces; sheep horn and moose antler carvings mounted on jade pedestals);

Referrals: Oro Stewart (Stewart's Photo, Anchorage).

JAPANESE GLASS FLOATS

Air-tight spheres of pale blue or green glass, Japanese floats are used to buoy up the edges of fishing nets. They are secured to the nets with netting, but the netting often wears out and the floats become loose. Tides deliver them to many parts of Alaska's extensive coastline. For dozens of coastal residents and dedicated beach buffs, they constitute one of the most prized bits of flotsam — something for display-ing in sauerkraut crocks on the porch or lined up on sunny windowsills. The average float is three inches across, but floats up to 19 inches are occasionally recovered. Sausage-shaped and pear-shaped floats sometimes surface. Dumbbell shapes are among the rarest.

Japanese floats are typically blue-green, but examples have been found ranging from clear to milky white to pale pink to turquoise, amber, olive, red, blue, wine, brown and even purple.

Not all "Japanese" floats are Japanese, explains Dory Stucky of Alaska General Store: "The Japanese ones have a molded seam around the middle, and sometimes harbor marks. (People like to collect one from each harbor.) Russian ones are hand-blown, and I think they're prettier." Stucky gets her floats from bush pilots, and her-self favors the ones which storms have dragged along the bottom — floats with that etched "beach glass" fogginess rather than their original transparency.

Whether of Japanese or Russian origin, older floats will be netted in hemp. Newer models are encased in colored (blue, yellow) plastic netting. Glass floats are becom-ing scarcer as they are gradually replaced by hollow plastic floats with a molded-in hook on the top.

Complete information about this collectible is available in *Beachcombing for Japanese Glass Floats* by Amos L. Wood (Binford & Mort, 1967).

85

DENISE WALLACE

Jewelry-maker Denise Wallace was born in Cordova and raised in Seattle. In 1976 she moved to Santa Fe, New Mexico, to attend the Institute of American Indian Arts. later, with her husband, Sam Wallace, she established the DW Studio, Inc., in Santa Fe, but has always made frequent visits to Anchorage and to see her Sugpiaq relatives in the Cordova area. She occasionally gives classes for art students and art educators.

Wallace has been described as a "storyteller who uses ivory, silver and precious stones to tell stories of her Sugpiaq ancestors and portray images of Alaska Native peoples." With human silhouettes reminiscent of kachina dolls, her jewelry tells of her relatives hunting, picking berries, drying fish, weaving baskets, playing games and rejoicing.

Although her subjects are taken from Alaska's subsistence lifestyle, her technique and her use of turquoise are borrowed from the tradition of Southwestern Indian art. Some of her most important works are done in the style of the concha belt.

Her first major piece was "Killer Whale Belt," the winner of several awards in the Santa Fe Indian Market in 1982. It was designed so that every other link combined cutouts and overlay to depict a different scene of Alaska life.

In 1989, her "Crossroads of Continents Belt" was inspired by the Smithsonian Institution's exhibition, "Crossroads of Continents: Cultures of Alaska and Siberia." Various parts of the belt could be detached and work separately as pendants, earrings or broaches. In the tradition of the transformation mask, some of the mask sections opened to display another image within.

Wallace's work has been exhibited at the Peabody Essex Museum (Salem), the Society for Contemporary Crafts (Pittsburgh); the George Gustav Heye Center (NYC); the Gene Autry Museum (Los Angeles) and the Heard Museum (Phoenix, AZ.) She has won dozens of awards.

Every August during Indian Market in Santa Fe, Wallace produces an annual show, "Visions of Alaska," at her studio showroom. In addition to jewelry, the show may include Eskimo dancers and singers and even a Pacific Northwest Indian fashion show.

An assortment of Alaskan jewelry: Pin (1 6/8 inches square) and matching earrings, high-fire, hand-formed porcelain, mauve edges with bronze centers, Molly Willson Perry, Anchorage, 1995. Perry coined the phrase "Anthropic Mobile Art" to describe her creations. Tooth face, fossilized ivory, Cha, Anchorage, 1986. Pin, black fimo(r) clay and turquoise, violet and pink paint, K. B. Sautner, Anchorage, 1990. Ivory scrimshaw pin of Eskimo child with sled, 1965, stylized signature, Kodiak. Ivory polar bear pin, signed "Mayac," Anchorage, 1995. Zipper pull/pendant in the form of a seal (3 1/8 inches), Uncle John, Mekoryuk, 1989, strung on red, blue and white trade beads from Sitka, with modern seed beads. Private collection.

Do it yourself: Beachcombing on remote Alaska shorelines, such as Montague Island and Kayak Island in Prince William Sound, or remote beaches on Kodiak and in the Aleutians. Trinity Island off Kodiak and Port Heiden, on the north shore of the Alaska Peninsula, are highly recommended by Amos Wood. Vancouver Island and the Queen Charlottes are also known to be productive.

Insider Tip: Melanie Gunderson of Nelson Lagoon gilds the lily by crocheting over antique glass balls.

Sources: Alaska General Store (Anchorage and Juneau); garage sales.

JEWELRY

Jewelry is objects of personal adornment for either sex, often incorporating precious metals as well as cut and polished precious or semiprecious stones, natural or cultured pearls, crystals or other organic elements. Alaskan jewelry is often made

from ivory, coral, and jade, or adorned with natural gold nuggets. Bands for men's watches and men's ornate belt buckles may combine jade and nuggets.

"Costume jewelry" is inexpensive, every-day jewelry, commonly made from synthetics such as plastic, or from clay, paper, etc.

See also, ALASKA CORAL, ARCTIC OPAL, BEADWORK, BRACELETS, CLOISSONE´, GARNET, GLASS, GLACIER ICE, GOLD NUGGET JEWELRY, HEMATITE, IVORY, JADE, SILVER, STAR OF ALASKA.

Insider Tip: J.C. Penney (Anchorage) carries the "Czarina Collection" in Royal Russianite, a semi-precious stone with amethyst coloring.

Practitioners: Drucilla Allain (Glennallen); Solvay Ava Bakke (Wrangell); Cha (Juneau, Eskimo angels designed to slide onto large chains or omegas); Judie Gumm (Fairbanks); Barbara Lavallee (Anchorage, pins); Rachel Nickerson (Klawock); Edgar Ningeulook (Shishmaref, earrings, rings); Linda Nott (Sitka); Charley Okpowruk (Shishmaref); Albert Olanna (Inupiat, Shishmaref); Lela Oman (Inupiat, Nome, face pins); Pat Pearlman (Pat Pearlman Designs); Molly Willson Perry (Anchorage); Robert Pfitzenmeier (Girdwood); Rose Prince (Anchorage); Ron Redman (Juneau); Bill Spear (Juneau); Denise Wallace (Sugpiaq, Santa Fe).

Sources: Alaska Shop (Seward; hematite, ivory, Arctic opal, Kabana Silver & Gold, gold nuggets, pewter, crystal, pins); Alaskan Heritage Gems & Gifts (Ketchikan); Anchorage Museum of History and Art; Annie Kaill's (Juneau); Artique Ltd.; Bobbi's Treasure Chest (Dillingham); Brown & Hawkins (Seward); Bunnell Street Gallery (Homer); Carr's Quality Centers (Anchorage); Cha (Juneau, catalog of gold designs available); Colombian Emeralds, Int. (Ketchikan); Crafts Emporium at Egan Center (Anchorage, in November); Crafts Weekend at the Anchorage Museum (the three days after Thanksgiving); Galligaskins (Juneau); J&M's Fine Jewelry & Gifts (Ketchikan); Joseph Machini Fine Jewelry & Designers (Ketchikan); The Kachemak Goldsmith (Homer); Resurrect Art Coffee House Gallery (Seward); Saturday Market (downtown Anchorage, May through September); Stephan Fine Arts (Anchorage); Sunday Market Bazaar (indoors market, Adante's, Eagle River); Town Square Art Gallery (Wasilla); Trapper Jack's (Anchorage); University of Alaska Museum gift shop (Fairbanks). Additional sources listed under specific materials.

For a catalog of gifts, collectibles, jewelry, T-shirts and clothing and gourmet gifts, call Galligaskins in Juneau, 800-586-5861, ext. 23.

Insider Tip: Cruise estate sales and auctions for jewelry and ivory. For example, try Alaska Auction Company (Anchorage).

KAMLEIKA

A kamleika is a waterproof parka traditionally worn by Alutiiq hunters when paddling their kayaks on the open ocean. It pulls over the head, has an attached hood, and ties around the face. A drawstring secures it to the kayak's hatch, making man and

craft one unit.

The garment is made of strips of seal gut (intestine). The gut is carefully washed, then inflated and dried. After it is dry, the intestine if slit down one side to form a long panel of fabric. Lengths of this panel are stitched one atop the other (like logs in a cabin wall) to form the garment. The seams are made waterproof by rolling their edges over beach grass and stitching them. The kamleika was an important item of barter with early Russian traders — often listed in company inventories.

See also FISH SKIN, GUT/INTESTINE.

Teacher Alert/Insider Tip: The Kenai Visitors and Cultural Center displays ethnographic material from the Athabascan, Yupik and Aleut cultures. The display includes artifacts, a samovar, homestead items, baskets, Russian dinnerware and coins, and a kamleika with matching gut trousers.

Museums: Anchorage Museum of History and Art; display at Gary King's Sporting Goods (Anchorage); National Museum of Finland. A kamleika sewn from walrus intestine can be seen at the Kotzebue city museum, Ootukahkuktuvik, or "Place Having Old Things."

Practitioners: Grace Harrod (Kodiak); Mary Smith (Alutiiq, Kodiak); Susan Malutin (Mary Smith's daughter, Kodiak).

Sources: Chiefly by commission.

KUSPUK

Eskimos themselves translate "kuspuk" *(qaspeg)* as "summer parka." The kuspuk is an over-the-head garment worn by women and girls. It is the sweater or windbreaker of village Alaska, sewn of colorful gingham, calico or other commercial fabric, decorated with woven braid or rickrack. It is usually topped with a hood.

Originally the *qaspeg* was worn as a cover over a fur parka to keep it clean; in the last several decades, it has become a garment in its own right. It is often adopted by non-Eskimo teachers who have taught in Bush villages, and seen in full flower on city sidewalks during summer months.

See also KAMLEIKA, PARKY.

Practitioners: Elsie Piyuk Ahnangnatoguk (Nome); Rosalind Attutayak (Teller); Vamori Kaufman (Palmer); Cecelia M. Richard (Kenai); Virginia M. Rowley (Anchorage); Bonnie Shurtleff (Willow, doll kuspuks and parkas).

Sources: Baranof Enterprises/Fitting Pretty (Sitka, Philip Moody, "Alaska summer parkas"); Laura Wright Alaskan Parkys (Anchorage); Great Alaska Tourist Co. (Wasilla, Eskimo dolls wearing kuspuks and mukluks, trimmed with fur and leather or synthetic materials).; Kiddie Kuspuks, Inc. (Anchorage, Marion Bowles, child-size kuspuks); Little Alaska Enterprises (Kenai, Patricia Little, husky *qaspecs* and critter tees).

⫷░◁-◁◁-◁◁-◁◁-◁◁-◁◁◁

FRED MACHETANZ

Fred Machetanz is often dubbed "the dean of Alaska's artists."

A resident of Palmer, he has been painting the state and its people for more than 50 years. He first encountered the scenes that appear again and again in paintings like "Trail of the Great White Bear" when visiting his uncle in Unalakleet. The intensity with which the Inuit searches for food and materials on the tundra and in the sea, the blue shadows of shorefast pack ice, the raspberry glory of January light on the snow, the gold of aspen leaves below Pioneer Peak--these are the sights that Machetanz has absorbed and endlessly tries to render at a peak of perfection. Like Shakespeare, Machetanz returns to his themes again and again — but always anew.

Machetanz has a real sympathy for hard work--for the grizzled prospector on a mountainside, for the sled dog, for the whaler in his skin boat on what seems an endless and hostile ocean.

Machetanz doesn't paint Alaska's present. He presents a golden age between the gold rush and the oil rush.

He says, "If anyone viewing my work has felt the beauty, the thrills and the fascination I have known in Alaska, then I have succeeded in what I set out to do."

A graduate of Ohio State University, the genial Machetanz and his faithful Sara initially earned their living in Alaska by writing books and making the winter lecture circuit. All that changed when Fred held his first one-man show in 1961. Since then his paintings and stone lithographs have been exhibited around the world.

His art shines in private collections and public places throughout Alaska. His work is published by Mill Pond Press and carried by Artique, Ltd.

LACQUERED BOXES (RUSSIAN)

Lacquerware is the name given objects, usually of wood, covered with a resinous varnish and often inlaid; lacquerware has a highly polished, lustrous surface.

A popular recent import to Alaska from Siberia, glossy lacquered boxes usually take the form of small desk or jewelry containers, some painted with scenes of winter sleigh rides or with characters from legend such as the Firebird or Alyenushka and her goat. Villages particularly known for the artistry of their lacquer boxes include Kholui, Mstera and Palekh. Lacquer boxes from Russia now appear in collectibles catalogs, cheek-by-jowl with handpainted Limoges porcelain boxes from France — and command comparable sums. Of similar artistry, but lower in price, are lacquer brooches.

Insider Tip: Look for examples signed by the artist.

Sources: Arctic Rose Galleries (Anchorage); Elaine S. Baker & Assoc. (Anchorage); Katherine The Great (Anchorage); The Russian America Co. (Sitka).

Mail-order Source: The Cottage Shop (Stamford, CT.; 1-800-965-7467).

LEATHER

Tanned leather is often called "buckskin," especially when made from the skin of a male deer. But it may also be made from the skins of elk, moose, reindeer, caribou and other animals. Leather was used for tunics, dance capes, shaman's aprons and leggings, hoods, mukluks, quivers and moccasins by many indigenous American tribes, including Alaska's Athabascans. Skin costumes were usually fringed, occasionally painted with crest designs or motifs of supernatural beings, and sometimes decorated with quills, blanket cloth strips, puffin beaks and deer hoofs.

Preparing skins is a laborious process that includes fleshing, removing the hair, applying brains as a cure, alternately kneading and drying the skin to soften it, and smoking it to an even color. The whole time-consuming process was generally handled (pun intended) by women, the most skilled of whom could produce a supple, flannel-soft product that draped gracefully and was deliciously comfortable to wear.

Chemically tanned leather is stiffer and harder to sew than Native-tanned leather.

Leather today is used for many crafts such as knife sheaths, moccasins, belt-suspended purses and "possibles bags."

For specifics of the process, consult *How to Tan Skins the Indian Way* by Evard H. Gibby (Eagle's View Publishing).

See also FISH SKIN, FUR, GUT/INTESTINE, PARKY.

Practitioners: Meribeth E. Orock (Anchorage; fur or leather items depicting Native scenes); Beauford Pardue (Haines, knife sheaths); Barbara A. Pearce (Ketchikan, leather dolls); Leslie Kozeluh (leather masks, salcha).

Sources: Black Elk Leather (Anchorage); Synergy Artworks (Seldovia).

LITHOGRAPHS

Lithography is a printing technique in which the image to be printed is fixed on a stone or metal plate with a combination of ink-absorbent and ink-repellent vehicles.

For details, see *The Alaska Journal,* IV, 1: 34-35 and V, 1:64.

Fred Machetanz has crystallized Alaskan life in his collection of 50 lithographs. Collectors should take a gander at *The 50 Stone Lithographs of Fred Machetanz,* a signed and numbered edition limited to 950 copies, $300. (Mill Pond Press, Venice, FL).

See also PRINTS, STONE LITHOGRAPHS.

Insider Tip: The Sheraton Anchorage Hotel features lithograph reproductions of some of the early wood block prints of Joe Senungetuk in 300 of its 410 rooms.

Museums: Lithographs by Lisiansky can be seen in *Choris' Voyage, 1820,1822*, in the Pacific Northwest Collection, University of Washington Libraries. Lithographs by von Kittlitz can be seen in the atlas to *Lutke's Voyage,* 1835, at the Beinecke Library, Yale.

Historic Practitioners: Louis Choris (1795-1828); Lisiansky; Friedrich Heinrich von Kittlitz (Sitka c. 1840).

Practitioners: Rachel Barton-Sabo (Anchorage); Mary Croxton (Palmer); Gary Lyon (Homer); Fred Machetanz (Palmer); Bonnie Morrison (also produces photographs, serigraphs); Ernest Robertson (Sitka); Joseph E. Senungetuk (b. 1940, Wales, AK.); Diana Tillion (Halibut Cove; Tillion also works in octopus ink, clay, wood, gouache, oil, and words).

Sources: Art Haven (Fairbanks); Artique Ltd. (Anchorage); The Artworks (Fairbanks); House of Wood (Fairbanks, Mill Pond Lithographs); New Horizons Gallery (Fairbanks); Obeidi's Fine Art Gallery (Anchorage, represents Ernest Robertson, Bev Doolittle, Fred Machetanz); Quiverbean Coffee Co. (Anchorage); R.T. Wallen Gallery (Juneau); The Sea Lion Gallery (Homer); Site 250 (Fairbanks); Stephan Fine Arts Gallery (Anchorage).

MASKS

"The mask makers utilized almost every material they could lay hands on ... feathers, swan's-down, stripped feather quills, porcupine quills, hair (reindeer, caribou, wolf, dog, and human), seal pup fur, Alaska cotton, beach grass, willow bark, willow root, rawhide strips, bleached strips of intestines (natural color or dyed red or black), baleen pendants, beads, string, pieces of crockery, brass, copper, lead, iron, cartridge shells, ivory, pieces of wood in various shapes, and animal teeth (usually dog)."
—Dorothy Jean Ray, *Eskimo Masks: Art and Ceremony*

"There were no masks where I grew up. They were all forbidden material by then. Everything had been scooped up by museums."
— Joe Senungetuk, who carved his first mask in 1967, in "Joseph Senungetuk: Alaskan Eskimo Artist" by Ann Chandonnet, *Northward Journal*, 1981. Senungetuk was born in the village of Wales on the Seward Peninsula in 1940.

Masks, common to prehistoric peoples all over the world, are a traditional aspect of Alaska's Eskimo, Aleut and Indian cultures. Into this century, masks were worn by dancers during ceremonies and by shamans during curative rituals, but their use was discouraged by Christian missionaries.

A century ago, Yup'ik masks were collected by travelers along the Bering Sea coast. Some made their way to New York and Europe, where they influenced artists like Andre Breton and other surrealists. Traditionally the masks were used to thank the

animals that had "given themselves" to successful hunters — to encourage the spirits of those animals to don flesh yet again and return. After the ceremonies, the masks were usually destroyed.

In the past, masks were made chiefly of wood such as cedar and alder. Appendages of feathers, fur, human hair and ivory, and/or wooden and baleen dangles accented the undulations of the dance. Bird quills might double as whiskers, porcupine quills as seal muzzle bristles, caribou teeth as human teeth.

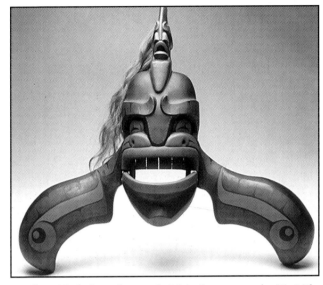

Because trees rarely grow on the arctic tundra, indigenous craftsmen along the Bering Sea collect driftwood to

"Killer Whale," mask, wood, 24 inches across, by T. Mike Croskrey.

carve into masks and other craft items. Unlike craftsmen who purchase raw materials from big city craft shops or catalogs, these Bush-dwellers are limited by the vagaries of nature. Their annual output literally fluctuates with the tide. This can be irritating to impatient collectors who "want it now," but others enjoy the quaintness of this age-old situation.

Today whale bone is increasingly being used for masks — especially masks meant for collectors. The single face mask without appendages was common north of St. Michael. Masks from other areas are more complex. They contain not only a central face, but also one or more halo-like surrounds of bent willow or steamed wood. On these halos are mounted additional, smaller masks and/or tools, birds or animals. These subsidiary elements seem to be helping spirits or "familiars," or targeted prey animals. This mask form is sometimes called the "halo mask," "ring mask" or "spirit wheel mask," and seems to have been most common in pre-contact times on Nunivak Island.

The denotation "spirit mask" is somewhat redundant because the majority of Native Alaskan masks portray spirits — of fox, of wolf, of driftwood, of walrus, of raven, of a good or evil shaman or of the owl. Occasionally, humans are portrayed. However, Eskimos believed that every animal and object possessed a spirit, one of

ELAINE SMILOFF

Aleut artist Elaine Smiloff was delivered by a midwife on Unga Island near Sand Point, AK. She was raised on Korovin Island and Kodiak. Childhood memories include trapping on the game-rich Alaska Peninsula with her mother, Nancy E. Jones.

She made her first carving, a soapstone bear, at age 14. She has been carving professionally for over 15 years, experimenting with materials including wood, soapstone, bone, baleen, ivory, clay, bronze and alabaster. She traces some of her skills back to an "Alutiiq Studies" course at Kodiak High, where Yvonne Zharoff and teacher Dave Kubiak encouraged her and "directed her interests."

Smiloff's specialty is masks. She prefers natural materials she can collect: driftwood, cottonwood bark, fish skin, fur, feathers and bones. She paints her masks with natural ingredients: charcoal, alder bark, urine, ground minerals.

"One mask, 'Kayungwok,' was in my mind for nine years before I put it in wood. I find the spirits for my masks from the land, from the sea and those who are remembered. Words cannot always express what is inside and around us."

"In my life, I have had to struggle with alcohol, family abuses, poverty and discrimination. As a race of people, how do [Aleuts] survive slavery, slaughter, foreign diseases, domestic disorder, drug abuse, alcoholism--and the loss of all that a people can hold dear. Of course we are inward and soft-spoken! After so much, we can only hope the few precious pieces of seal meat will not be taken from our mouths!"

At first, Smiloff preferred to give away all her work, to find "the right home" for each mask. But her husband, knowing the many hours and unusual materials involved, persuaded her to sell her dolls and masks. However, gallery owners have encouraged her to go into mass production--creating 10 or so of each original design. But she resists: "How is it sacred? How is it cherished if you make so many?"

"Each piece [I carve] is special. It is opening myself up to other people."

whose various forms was a human form. When an Eskimo artist creates a fox mask, for example, the aim is not to make a scientifically correct fox such as might appear in a textbook about mammals, but to interpret the form of the fox's spirit. Occasionally both the fox and its enigmatic spirit appear in one mask, superimposed, or side-by-side.

Yupik carver Nicholas Charles Sr. of Bethel thought of the mask as "the eye of the dance." For more on this subject, see *The Artists Behind the Work* by Ann Fienup-

Riordan, Sophie M. Johnson, Katherine McNamara, Rosita Worl and others.

The word "mask" typically conjures up an image of something the size of a human face. However, Northwest masks can be much larger. Two of the largest Kwakiutl masks were a cannibal mask, the Crooked Beak of Heaven, and the Hohok. The Hohok was another legendary cannibal, a long-beaked bird, a cruel creature who split men's skulls in order to dine on their brains. The beaks of both these masks protruded three or four feet past the faces of the dancers wearing them. In winter, when the weather was inhospitable to hunting and fishing, the Kwakiutl retired to their plank houses and brought out such masks for *tseyeka,* the supernatural season.

On the other hand, masks may also be miniatures, four inches or so from ear to ear; these are sometimes called "maskettes," and were hand-held by shamans during special ceremonies.

Larger masks could be "transformation masks" or "articulated masks" suitable to recreate dramatic events in legend. An artic- ulated mask of a whale in the collection of the Denver Art Museum, for example, is enhanced by its movable jaws, tail and fins, as well as a blowhole through which eagle down could be wafted to simulate spouting. An eagle mask that opens to reveal a human

Model of Kwakiutl mask, wood, feathers, grass, 6.5 inches by 1.5 inches (wig, 8 inches) by Richard A. Andrews, 1995. Masks of the Hokhokw or hohok bird were worn at winter ceremonials. Some were over five feet long. Private collection.

face dramatizes a transformation or metamorphosis of a bird to human form.

Traditionally, masks were created for a specific occasion such as a ceremony of several days' length, and discarded, placed in a burial cave or burned when that occasion had been played out. In modern times, however, many masks are created specifically for sale. Some carvers are reproducing historic masks from photographs in books and catalogs of museum collections. If the mask is a reproduction of a specific piece, details of the original may be carved or inked into the reverse of the mask — or available anecdotally from the dealer.

Playwright/sculptor Jack Abraham is considered one of Alaska's chief revivers of the Eskimo mask. Abraham's work can be viewed in the permanent collections of the Anchorage Museum, the Alaska Native Medical Center, and aboard the state ferry *Tustumena.* Abraham actively passes the baton by teaching traditional toolmaking

and wood carving to high school students.

The beat goes on.

For in-depth information, consult *Eskimo Masks: Art and Ceremony* by Dorothy Jean Ray (University of Washington Press, 1967, 1975). Another excellent source is Ann Fienup-Riordan's *The Living Tradition of Yup'ik Masks* (1996). For illustrations of articulated masks, see *Native American Art in the Denver Art Museum* by Richard Conn (1979).

See also CARVING, FINGER MASKS, FRONTLETS/HEADDRESSES, HALO MASK, SOAPSTONE, TRANSFORMATION MASKS, WHALE BONE.

Teacher Alerts: Ancient Graffiti (Middlebury, VT, 802 388-2919) creates kits about the lives and art of ancient peoples. One of their kits deals with Mask-Making. Dover Publications publishes several books of punch-out, full-color Native American masks.

Consult the *The Cedar Plank Mask Activity Book* by Nan McNutt et al (Sasquatch), which introduces children to Northwest Coast Indians and their cultures.

Yvonne Merrill's *Hands on Alaska* (K/ITS, Salt Lake City,1996) offers directions for making masks, plus splendid full-color photographs of masks and other Native art in museums; Merrill is a longtime Alaskan. Kenneth DeRoux of Formline Designs in Juneau produces a mask kit.

Museums: Alutiiq Museum and Archaeological Repository (Kodiak); American Museum of Natural History (New York City); Anchorage Museum of History and Art; Denver Art Museum; University Museum, University of Pennsylvania (Philadelphia); Lowie Museum of Anthropology (University of California, Berkeley); Peabody Museum, Harvard University (MA); St. Joseph Museum (St. Joseph, Missouri); Yugtarvik Regional Museum.

The Sheldon Jackson Museum in Sitka has one of the finest collections of Eskimo masks in the world. Federal education agent (and missionary) Sheldon Jackson collected many of them between 1890 and 1900 at Andreafsky, King Island, Nushagak, Point Hope and St. Michael.

"Agayuliyararput: The Living Tradition of Yup'ik Masks," a major traveling exhibition of more than 120 masks, spent six months at the George Gustav Heye Center in NYC in 1997 and then rolled on to the National Museum of Natural History in Washington, D.C. Many of the masks in this exhibit were collected in the Bering Sea region of Alaska between 1877 and 1881 by an agent of the Smithsonian, Edward William Nelson. Ann Fienup-Riordan curated the exhibit.

Historic Practitioners: Chief Jim Charley (Nanaimo, f. 1870); Sam Fox (Yupik, d. 1983); Chief Mungo Martin (Kwakiutl, d. 1962); George Walkus (Kwakiutl); James Schoppert (Tlingit, d. 1992); Willie Seaweed (Kwakiutl).

Practitioners: Jack Abraham (Anchorage); Richard Andrews (Anchorage); Sylvester Ayek (King Island, masks of wood and ivory); Kathleen Carlo (Fairbanks; CIRI Collection); Nicholas Charles Sr. (Yup'ik Eskimo, Bethel); Frank Ellanna (King Island, walrus and raven masks); Susie Bevins Ericsen; James Grant St. (Fairbanks); Dave and Marilyn Hendren; Kay Hendrickson (Bethel); Allie High; Thomas R. Ignatin (Old Harbor, wood masks, wood hats, kayaks); Nathan Jackson; Adam John (cottonwood masks named after relatives); Leo Jacobs (Haines); Travis Johnson; John Kailukiak (Yupik); John Komakhuk (Eagle River); Reggie Komakhuk (Anchorage); Samuel L. Komakhuk (Anchorage); Charlie Komakukuk (Anchorage); Margaret Konukpeok (Fairbanks; masks, drums, baskets, dolls, mukluks); John Kusauyaq

> "Masks are an important part of ceremonial life; they make the supernatural world visible and bring it to life in dance dramas."
>
> — Gary Wyatt in the Introduction to *Spirit Faces: Contemporary Native American Masks from the Northwest* (Douglas & McIntyre, 1994).

(Bethel, owl masks and feathered dance wands; AKA Uncle John); Jerry Lakotonen (Alutiiq masks); Robert McMullen (Port Graham); Ron Manook; Wel Mulson; Olie Olrun (Bethel, masks in ivory and baleen); Carson Oozeva (Siberian Yupik, Gambell, whalebone masks decorated with polar bear fur and baleen); Carmen Quinto Plunkett (Tlingit, work in the collection of the Alaska Contemporary Art Bank); Anthony S. Pushruk (Palmer); Charlie Post (Tununak); Harvey Pootoogooluk (Shishmaref); Michael E. Scott (reproductions of historic masks); Jim Schoppert (Tlingit); Ralph N. Segock (Elim, hunter's mask); Joseph E. Senungetuk; John Sinnok (Shishmaref); Warren Sinnok (Shishmaref); Wayne Smallwood (Juneau); Elaine Smiloff (Aleut, Kodiak); Ishmael Smith (Mekoryuk, loon masks); Peter Luke Smith (Mekoryuk, masks with appendages); Michael Clark and Amy Nelson; Florence VonFintel (Wasilla, birch bark masks, baskets); Harry Wesley (Mekoryuk); George Williams (Mekoryuk, masks in ivory and baleen).

Sources: Alaska Fur Exchange (Anchorage, represents Florence VonFintel); Alaska Native Arts & Crafts Co-op (Anchorage); Alutiiq Museum (Kodiak); Boreal Traditions (within Captain Cook Hotel, Anchorage); Billikin Gift Shop (halfway between Anchor Point and Homer); Anchorage Museum of History and Art; Clarke & Clarke Tribal Arts (Seattle, WA.); Decker/Morris Gallery (Anchorage); Inuit Gallery of Vancouver; Norman's (Kodiak); Makah Museum (Neah Bay, WA.); One People (Anchorage); Sheraton Anchorage gift shop; Hilton gift shop (Anchorage); Ship Creek Center (within Ship Creek Hotel, Anchorage); SITE 250 Fine Art (Fairbanks); The Spirit Hunters (907 258-3440).

MASTODON IVORY

Mastodon ivory is a fossilized ivory from the tusks of the extinct mastodon or woolly mammoth. In Alaska, mammoth tusks and bones are unearthed in coal mines or other excavations with fair regularity. The estimated age of this material is 10 to twelve thousand years.

Other sources of fossilized ivory include walrus tusks. Fossilized ivory ranges in color from cream through buff and brown, to dark green, blue and even black. The discoloration results from the ivory's having been buried in frozen ground for many years. Modern scrimshanders and ivory carvers often work in this material.

See also FOSSIL IVORY.

Museums: F.E. Industrial Complex museum (Fairbanks); The Covered Bridge (Anchorage); University of Alaska Museum (Fairbanks).

Practitioners: Cha (Juneau); Keith Greba (Sitka).

Sources: Alaska State Museum gift shop (Juneau); Cha (Juneau); Portfolio Arts (Juneau); Snowshoe Fine Arts & Gifts (Tok); Timberline Creations (Anchor Point).

MATRUSHKA DOLL (RUSSIAN)

Nested boxes originated in China about 1000 AD and evolved into the nested folk art toys that are so popular today.

A matrushka, or "matryoshka," is a Russian "mother" doll, typically taking the form of five wooden dolls of descending size, nested one within the other. Some sources say that this variant on the nested box developed c. 1870. The mother is usually portrayed wearing ethnic dress — a lace headdress (or country kerchief) and a long embroidered gown. Variants show women holding portraits of Russian churches or, where the apron would logically appear, a medallion of a fairy tale or troika (horse-drawn sleigh) scene — or house cats alternated with birthday cakes. The "Samovar doll" shows each "mother" holding a different component of teatime — from the gleaming samovar to a pot of honey and a stack of blini.

The matrushka's painted surface may be varied with gold leaf or burnt wood accents. Average height of the largest doll is five inches. There are inexpensive versions of this doll, suitable as children's playthings. And there are expensive variants painted/lacquered with satiric portraits of Russian patriarchs, American presidents, and other public figures; these usually exceed the average height of the matrushka. Serial forms may portray the Beatles, the story of Pinocchio (with a different scene or character on each doll rather than a miniature of the previous scene), angels or saints. Specialty forms of the matrushka may be produced in sets not of five nesters, but of seven to 15.

Alaska's Russian heritage and closeness to Russia means that many Russia collectibles, particularly lacquer boxes, lacquer brooches, birchbark boxes, and amber jewelry, are common in this state's gift shops. Another Russian painted collectible to

watch for is the wooden egg on its own wooden stand — a *nouveau riche* version of the fabulous jeweled eggs Faberge´ created for the Czar. The wooden eggs are often patterned in complex geometrics after traditional Ukrainian Easter eggs or *pysanky.*

See also: LACQUERED BOXES.

Sources: Alexsandr Baranov Russian Gifts (Anchorage); Anchorage Museum of History and Art; Arctic Rose Galleries (Anchorage); Baranov Museum (Kodiak); Elaine S. Baker & Assoc. (Anchorage); Grizzly Gifts (Anchorage); Katherine The Great (Anchorage); Norman's (Kodiak); One People (Anchorage); The Russian American Co. (Sitka); Sheldon Jackson Museum (Sitka); Trapper Jack's (Anchorage).

MOOSE NUGGETS

Moose "nuggets" are the hard, dry, brown droppings of moose, excreted (depending on season and diet) in form rather like small kiwi fruit. Composed of recycled wood, they are excreted dozens at a time, forming clusters or "nests."

Easily spotted in spring before grass sprouts around them, these renewable resources are collected by Alaska craftspeople who don't mind stooping to their work. They are dried, shellacked, and then hot glued into kitsch forms including "moosletoe," earrings or comic Christmas tree ornaments, swizzle stick toppers, etc. Believe it or not, tens of thousands of moose nuggets are annually recycled in this fashion.

Insider Tip: In Talkeetna in July, sniff out the Moose Dropping Festival, which includes a Mountain Mother contest, a moose nugget drop and a nugget toss.

Nugget Spin-off: Fenton Woods of Wasilla has invented "The Original Poop Moose," a wooden critter that "releases" candy. Woods makes his moose in walnut or poplar.

Sources: Alaska Wild Berry Products (Homer); The Unlimited (Wasilla); Once in a Blue Moose (Anchorage). The majority of Alaskan gift shops carry one or more of these inexpensive gag gifts.

MUKLUKS

Once a perfect item of footwear is created, its design doesn't change much, as Barrow anthropologists Glenn Shehan and Anne Jensen proved recently when they dug up 300-year-old mukluks at Point Franklin.

Mukluks are knee-high boots worn in Native villages all over Alaska. They are worn in winter, and need to be both warm and water-resistant. Soles are usually cut from strong, stiff leather. For the legs, animal legs may be used — moose or caribou; it takes several caribou leg skins to make one mukluk leg. Vamps may be beaded with the beading appliqued on wool felt. Felt or wool with a gathering string usually tops the mukluk, to keep in warmth and keep out powder snow. Summer/breakup boots are shaped to the same pattern but often stitched from the tough skins of large fish such as halibut.

In aboriginal times, boots were worn with grass innersoles and/or woven grass socks. Traditional mukluks are fast being replaced by "breakup boots" (tall rubber boots) and other manufactured footwear.

For fancy dress occasions such as memorial potlatches and dance performances, "dancing boots" are right in style. The soles are usually moosehide, with uppers of sealskin or caribou, decorated with fur cuffs and beaded vamps and side panels.

Skinsewing Trivia: During World War II, Esther Norton sewed 17 parkys and 1,068 mukluks for the U.S. Army.

See also FISH SKIN.

Museums: Anchorage Museum of History and Art. In 1997, Robert and Margaret "Petey" Lathrop gave a collection of 109 pieces of traditional Inupiat clothing, mukluks and hunting equipment to the University of Alaska Museum in Fairbanks. The couple collected these things between 1950 and 1964 when living in Point Hope, Barrow and Kotzebue. Most of the objects are made of seal, caribou or walrus skin, hand-stitched with caribou back sinew. Mukluks range from beaded dancing slippers to utilitarian water boots. The trim on many of the mukluks and parkas has a distinct twist to it that is unique to Point Hope skin-sewing.

> "When I went to the Arctic, it did not matter if I had a proper bed, or slept on the ice, in the tents, or if I ate seal liver or whale heart ... I did not care if I had a bath, a shower, or washed in a tin basin with sea water. I was happy, words flowed from my pen like an avalanche.
> "I did the best drawings of my life sitting on a rock, the north wind blowing and the dogs howling."
> —Claire Fejes, *Cold Starry Night* (Epicenter Press, 1996)

Historic practitioner: Cecilia Amokan Chikigan (Alakanuk, d. 1993).

Practitioners (Athabascan-style moose hock boots, worn while snowshoeing): Al Jones and Maggie Brady (Kenai)

Practitioners (Eskimo-style): Margaret Cooke (Bethel; studied with Sophie Nicholai); Stella Davis (Shishmaref, mukluks for babies); Luci Eningowuk (Shishmaref, polar bear fur mukluks); Lisa Huffaker, Tanna's Mukluks, Fairbanks); Helen McNeil (Anchorage, parkys, hats, gloves, mittens); Cecilia A. Muktoyuk (Nome, sealskin slippers); Ida Ruth Nayokpuk (Shishmaref); Inez Nayokpuk (Shishmaref); Sheryl Nayokpuk (Shishmaref); Sophie Nicholai (Napaskiak); Esther Norton (b. 1913 in Selawik); Hannah Solomon (Athabascan, Fort Yukon); Marleita Wallace (Wrangell); Flora Weyiouanna (Shishmaref); Jane Young (Kiana).

Sources: Alaska Fur Factory (Anchorage); City Fur Fashion (Anchorage); Country Crossroads (Anchorage, C.A. Phillips, quilts, kuspuks, mukluks); Great Alaska Tourist Co. (Wasilla, Eskimo dolls wearing kuspuks and mukluks, trimmed with real fur and

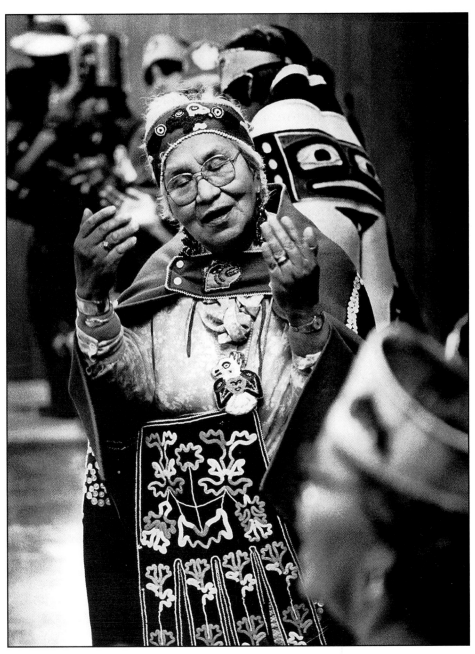

A Tlingit dancer wearing beaded headband, button blanket, silver bracelet and octopus bag loses herself in her performance.

101

leather or synthetic fur and leather); Kodiak Furs (Lenora Preston, Anchorage; fur coats, mukluks, hats and mittens); Shishmaref Tannery (slippers of either genuine harbor seal, ring seal or bearded seal with beaver trimming around the cuffs and a hand-beaded design on the vamp); Tanna's Mukluks (Fairbanks, 907 457-4833); The Trading Post, Inc. (Ketchikan, beaver moccasins).

NUNIVAK EYE

The "Nunivak eye" is a motif used in ivory carving. It consists of a dot within a circle, and is also called "the eye of awareness." Some sources explain this motif as a symbol of the ability of a shaman to see into other worlds or as a symbol of the oval or circular doorway through which he travels into another world. However, this motif can be seen on the handles of ivory spoons — unlikely shaman's equipment.

NUNIVAK TUSK

The "Nunivak tusk" was an innovation in ivory carving that first appeared in the 1920s among the carvers of Nunivak Island. Like the cribbage board, this carving used an entire walrus tusk. Seals and other sea mammals were carved in bas-relief or full relief, intertwined sinuously. Siberian Yup'ik carver Susie Silook has built on this tradition, creating "mobiles" of angel-like figures that are meant to hang from the ceiling.

Museums: Alaska State Museum (Juneau).

Practitioners: Judy Pelowook (Savoonga); Susie Silook (Anchorage and Gambell).

OCTOPUS BAG

The octopus bag is a decorative form of beadwork. Bags were worn over the shoulders with the pouch hanging ostentatiously in front; in an 1895 Winter and Pond photograph of Chilkats in dancing costume, one dancer sports two, one over each shoulder.

In *Northern Athapaskan Art: A Beadwork Tradition*, beadwork expert Kate C. Duncan defines the octopus bag as "a vertical firebag with tentacles or 'fingers' (usually four) extending below the pouch....A few rectangular firebags of hide with pointed tentacles separated by long fringes date as early as the mid seventeenth century."

(The firebag was a men's pouch of tanned moose or caribou skin once used to hold steel, flint and tinder, and later to hold ammunition for muzzle loaders. George T. Emmons wrote in his 1911 monograph on the Tahltan of the Upper Stikine River that it had "degenerated into a ceremonial appendage.")

In the Tlingit/Chilkat tradition of the late 1800s, the octopus bag apparently had no functional purpose but was worn on ceremonial occasions only. It was usually beaded on one side only.

The original form perhaps derived from a European shoulder bag, and this form

seems to have slowly drifted from tribes on the Atlantic Coast across the country to the Pacific and Northwest. Rectangular beaded bags are common to many Native American tribes. The outstanding difference in the octopus bag is the four "legs" at the bottom, the fabric for which is cut as one with the body of the bag. This form may have derived from Woodlands bandoleers trimmed with yarn tassels or Cree pouches with lavish fringe. The pouches were first trimmed with porcupine quill decoration in stiff geometric designs; the introduction of beads made it possible to abandon geometry for the relative freedom of expression found in swirling floral forms.

Materials include wool felt, lining (such as satin or calico), wool or cotton trim, and glass beads. Yarn is sometimes used for tassels.

Museums: National Museums of Canada; Anchorage Museum; Sheldon Jackson Museum (Sitka)

Historic practitioners: Martha Shields (Tlingit, d. 1990).

OIL SPILL SAMPLES

Crude oil sent through the 700-mile trans-Alaska pipeline has been sealed in glass tubes and used to ornament clock faces made from welded sections of leftover pipe.

Oil gathered from the *Exxon Valdez* supertanker spill of 1989 has also been recycled in various souvenirs. In December, 1997, for example, the Alaska Department of Environmental Conservation offered oil samples for $5 each, $7.50 for two, or three for $10, plus $5 shipping; with each oil sample came a certificate of authenticity.

See also: PIPELINE KITSCH.

Source: Alaska Resource Samples (Thorne Bay); DEC.

OKVIK CULTURE

Prehistoric Eskimo art is documented by several major stylistic transitions. One of these transitions is called the Okvik culture (300 B.C.), which flourished on St. Lawrence Island, the Punuk Islands and a handful of other locations in Siberia and Alaska. Typical of the Okvik period is an armless, legless doll of walrus ivory. The features are shadowed by a heavy brow ridge, while the body is incised with chevron-like ribs. Okvik doll faces may also show tattoos. (For illustrations of early dolls, see Dorothy Jean Ray's *Aleut and Eskimo Art*, p. 145.)

Some contemporary dollmakers, such as Susie Brown of Eek, are influenced by Okvik dolls.

See also ARTIFACTS.

ONE PERCENT FOR ART

Although neither an art form nor a material, the One Percent for Art program is defined here because of its importance in disseminating art among Alaska's populace and in encouraging and financially supporting artists. The program is the result of a

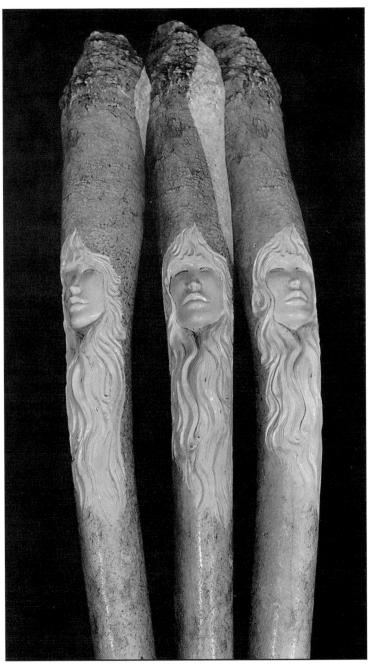

Triple exposure of an oosik (walrus penile bone), 24.5 inches long, carved by Cha, mounted on ebony, 1997.

1978 Alaska law that requires new public construction to devote 1 percent of the construction cost to the commissioning of permanent works of art for the structure. This means that structures as diverse as libraries and salmon hatcheries are adorned by tile murals, webs of strung beads, fiber garlands, murals executed in carpet, kinetic sculptures, etc.

In Anchorage, the 1 Percent for Art program is administered by the Anchorage Museum of History and Art. By 1997, 240 artworks had been commissioned for Municipal buildings and schools throughout the city. The value of those artworks is $4.4 million.

In Fairbanks, this program has spawned the like of "Teacher's Pet" (1996) at the Anne Wien Elementary School and "Arctic Lights" (1995) at the Arctic Light Elementary School — both by Marvin Oliver. Evon Zerbetz installed a piece at Fort Wainwright in 1998.

Washington state has a similar program for which Oliver has completed a dozen commissions.

OOSIK

"In the gallery we say oosiks are 'the center part of the business end of the male walrus's reproductive system' ... then you don't embarrass anyone, including yourself!"

— Carver Cha, letter to author, Nov. 28, 1997

Walrus penis bones, or oosiks, sturdy articles up to a yard long, became items of trade on King Island in the 1940s. Bored GIs stationed on the barren, rocky island suggested to resident Eskimo carvers that they carve animals heads on both ends of these bones, thus creating souvenirs.

When Barrow taco restaurant owner Fran Tate presented an oosik to talk show host Johnnie Carson on late night television a few years back, world appreciation of this conversation piece rose.

Practitioners: Cha (Juneau); Charlie Pardue creates custom knives upon request, using oosiks, whale bone, baleen, fossil and fresh ivories as handles. Contact him at Aatcha's Shop in Haines.

Sources: Alaskan Ivory Exchange (Anchorage); Cha For the Finest (Juneau).

OVOID

The ovoid — neither spherical nor rectangular — is a common one in Tlingit and Haida crests, carvings, paintings (whether on house fronts or box drums), blankets and totems. For a more extensive consideration of this subject, see Hilary Stewart's *Looking at Indian Art of the Northwest Coast* (Douglas & McIntyre, 1979).

Art historian Aldona Jonaitis subdivides the design elements of Northern Tlingit

Eustace Ziegler (1881-1969) poses in his Washington studio. From the collection of his daughters, Ann Ziegler Cohen and Elizabeth Ziegler Stark.

EUSTACE ZIEGLER

Because Eustace Ziegler's father was a minister as were three of his brothers, it is no wonder he first came to Alaska as a missionary.

Ziegler sailed North in 1909 to manage the Red Dragon, a social club established by the Episcopal Church as an alternative to the saloons in the booming railroad town of Cordova. His salary was $750 a year.

In the early 20s, Ziegler moved to Seattle to devote full time to his avocation, art. During the summers he often returned to Alaska, drifting down the Yukon River with fellow painter Ted Lambert, painting along the way. He soon became nationally known, with his works hanging on the walls of the White House during the tenures of presidents Harding and Hoover. By the time of his death in 1969, he had produced an average of a hundred paintings a year for nearly 70 years.

Among Ziegler's favorite subjects were Native women like Horse Creek Mary, miners, mountains, men playing cards, and horses.

One of Ziegler's first exhibits was at a Fairbanks radio station. Today his work is considered eminently collectable. Examples are on view at the Anchorage Museum of History and Art, the Z.J. Loussac Library and in the Morris Collection housed at the Juneau *Empire*.

art into three-dimensional style, two-dimensional style, formlines, eyelid lines, ovoids, U forms, split U forms, S forms, inverted V forms and V form eyebrows. For details of her analysis, see her *Art of the Northern Tlingit* (University of Washington Press, 1986).

For related information, see CHILKAT BLANKET, FORM LINE, TOTEM POLES.

PAINTING

"It's a form of magic designed as a mediator between the strange, hostile world and us, a way of seizing the power by giving form to our terrors as well as our desires."

— Pablo Picasso defines painting

"(Sydney Laurence's) success was a double-edged sword, for as one who drank deep from the cup of life, he also applied the same energy to drinking from the cup of the demon. The result was his later works show a recognizable diminishing of discipline."

—Art historian and appraiser Joe Crusey

Alaska's painters have been schooled all over the world and work in every imaginable medium. Some create abstracts. Others stick to subjects like snowy peaks and sled dogs, snowy owls and grizzlies, dancing Eskimos and flapping laundry. Occasionally an Alaskan painting winds up on a postage stamp — or a duck stamp. Many paintings, drawings and woodblock or linoleum prints are reproduced as greeting cards, holiday cards or postcards.

"Poppies and Peonies," 30 x 36 inches, oil on canvas, Susan Lindsey.

Independent and spirited, Alaska's painters sometimes work on very local "canvas," including conks (bracket fungus), gold pans, circular saw blades and birchbark.

In addition to resident painters, Alaska has been visited — and painted — by many famous artists including William Keith, Thomas Hill, James Everett Stuart, Theodore Richardson, Albert Bierstadt (1830-1902), Jules Dahlager (1884-1952),

Artists of All Alaska Juried Art Exhibition Series, 1976 to 1996, with 10 or more works accepted

Artist	Media	No. works/no. exhibitions	Awards: Juror's — Media — H. Mention	No. awarded media
Arend, Chris	ph	16 / 11	0-1-1	1
Austin, Pat	wc, pr, d,p	15 / 9	0-1-0	1
Bethel, Don	ph	13 / 7	0-0-1	1
Birdsall, Byron	wc, pr, p	12 /9	0-1-2	1
Bremner, Susan	pr,d,p	10 / 6	0-1-0	1
Bryner, Carol Crump	p, d	15 / 10	0-0-1	1
Buchanan, Garner G.	ph	10 / 4	0-1-0	1
Clapsaddle, C. Lee	mx, pr, d	10 / 4	0-1-3	2
Counsell, Steven, E.	d, wc	10 / 5	0-0-2	1
Cox, Jocelyn	pr, ph, mx,d, s	11 / 7	0-2-0	2
Decker, Don	ph, d, p, s	19 / 13	0-1-2	3
Doss, Catherine	pr, d, mx, s	14 / 7	1-1-2	3
Gray, Jane	d, pr, s	11 / 8	0-1-2	2
Guerin, Spence	wc, d, p, pr	20 / 10	1-3-4	4
Harrington, Sandra	d, mx	11 / 8	0-0-0	—
Kimura, Joan	f, d, p, sc	22 / 10	1-2-3	2
Kimura, Sam	ph	19 / 10	0-1-2	1
Kimura, William	pr, p	10 / 5	0-2-2	2
Kraft, Susan	p, wc	15 / 9	0-1-0	1
Marx, Gary	mx, s	10 / 4	0-3-2	2
Mishler, Clark	ph	10 / 6	0-1-0	1
Mollett, David	pr, p	10 / 7	0-2-0	1
Ogle, Susan	p, d	10* / 8	0-0-1	1
Patrick, Jeff	s, mx	10 / 5	1-0-0	1
Pfitzenmeier, Robert	j, s	10 / 8	1-0-0	1
Sabo, Bill	d, cl, wc, s	14 / 8	0-0-3	3
Seamster, Wanda	d, p, ph,mx, wc	17 / 9	0-2-2	2
Terzis, Jane	wc, p, mx	10* / 6	0-0-2	1

*Includes collaborative works

Media:

pr — print; p — painting; ph — photography; j — jewelry; s — sculpture; f — fibre (paper, cloth, basketry); wc — watercolor, aquarelle; cl — clay; d — drawing; mx — mixed media

Paul Lauritz (1889-1976), Cleveland S. Rockwell, Julius Ullmann, Walter Sykes, Wuanita Smith, William Selzer Rice, Jan Van Emple, the writer and mountaineer Belmore Browne and Rockwell Kent.

For additional information, read Kesler Woodward's *Painting in the North: Alaskan Art in the Anchorage Museum of History and Art* (Anchorage Museum Association, 1992). See also Woodward's *Sydney Laurence: Painter of the North* (Anchorage Museum, 1990), Ann Chandonnet's *"Ten Alaskan Artists: An In-Depth Look at Their Lives, Their Craft, and Their Works"* (*Anchorage Magazine* 1, no. 8), and Frank Stokes' *Arctic and Antarctic Paintings* (New York, 1925). Books about the art of Fred Machetanz and Byron Birdsall have been published, but are currently out of print. Two books are available about Rie Munoz, and one about Barbara Lavallee.

"Filtered Sunlight," watercolor landscape, 20x28 inches, c.1992, by Teresa Ascone.

See also ICONS, LITHOGRAPH, PRINT, WATERCOLOR.

Museums: Anchorage Museum of History and Art; Heritage Library and Museum (National Bank of Alaska, Anchorage); University of Alaska Museum (Fairbanks). The Frye Museum (Seattle) owns some of Eustace Ziegler's work, as does the Morris Museum in Georgia.

The Phoebe Apperson Hearst Museum (Berkeley, CA.) houses 36 paintings by artist H.W. Elliott, U.S. Treasury Agent on the Pribilof Islands in the 1870s.

For examples and valuations of paintings by Ziegler, Machetanz, Jon Van Zyle, Laurence, Van Emple, Heurlin and others, see "Alaskan Art Auction, October 9, 1997," the catalog of a sale held at the Anchorage Museum of History and Art by Pacific Galleries of Seattle.

Historic Practitioners: Nina Crumrine (1889-1959); Jules Dahlager (1884-1942); H.W. Elliott; Ellen Henne Goodale; Harvey Goodale; "Rusty" Heurlin (1895-1986); Theodore Roosevelt "Ted" Lambert (1905-60?); Sydney Mortimer Laurence (1865-1940); Josephine Crumrine Liddell; William Y. "Bill" Kimura (1920-91); Theodore Richardson (1855-1914); Howard Rock (born at Point Hope; 1911-1976; painter, linguist, editor); Eustace Ziegler (1881-1969). See Lael Morgan's *Art and Eskimo Power*, an insightful biography of Howard Rock.

"Veiled," 20 x 48 inches, acrylic, by Dan DeRoux, c. 1993. Based on the muse in Vermeer's "The Artist's Studio."

Insider Tips:

1) Look for easel-fresh oil paintings at many small, non-gallery exhibit spaces, such as Cafe Cups (Homer) and Quiverbean Coffee Co. (Anchorage). And consider innovative student art, as shown at the Campus Center gallery and the Kimura Gallery (both at UAA), and the Carr-Gottstein Gallery (Alaska Pacific University, Anchorage).

2) Murals are rare birds in Alaska, but one of the oldest is "The Resurrection," which features Resurrection Bay as its background. Located in St. Peter's Episcopal Church in Seward, it was painted in 1925 by Dutch artist Jan Van Emple, using local residents as models. To view the mural, ask for the key at the Chamber of Commerce Information Cache.

3) Decker/Morris Gallery represents more than 100 artists, including Dan DeRoux, Kes Woodward and Carol Crump Bryner. Opening receptions are held on the first Friday of each month from 5-7 p.m. Blues music and food are a given for these events — very popular with hungry college students.

4) Look for a mural by Rie Munoz at the Juneau Airport.

Trivia: Alvin Amason was chosen to create the artwork symbolic of the 1996 Governor's Award for the Arts. He created "Peeker," a sculptural depiction of a seal surfacing in the ocean. One of the recipients of this award was *Alaska Quarterly Review*, which showed "Peeker" on the cover of its 1997 issue "Intimate Voices, Ordinary Lives."

Practitioners: Among the best known are Alvin Amason (Aleut, Kodiak, who often

"The Pink Dog's Dream of Piedras Negras," 24 x 32 inches, alkyd, 1991, Mary Beth Michaels. From the series "Les Tres Riches Heures de la Chienne Rose: The Pink Dog Visits the Middle Ages."

makes "attachments" that stand out from his paintings; his works depict what he calls "Alaskan animals of the 20th century"); Keith Appel (Anchorage); Dot Bardarson (Seward); Richard Benson; Daniel E. DeRoux (Juneau; also collaborative work with Jane Terzis and Bill C. Ray); Claire Fejes (b. 1920; Fairbanks and California); Charles Gauze (Anchorage); Joan Kimura; Barbara Lavallee (Anchorage); Chuna McIntyre (Yupik Eskimo artist and dancer); Fred Machetanz (Palmer, grizzled prospectors, polar bears, Eskimo scenes); Mary Beth Michaels (Clear, pink dog series); Robbie Mohatt; Nancy Taylor Stonington; Ray Troll (Ketchikan, fish, fossils, T-shirts, etc.); and Jon Van Zyle (Eagle River, Iditarod scenes, scenes from Native life, wolves, caribou and children's books). Van Zyle's twin brother, Daniel, lives in Honolulu, but occasionally dabbles in Alaska subjects, illustrates Alaska books, and exhibits in Alaska. (See *Flight of the Golden Plover* by Debbie Miller.)

Painter Joan Kimura is an Abstract Expressionist, a style that surfaced in the 1950s and 1960s. This expressive style relies on bold, seemingly impulsive strokes of paint to create a feeling of freshness and immediacy.

For more on Nancy Taylor Stonington, see "Nancy Stonington, Watercolorist" by Amabel Poulson, *The Alaska Journal*, V, 1:32-40.

Landscape artists in Alaska include James Behlke, Leon Anderson, David Mollet,

Spence Guerin, Kesler Woodward, Mary VerHoef and Laurence Vienneau. During the summer, Behlke and Mollet travel into wilderness areas in remote parts of the Brooks Range and Noatak region. They camp out and sketch. Then, as did Sydney Laurence before them, they return to their studios to produce larger, finished paintings.

"When I paint, I am attempting to be a communicator. I want the viewer to see what struck me when I saw a particular element of a landscape--the light, color, texture or mood. Rocks are one of my favorite subjects. I like the way they fit together, the solidity and angularity; I like the feeling of massive strength and endurance they symbolize. I also like the idea that the Chugach Range is growing a fraction of an inch every year, and that slopes are gradually changed by earth-quakes, avalanches and our extreme weather."

--Teresa Ascone, *We're All Artists*

For more on the work of Carol Crump Bryner, Todd Sherman and Kenneth DeRoux, see *Beyond Description: Work by 3 Alaskan Artists*, edited by M.B. Michaels (Sky High Publishing, 1995). For information on the aesthetics of James Behlke, Claire Fejes, Marionette Stock, Scott Hansen, Robby Mohatt, Eloise Larson, Darleen Masiak, Bill Brody, David Mollett, Todd Sherman, Kesler Woodward and her own work, see Michaels' *Expressions: Art By Interior Alaskans* (Sky High, 1994).

Others Alaska painters include R. Ryan Anderson (Juneau); Saradell Ard; Jannah Atkins (Anchorage); Pat Austin (formerly of Anchorage, now of Port Townsend, WA.); Susan Bremner (abstract); Carol Crump Bryner (Anchorage, naturalistic); Shannon Cartwright (Talkeetna, also makes jewelry and illustrates books); Myong Christensen; Randall Compton (Fairbanks; Mt. McKinley); Dan DeRoux (Juneau); Anne Duffy (mixed media); Mindy Dwyer (Anchorage); Christine Fortner ("Pop-Icon type imagery" in watercolor and acrylic); Lee George (Seward; marine subjects on canvas; original oils, $500 to $3,000; prints start at $35); Katy Gilmore (Anchorage); Douglas Girard (Palmer); Kari Glass (landscapes, "Hale Bopp Over Susitna," "Wonder Lake" — in collaboration with Judith Hoersting); Mariano Gonzales, Jr.; Steve Gordon; Diana Hamar; Ron Hamilton (Nootka, house screens); Renate Hampke; Scott Hansen (prints and paintings); Teri Jo Hedman; Judith Hoersting (Anchorage); Ward Hulbert; Linde Kienle (mixed media); Brenda Kleinfelder (Petersburg, mixed media); Susan Lindsey (still lifes, oil); Gary Lyon (Homer); Marvin Mangus (b. 1924); Garry Mealor (Anchorage); Laura Myntti (Fairbanks); Nancy Taylor Stonington; Vonnie Gaither (acrylic); Jakki Kouffman; William Kimura; Armond Kirschbaum; Janaan Kitchen (Anchorage, batiks, oil and

"View from the Closet," 48x72 inches, oil on canvas, 1997, by Todd Sherman, part of his "dreams and nightmares" series.

acrylic paintings); Art Koeninger (Chitina); Don Kolstad; Jakki Kouffman; Linda Larsen (Sitka); Jean Lester (Ester); Susan O. McKittrick; Hugh McPeck (Seward, represented by Landau-Mintz Fine Art Gallery, Anchorage); Robby Mohatt; David Mollet (Fairbanks; Kuiu Island Artists' Project); Leslie Morgan (Ketchikan); Rie Munoz (Juneau); Laura Myntti ("Party Pictures and Other Continuations"); Gail Niebrugge (Glennallen); Michael Olson (Seward); Lyric Ozburn (Fairbanks); Davis Perkins (landscapes, smoke jumping scenes); Bill C. Ray; Halin de Repentigny; Joyce Reynolds (devil's club, represented by The Gallery); Linda Richardson (mixed media); Ernest Robertson (Sitka, oil on canvas, wilderness, McKinley); Catherine Rogers; David Rosenthal (oil on linen); Joseph E. Senungetuk (Anchorage); Ronald Senungetuk (Fairbanks); Todd Sherman ("dreams and nightmares" series); Bruce Shingledecker (Glacier Bay, exhibits in Cha's gallery, Juneau); Gill Smith (b. 1911; Haines); Mary Jean Sommer; Wassily Sommer; Marionette Donnell Stock; Jane Terzin (Juneau); Diana Tillion (Halibut Cove, octopus ink); Dennis Delay; John Pitcher (wildlife, animals in motion); David Rosenthal; Todd Sherman; Alfred Skondovitch (acrylic); Isaac Smith (oils); Alexandra Sonneborn; Karen Stomberg (paintings and drawings); Nancy Tetrault (Homer, "Cabin Fever"); Kara Thrasher; David Totten (Willow); Ed Tussey (acrylic); Mary VerHoef (acrylic); Larry

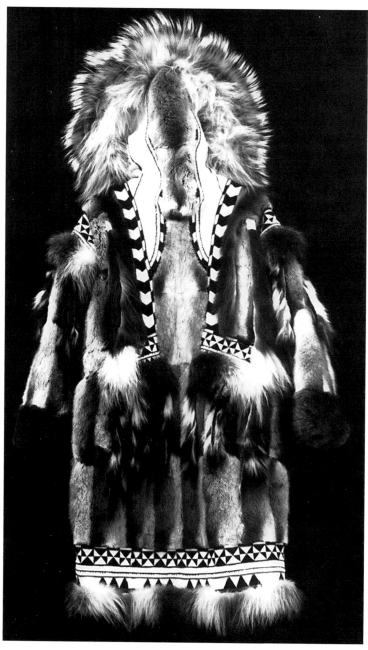

"Untitled Eskimo Parka," 147x99 cm, 86.6, muskrat bellies, wolverine, calfskin, beaver, wolf, felt, cloth and glass beads. Esther Norton, 1985-86. The traditional trim represents three mountains. Cook Inlet Region, Inc. Collection.

Vienneau (landscapes); Penny Wakefield (mixed media); Harold Nels Wallin (Anchorage); Leslie Waugh (oils); Stephen Whipple (oil, wax and dirt); Anne Williams (watercolor and mixed media); JoAnn Wold (Anchorage, watercolors); David Woodie (Juneau); Kesler Woodward (Fairbanks). Note: This list is necessarily incomplete.

Sources: Alaska Mystique (Juneau); Artique Ltd. (Anchorage); Bardarson Studios (Seward); Bunnell Street Gallery (Homer); Cafe Cups (Homer); Cafe del Mundo (Anchorage); Decker/Morris Gallery (Anchorage); Diana Tillion Studio and Gallery (Halibut Cove); Fireweed Gallery (Homer); Fjordland Studio (Seward); Gallery of Contemporary Art (Anchorage); Halibut Cove Artists (Halibut Cove); The Gallery (Palmer); Gallery of the Lakes; Gallery of the North (Juneau); House of Wood (Fairbanks); International Gallery of Contemporary Art (Anchorage); Kaladi Brothers Coffee Co. (Anchorage); Kolstad Gallery (Anchorage); Landau-Mintz Fine Art Gallery (Anchorage); Limner Press (Anchorage); New Horizons Gallery (Fairbanks); Northern Exposure Gallery & Frame Loft (Kodiak); Obeidi's (Anchorage; Machetanz, Doolittle, Ed Tussey, Randall Compton, etc.); Old Shanty Art Gallery (Dawson); Out North Contemporary Art House (Anchorage); Picture Alaska Gallery (Homer; archival photos a specialty); Portfolio Arts (Juneau); the "Q" Cafe (Anchorage); Rainbow Art (Anchorage); The Reluctant Fisherman gift shop (Cordova); Resurrect Art (Seward); The Sea Lion (Homer); Side Street Espresso (Anchorage); SITE 250 Fine Art (Fairbanks, David Mollet and nearly 100 others); Soho Coho Gallery (Ketchikan, Ray Troll and others); Stephan Fine Arts (Anchorage, represents Charles Gauze); Poppies Publishing (Ester); Toast Gallery (Anchorage); Town Square Art Gallery (Wasilla); Willow Wildlife Art Gallery (Willow); gift shop at Wrangell-St. Elias National Park and Preserve.

PARKY

A parky is a winter jacket with an attached hood trimmed with a fur ruff. The aboriginal parky pulls over the head and covers to the mid-thigh; the hood is very deep, especially in places like Barrow which experience ground blizzards. The body and sleeves were often sewn of caribou, ground squirrel or sealskin. Wolverine or wolf is used for the fur ruff. In Eskimo communities like Barrow, Kotzebue and Nome, the slim legs and formidable claws of the wolverine are used as decorations that depend from the shoulder onto the front of the parky. Front legs are used for men's parkys; back legs, which have longer fur, for women's parkys.

Contemporary fancy or dress parkys lean toward velvet, corduroy or velveteen on the outside, with a lining and trim of wolf, fox, rabbit or polar bear fur. They usually zip down the front. Everyday parkys may be lined with Thinsulate ™ or quilted fabric, with fur trim only around the hem, cuffs and hood. Modern hoods may be only half as deep as traditional North Slope hoods; they act more as photogenic frames for

the face than as protection from subzero wind — wind that can instantly freeze flesh.

Muskrat and hare are the least prized furs available, and commonly used for the parkys of children — who will outgrow them quickly. For Native Alaskan adults, especially beauty queens and village and corporation leaders, parkys may be sewn of sea otter. The most expensive parkys are sewn entirely of wolf or wolverine.

Making a fur parky is a labor intensive process that, traditionally, begins with the trapping of the animals whose fur is required. Then the pelts must be tanned. In times past, urine was saved and used for tanning. Today, some skin sewers swear by a slippery combo of sourdough starter and laundry soap. Others use mayonnaise, vegetable shortening like Crisco™, dishwashing liquid, salt and water. Repeatedly kneaded and handled over many days, home-tanned furs are softer and more resilient than furs commercially tanned with chemicals. Trim may include borders of an Outside material, such as light and dark calfskin chevrons or calfskin with village scenes inked onto it.

> "A traditional parky is a gift of love."
> — Sheila Ezelle, granddaughter of Laura Wright, in The Anchorage *Times,* March 8, 1992.

A traditional parky made by Clara Tiulana (b. at Ukivok, King Island, 1924) was presented to Pope John Paul II during his 1984 visit to Fairbanks to meet with President Ronald Reagan.

A parky made in 1985-86 by Esther Norton (Inupiat) combines muskrat, wolverine, calfskin, beaver, wolf, felt, cloth and beads. The trim represented three mountain peaks. This parky is part of the CIRI Collection at the Anchorage Museum of History and Art; the collection represents "the best of the contemporary artists and artisans of the Alaska Native Heritage."

Since a parky can take a year to make, most parkys today are created precisely as in times past: for family members only. To purchase an authentic native parky (or beaver mittens or beaver-and-marten hat), it may be necessary to lay the groundwork by calling a village corporation and then flying into the village in person. Stony River (185 miles northeast of Bethel, 245 miles northwest of Anchorage) is one such destination for birchbark baskets, moccasins, mukluks, beaver mittens and beaver-and-marten hats with earflaps that can be tied up on warm days. The village of Nightmute (510 miles west of Anchorage) is renowned for its fur garments and grass baskets.

Sometimes confused with the parky, the *kuspuk* is a summer jacket that pulls over the head or zips down the front. Originally this cloth garment was worn over a fur garment to keep it clean; now it has become a garment in its own right.

The collector may acquire an example of Native skin sewing without spending thousands on a full-size garment by purchasing a doll wearing authentically and lovingly constructed fur clothing. As a rule of thumb, the older the doll-maker, the bet-

ter the doll clothes.

For how-to information, see Anna Mae Osip's *Tanning Moosehide & Making Babish* (Circumpolar Press; 907 248-9921), a text written for the Tanana Chiefs Survival School. A more detailed, historical and circumpolar source is *Sinews of Survival: The Living Legacy of Inuit Clothing* by Betty Kobayashi Issenman (University of Washington Press, 1997).

See also DOLLS, FUR, MUKLUKS.

Insider Tip: An Eskimo thimble of walrus skin makes a unique, inexpensive and easily portable souvenir.

Insider Tip: Barbie doll kuspuks complete with genuine fur ruffs can be found at the University of Alaska Museum (Fairbanks).

Insider Tip: If you're in Fairbanks in March, take in the Winter Carnival, which includes snowshoe softball and a parky parade.

Museums: A 100-year-old ground squirrel skin parka hangs in the permanent collection of the Smithsonian (Washington, D.C.). The pelts were so expertly tanned that even the noses of the squirrels remain intact. For more garment glimpses, visit the Anchorage Museum of History and Art; Burke Museum (Seattle); Heritage Library and Museum (Anchorage); Heye Museum (NYC); Sheldon Jackson Museum (Sitka); University of Alaska Museum (Fairbanks).

Historic practitioners: Ah-Ka Lena Ahnangnatoguk (b. 1891 in Ikpik, hunter, midwife; d. 1992, Nome); Mabel Ramsey (Nome); Clara Yamane Tiulana (Inupiat, 1924-1997); Laura Wright.

Practitioners: Anna Anirl; Sheila Ezelle (granddaughter of Laura Wright); Elmer M. Jackson (Kiana, parkys, mukluks, mittens, caps, socks); Frances Johnson (Nome); Susan Malutin (Kodiak); Esther Norton (b. 1913, Selawik, later lived in Kotzebue); Anne Otten (St. Michael); Lillie Pauk (Monokotak); Mary Schaeffer; Jane N. Snyder (North Pole, *atiqluks* and parkys); Lena Sours (Inupiat); Sabrina Sykes (Juneau); Francesca Sutton (Togiak); Sarah Tocktoo (Shishmaref); Darlene Turner (Shishmaref); Maxine J. Ungott (Shaktoolik); Marleita Wallace (Wrangell); Suzanne Wardlow (Anchorage); Flora Wassillie (Togiak); Loulare Wassillie (Togiak); Elsie Weyiouanna (Shishmaref; parkas, mittens, mukluks, seal skin pants, fur socks); Flora Weyiouanna (Shishmaref); Shirley Weyiouanna (Shishmaref); Emma Willoya (Nome); Jane Young (Kiana; mittens, muskrat parkys, socks).

Practitioner (calico *kuspuk* with fur trim): Virginia M. Rowley (Anchorage).

Sources: Alaska Native Medical Center gift shop (Anchorage); Laura Wright Alaskan Parkys (Anchorage); David Green Furs (Anchorage).

PHOTOGRAPHS

The skill and developing expertise of master craftsmen like Ansel Adams have made photographs one of the best-known collectibles of the 20th century. The pho-

tograph has an appealing immediacy and typically retails for considerably less than original paintings of identical subjects.

However, photographers usually divide their craft into two parts: fine art and tourist. "Fine art" seems to be in the eye of the beholder. "Tourist" connotes items like portraits of ripe blueberries nestled in red leaves, confrontational bears peering over bracken, or posters of landscapes and spectacular scenery such as Mendenhall Glacier or Mount McKinley reflected in Wonder Lake.

Collectors of fine art photography should inquire about the "print run" of any purchase, just as collectors of prints do. Furthermore, photographs will probably not appreciate at rates similar to those at which original paintings would appreciate.

Teacher Alert: *Click! Fun with Photography* by Suzanna Price and Tim Stephens is available from Lark Books with a 35-mm focus-free camera, album and frame for $19.95. This beginner's manual covers the basics of photography plus projects like making panoramic pictures and greeting cards.

Insider Tip: Sighing with disappointment, photographers tell me that galleries often give pride of place to paintings and drawings; collectors may have to ask after art photography.

Some Alaska photographs are now available as screen savers. $1 for color catalog to Wilderness Inspirations, Box 190647, Anchorage 99519; or contact the web site at http://www.awimages.com. Todd Communications (Anchorage) carries screensavers by Leo and Dorothy Keeler.

Museums/Archival Collections: Alaska and Polar Regions Department, University of Alaska (Fairbanks); Alaska Historical Library (Juneau); Anchorage Museum of History and Art; Bancroft Library (Berkeley, CA); Hubbard Collection, Santa Clara University; Skagway City Museum; Special Collections, University of Washington Libraries (Seattle).

Historic practitioners: Samuel J. Call (Army Signal Corps); Edward S. Curtis; Arthur Eide (Point Barrow area); E. A. Hegg (Klondike Gold Rush); Orville Herning (Wasilla, Willow Creek mining district); Michio Hoshino (1952-1996, wildlife); Waldemar Jochelson (see *Jochelson's History*, 1933); Sydney Laurence; Lu Luston (Anchorage, d. 1993); Sam Kimura; John E. Thwaites; H.M. Wetherbee; Alwin Wheatley; Winter & Pond; Jasper N. Wyman.

New Source: A new book about the life and works of John Thwaites will be published in 1998. For details about *Seven Years on the SS Dora: 1905-1912*, contact the author, J. Pennelope Goforth of Ketchikan, jgoforth@ptialaska.net.

Practitioners: Brian K. Allen (Fairbanks); Hall Anderson (Ketchikan); Thomas S. Alvarez (Anchorage); Chris Arend (AKA James C. Arend, Anchorage); Robert Armstrong (Juneau, birds); Allen Bailley ("The Other Alaskan Landscape"); James Barker (scenes of village life); Ed Bovy (Anchorage); Eberhard Brunner (Anchorage); Garner H. Buchanan; Betty Clover (Anchorage); Roy Corral (Eagle River); Alissa

Crandall (Anchorage); Don Decker; Patrick Dixon (rubbings); Carmen Field (Antarctic blue ice photography); Danny Daniels (Anchorage); Mark Daughhetee; Laurent Dick; Fran Durner; L. J. Evans; Frank Flavin (Anchorage); Steve Gilroy (Talkeetna; custom photo tours); Ken Graham; Al Grillo (Anchorage); Rene Haag ("Generation X"); Bob Hallinen; George Herben (Anchorage); Bill Hess (whaling, the North Slope); Fred and Randi Hirschmann (Wasilla, land-

Photographer and author Bob Armstrong of Juneau, 1995.

scapes, mountains, bush planes, aerial views, glaciers); Kim Heacox (Inside Passage, glaciers, Tlingit regalia); Nick Jans (Ambler, Brooks range, wolves); Joyce Jennett (Anchorage, Girdwood); Karen Jettmar (Anchorage, Glacier Bay, Unalaska, rafting, canoeing); David Job (Juneau); Johnny Johnson (Anchorage); Susan Hackley Johnson (Anchorage); Wayne Johnson (wildlife and outdoor photography); Mark Kelley (Juneau); Lon E. Lauber (hunting); Jim Lavrakas; Ron Levy (Anchorage); Didier Lindsey (Anchorage, wildlife); Thomas D. Mangelsen (polar bears); Charles Mason (Fairbanks); David Moncrieff Massie (Anchorage; entered All Alaska Juried Art Exhibition, 90, 92, 96); Steve McCutcheon; Rick McIntyre; Clark James Mishler (Anchorage); Lin Mitchell (Palmer); Yvonne Mozee (Sitka, black and white); Rollie Ostermick (Trapper Creek; limited edition prints); Alan J. Parks ("The Lost and the Found," photographs of the sea); Chip Porter (Ketchikan); Jill Posener ("Louder Than Words" activist photography); David Predeger (Anchorage); Allen Prier; Alice Puster; Nancy Rabener; Myron Rosenberg (Anchorage); Todd Salat (former Arco geologist; has photographed in Australia and New Zealand; shoots northern lights, mountains, winter landscapes); Gary Schultz (Alaska Stock Images); Jeff Schultz; Wanda Seamster (Anchorage; also works in drawing, painting, mixed media, sculpture); Nancy Simmerman; Kevin Smith ("Altered Egos" with Chris Arends) Linda Smogor (Homer, "Everyday Angels"); Evan R. Steinhauser; Marion Stirrup (Kodiak); Greg A. Syverson (Dillingham; wildlife, auroras, underwater); Kennan Ward ("Grizzlies in the Wild," "Journeys with the Ice Bear," 800 729-5302); Myron Wright; Joe Upton (formerly of Alaska, now of Bainbridge Island, WA; Inside

Passage, fishing); Sharon Walleen; Harry M. Walker; Tom Walker (Denali National Park, wildlife, birds); Dennis Witmer (shopping carts); Art Wolfe; Myron Wright (Anchorage); Aleda Yourdon (Homer, "Angels in the Wings").

Sources: Alaska Homecrafters Outlet (Anchorage); Alaska Stock Images; Alaska Wild Images (Trapper Creek; catalog available); Artique Ltd. (Anchorage); Bristol Bay Photography (Dillingham); Carr-Gottstein Gallery (Alaska Pacific University, Anchorage); Decker/Morris Gallery (Anchorage); Dedman's Photos (Skagway, Gold Rush photos a specialty); Denali Graphics & Frame (Anchorage); Fireweed Gallery (Homer); Gallery 49 (Juneau); Greatland Graphics (Anchorage); Kaladi Brothers Coffee Co. (Anchorage, Tudor Drive and Brayton Drive locations); Kaye Dethridge (Sitka, antique photos); Kennan Ward Photography (800-729-5302); Myron Rosenberg Gallery (Anchorage); Out North Contemporary Art House (Anchorage); Mt. Juneau Artists (Juneau); Natural Wonders (Sears Mall, Anchorage); Nature's Window (Anchorage); New Horizons Gallery (Fairbanks); Out North Contemporary Art House (Anchorage); Picture Alaska Gallery (Homer; archival photos a specialty); Ptarmigan Arts (Homer); SITE 250 Fine Art (Fairbanks, represents James Barker); Snapshot Photography (Anchorage); Stephan Fine Arts (Anchorage); Walleen's Northlights Gallery (Anchorage).

Note: Many Alaskan photographers have produced books. Look for Fred Hirschmann's *Alaska and Portrait of Arizona,* George Herben's *Picture Journeys in Alaska's Wrangell-St. Elias,* Kim Heacox's *Alaska's Inside Passage,* Jeff Schultz' *Iditarod Silver* and others.

Insider Tip: Look for innovative photography at Anchorage's many small, impromptu exhibit spaces, such as Side Street Espresso. and Kaladi Brothers.

Referrals: Alaska Photographic Center, 907 345-5444. The Center sponsors the annual "Rarefied Light" show.

PIPELINE KITSCH

What does one do with leftover chunks of the 48-inch Trans-Alaska Pipeline? Your friendly neighborhood welder knows, because thousands of bits and pieces of that famous transportation facility turn up on gift shop shelves as durable kitsch.

Convex bits of steel have been cut into clock faces, magnets in the shape of the Alaska flag with star-shaped inlaid brass Big Dipper ($39.95 including S&H), or wall ornaments. Guaranteed never to wear out.

At the terminus of the 700-mile Pipeline lies the ice-free port of Valdez. The Valdez Museum store finds it desirable to stock desk weights as well as palm-sized cutouts of the state — both made from pipe.

Sources: Pipeline Gifts (Fairbanks; 888-248-5235; www.alaska.net/~bystedt. Color brochure available); Valdez Museum.

PORCUPINE QUILLS/QUILLWORK

Before beads were introduced to Alaska by traders, Athabascan Indians decorated clothing, knife sheaths and quivers with seeds, self-fringe, shells, and porcupine quills. The quills were dyed, flattened between the teeth, and woven ("plaited") into borders for tunic yokes and other leather surfaces. The effect is shiny, something like rows of raffia. Quills were also wrapped around fringes. Interior Athabascans were so expert at skin-sewing and quillwork that they were able to trade many of their dress garments to the Tlingit for valuable fish oil and other products of the sea.

Canada's Slavey and Dogrib Indians, who share many traditions with Alaska's Athabascans, also decorated with porcupine quills. In 1789, Alexander Mackenzie encountered a Canadian Indian encampment where some of the people were wearing tunics "embroider[ed] very neatly with Porcupine Quills & the Hair of the Moos Deer painted [colored] Red, Black, Yellow & White." Mackenzie thought the belts and garters of quills worn with the tunics "the neatest thing of the kind that ever I saw."

Geometric design worked in porcupine quills on leather, Athabascan, Western Canada, probably 19th century. Rendered by Paul E. Kennedy.

With Russians and other new arrivals coming into the country, glass seed beads in many different sizes were introduced as trade goods. Larger beads were quickly adopted for necklaces and ornaments for grass hats, while the smaller sizes were suitable for garment trim. Beads are less fragile than quills, and available in almost infinite colors. However, quills are nearly weightless, and extensive beadwork can add several pounds to a "fancy dance" outfit.

Few Alaskans hunt porcupine today, so most craftspeople who work with this unique natural material purchase the quills — eliminating the steps of harvesting and cleaning them.

Modern quillwork sometimes takes the form of strung lengths of quill, employed in the manner of tubular beads. Earrings, necklaces, pins and barrettes combining quill sections and glass seed beads are common.

For more information consult William C. Orchard's 1917 classic, *The Technique of Porcupine Quill Decoration Among the Indians of North America* (perfect bound

RIE MUNOZ

Rie Munoz was born in California and raised in both California and Holland. Her life changed in 1950 when she took a two-week vacation to Southeast Alaska.

Munoz lives today in Juneau, but she has traveled extensively throughout the state. From 1951-52, she lived on King Island (off Nome), where she taught 25 Eskimo children. Her experiences in small fishing villages and mining camps have given her a strong affection for down-to-earth scenes of boots drying by wood stoves, laundry flapping on the line, howling dogs, ferries arriving, children sledding, ice fishing, whale butchering, migrating birds and cannery slime lines.

As Sarah Eppenbach wrote in her Introduction to *Rie Munoz: Artist in Alaska* (1987), "She dazzles our eyes with color and fanciful shapes, all the while recording the Alaska she feels is 'disappearing very fast.' Crowded with authentic Alaskan figures such as Indian berry-pickers or Eskimo hunters; lively with caribou, whales, geese, and other northern creatures, Munoz's serigraphs and paintings are documentaries on a lifestyle that is undergoing dramatic flux."

Munoz works in watercolor. From her originals, some are chosen for limited-edition prints and posters reproduced by the offset lithograph process. Select works have been woven into tapestries in Aubusson, France, or worked up as stained glass panels or serigraphs. Her originals can be seen at her popular Juneau gallery and in the collection of the Alaska State Museum. She has illustrated several children's books, including Jean Rogers' *King Island Christmas* (1985) and *Kahtahah* (1996). She has exhibited at the Charles and Emma Frye Art Museum in Seattle and Art Expo New York.

edition available from Eagle's View Publishing). A newer source is Jean Heinbuch's *A Quillwork Companion: An Illustrated Guide to Techniques of Porcupine Quill Embroidery* (Eagle's View). Shirley Holmberg's techniques are described in Jan Steinbright's *From Skins, Trees, Quills and Beads: The Work of Nine Athabascans* (Institute of Alaska Native Arts, Fairbanks, 1984).

Note: Tiny boxes of birch bark or moose hide decorated with porcupine quills are typical of Canadian craft rather than Alaskan.

Teacher Alert: Lark Books offers both Heinbuch's book, *A Quillwork Companion,* and a kit for making a quilled pouch or "possibles bag." Lark is located at 50 College St., Asheville, N.C. 28801; 800 2848-3388.

Museums: Anchorage Museum of History and Art; State Museum (Juneau).

Practitioners: Almeria Christiansen (Old Harbor); Shirley Holmberg (Athabascan, Tanana, apprenticed with Lilly Pitka of Beaver); Vamori Kaufman (Palmer); Julia

"Close Encounters" (two wolves), 11.75x25 inches, pastel, 1994, by animalier Judi Rideout. Available as a print.

Peter; Rose Prince (Anchorage); Glenda L. Scott (Chugiak); Nancy Yaska (Fairbanks); Ruth Holland (Willow).

Sources: Black Elk Leather (Anchorage); University of Alaska Museum (Fairbanks, porcupine quill earrings); The Yankee Whaler (Anchorage).

PRINTS

A print is a reproduction of an original painting, etching or drawing. It is a graphic image produced by applying inked plates or blocks to paper or other material either by direct pressure or indirectly by offsetting an image onto an intermediate cylinder. Many prints are issued in limited editions, numbered consecutively, and signed by the artist. The smaller edition and the greater the fame of the artist, the greater will be the appreciation in value of any particular print — although, of course, quality of reproduction is significant, too.

A good percentage of Northwest Coast Indian artists execute their silk-screen prints in the traditional colors used on carvings, house fronts or totems: red alone; red and black; or red, black and green.

Printmaking among Alaska's Native artists was given a boost from 1964 to 1965, when the Manpower Development and Training Act supported their taking classes in basic drawing, drafting, sculpture, metal work, stone cutting and polishing and printmaking at the University of Alaska. Ronald Senungetuk administered the classes, and printmaking and silverwork, especially, "took." In the 1970s and '80s, the Visual Arts Center in Anchorage played a similar role.

Mill Pond Press has been publishing limited edition art prints by Fred Machetanz since 1978, in Machetanz' romantic "Heritage of Alaska Collection." Subjects include

SUSAN WOODWARD SPRINGER

"Fishman Dances in the Primordial Soup," 1995, a card adapted from an original linoleum block print, with pen-and-ink border, by Susan Woodward Springer, Seldovia. "Copyrabbit 1996."

"Born 1958 in New Jersey. Raised in Rockport, ME. Dropped out of college to go skiing — no formal art education. Seldovia resident together with my husband since 1985. Left a corporate career in 1989 to pursue art. Past sideline: Owner Crow Hill Bed and Breakfast. Present sideline: Commercial fishing — Kalgin Island in Cook Inlet." Currently, proprietor of Herring Bay Mercantile.

Creates postcards, notecards, greeting cards, Christmas cards, T-shirts, sweatshirts, aprons, totes, hand-rubbed linoleum block prints, rubber stamps, The Fisherman's Wife Collection of jewelry and handmade beads. "Sporadic forays into Woodworking and Decorated Bakeware."

"When not creating, I hike, ski, and write.

"About my work: There is so much to delight in and wonder at in the world — stuff that's absolutely free of charge. In Alaska, it's show-stopping scenery and wildlife, but there is potential everywhere if our pace is slow and our hearts are open: A tiny perfect flower bursting through a crack in the pavement, living and beating the odds; A dog with a very wise and knowing expression; A clean window with a bit of lace curtain and a geranium on its sill, putting on its best face to greet the passing world; Reflected clouds sailing across a puddle; A big joyful flock of birds, flying oblivious to earthbound care; I try hard to capture some of this delight and put it on paper. I think it might be what I was put here to do."

dog sleds on the trail, brown bears standing on their hind legs, traditional Eskimo life, Mt. Susitna, and polar bears. Titles include "Search on the Pressure Ice," "Regal Ruler," "Trail of the White Bear," "Rarin' To Go," "Fishing Rights" and "Across the Inlet." These prints are in signed and numbered editions of 950, plus artist's proofs and publisher's proofs.

Inexpensive reproductions in miniature of many noted Alaskan painters and photographers appear on blank greeting/correspondence cards and on Christmas cards.

Among those thus represented are Doug Lindstrand, Mark Kelley, Ernest Manewal, Scott Darsney, Jeff Schultz, Chad Carpenter, and Johnny Johnson.

"The Duckhunter": A watercolor by Sydney Laurence has been reproduced from the collection of Anchorage Mayor Zach Loussac by the Friends of the Z.J. Loussac Library. Priced at $30 (plus postage), the prints are available from The Friends or from Todd Communications, a company which also produces a Sydney Laurence calendar. The prints, in an edition of 1,000, are reproduced on archival quality, acid-free stock.

"Stations of the Raven IV: Following the Hunter," hand-colored linocut, Evon Zerbetz. Zerbetz makes all her prints originals by handcoloring the black design produced by her linocut.

See also DRAWINGS, LITHOGRAPHS, WATERCOLOR.

Insider Tip: For installations in non-gallery spaces in Anchorage, visit Great Harvest Bread Co, the Northway Mall (on the Payless side next to Baskin-Robbins) and Borders Books & Music.

Practitioners: Teresa Ascone (Anchorage), Robert Bateman; Byron Birdsall (Anchorage); Randall Compton (Fairbanks); Robert Davidson (Haida); Bill Devine (Anchorage); Beau Dick (Kwakiutl); Freda Diesing; Bev Doolittle; Cheri Govertsen Greer (Homer); Fred Machetanz (Palmer); Annette Hartzell; Tony Hunt (Kwakiutl,

Victoria, B.C.); Don Kolstad; Doug Lindstrand (distributed by Todd Co., Anchorage); Gerry Marks (Haida designs); Darlene Masiak (Fairbanks); Pat McGuire (Cordova, fish prints); Earl Muldoe ('Ksan); Rie Munoz (Juneau); Guitta Corey (Anchorage); Jacqui Ertischek (Anchorage); Judi Rideout (Palmer, specializes in wildlife such as wolves; represented by Artique Ltd.); Kathy Sams (intaglio etched and hand-pressed prints); John Seery-Lester; Bruce Shingledecker; Vernon Stephens ('Ksan style); Art Sterritt ('Ksan); John Svenson (Juneau); Nancy Taylor Stonington; Norman Tait (Nishga, Nass River); Nancy Tetrault (Homer); Ray Troll (Ketchikan); Ed Tussey; Jon Van Zyle (Eagle River); Clarence Wells (Coast Tsimshian); Don Yeomans (Haida designs).

> "Only a few can look the mountains straight in the eye and preserve their objectivity. Only a few can interpret the forms into lines and colors on a 16- by 20-inch piece of paper, so an image is produced that calls to mind a mountain landscape."
> — *American Artist* magazine describing the work of Byron Birdsall.

Practitioners (calligraphy): Jean F. Tousignant (Anchorage).

Practitioners (greeting cards): Byron Birdsall (Anchorage); Cheri Govertsen Greer (Homer); Barbara Lavallee (Anchorage); Tennys B. Owens (Anchorage); Wendy Shaft of Limner Press (Anchorage); Susan Springer (Seldovia); Evon Zerbetz (Ketchikan).

Sources: Accents West (Bozeman, MT); Alaska Mystique (Juneau; greeting cards); Alaska Wild Images (Trapper Creek, wildlife and wilderness cards, notecards, Christmas cards); Art Shop Gallery (Homer; Greenwich and Mill Pond dealer); Artique, Ltd. (Anchorage); Alaskan Portfolio (Anchorage, watercolor instruction book, palette, video); Aurora Lights Gallery (Anchorage); Bardarson Studio (Seward Boat Harbor, represents Birdsall, Lavallee, Dot Bardarson, Ed Tussey, and others); Bear Track Mercantile (Gustavus, AK); Bunnell Street Gallery (Homer); Cafe del Mundo (Anchorage); Celebration Books (Coeur d'Alene, ID); Cha (Juneau); Cheri Govertsen Greer Studio (Homer); Chilkat Art Co. (Anchorage; limited edition prints); Denali Graphics & Frame (Anchorage); Diamond Arts (Anchorage, aviation prints, Civil War and military prints, Maija prints, wildlife prints; search service for secondary market prints); Eluk Enterprises (Juneau; wholesale Alaskan greeting cards); Fathom Gallery (Cordova); The Greenwich Workshop Inc. (creates limited edition prints from original watercolors by Bev Doolittle); Heritage Art & Frames (Anchorage); Frame House Art Gallery (Anchorage, dealer for Greenwich Workshop, Hadley House, Apple Jack, Wild Wings, Somerset House, Mill Pond Press — Venice, FL; 800 533-0331); Herring Bay Mercantile (Seldovia); Kolstad Gallery (Anchorage); Limner Press (Anchorage); Northern Exposure Gallery &

Frame Loft (Kodiak); Northern Flight Gallery (Anchorage, duck stamp prints); Obeidi's Fine Art Gallery (Anchorage); Orca Book & Sound (Cordova); Ptarmigan Arts (Homer); Rie Munoz Gallery (Juneau); Laura Myntti (etchings); Quality Classics Sportswear (Troll's prints on T-shirts); Rainsong Gallery (Juneau); Scanlon Gallery (Ketchikan); The Sea Lion (Homer); SITE 250 Fine Art (Fairbanks); Soho Coho (Ketchikan); Stephan Fine Arts (Anchorage).

Insider Tip: Byron Birdsall is offering several of his Russian icon prints on Anchorage framer Jeremy Sefter's Perimeter Alaska Artists Online, an on-line art gallery and web site: http://www.akgallery.comn.

Spin-offs: Anchorage public television station KAKM offers a half-hour video about the art of Teresa Ascone. Teresa has also written her own book, *We're All Artists,* and patented her own palette.

Doolittle in Anchorage: When a new print by Bev Doolittle comes off the presses, Obeidi's quickly sells 700 of them in a city of 260,000. Doolittle is known for her camouflage technique in prints such as "Let My Spirit Soar," "Sacred Ground," "Two Indian Horses," "The Forest Has Eyes" and "Music in the Wind." This "fine art phenomenon" erupted onto the scene in 1979 with the publication of her first print, "Pintos," a tricky scene of spotted horses among spotted trees. She established a record for edition size with "Sacred Ground": 69,996 prints. Doolittle's first art story book, *The Earth is My Mother,* was published in 1998.

Sources (duck stamp prints): Alaska Art Exchange (Fairbanks); Northern Exposure Gallery & Frame Loft (Kodiak).

Classes: Nature artist Robert Bateman occasionally gives summer classes in drawing as part of Camp Denali's Special Emphasis Sessions. Call (907) 683-2290 for information or reservations.

QIVIUT

Qiviut is the Inuit word for the woolly undercoat or fleece of the musk ox, a shaggy northern member of the goat family. Lightly curled, a warm gray-brown in color, the fleece is softer than angora and easy to work with. It is knitted into beautiful articles of clothing sold around the world.

Alaska's natural herds of musk oxen were wiped out by 1850. The slaughter continued in Greenland and Canada, spurred on by the turn-of-the-century popularity of musk ox carriage robes.

Musk oxen were reintroduced to Alaska in the 1930 with 34 calves and yearlings from Denmark; these seed animals were placed on Nunivak Island and continue to thrive there. A small herd lives at a farm in Palmer, north of Anchorage, where they may be visited. Another herd lives at the experimental breeding station of the University of Alaska Fairbanks.

Eskimo women on Nunivak came upon tufts of qiviut (also spelled "qiveut")

A handler tempts young musk oxen out for a bit of winter exercise in Palmer.

caught on bushes. Following their long tradition of harvesting seasonal materials, they cleaned this promising new stuff, spun it into yarn and wove shawls. The new yarn proved to give several times as much warmth as sheep's wool; it was even finer, lighter and warmer than cashmere.

Musk oxen are very sensitive to heat. They shed their dense undercoat during the warm months, and it can be peeled off in sheets, or gently combed free. The fleece is processed into yarn in Boston, and then mailed to members of the Musk Ox Producers Cooperative or "Oomingmak" ("the bearded one"). Villagers knit the yarn into luxurious, weightless hats, sweaters, scarves, smoke rings, stoles, socks and mittens, all marketed at the Coop's store in Anchorage. Look for the tiny brown house with musk oxen painted by the door.

Insider Tip: For a donation of $50 to the Musk Ox Farm, you can have a musk ox named after yourself or a significant other. The Palmer farm is open daily, May to September.

Practitioners: Nellie Forbes (Wainwright); Margie Sparks (Tok); Elizabeth V. Spud (Anchorage); Colleen E. White (Palmer).

Sources: Oomingmak (Anchorage); Musk Ox Farm (Palmer); Qiveut Creations (located within Tundra Arts, Anchorage).

RATTLE

Carved wood rattles were used in shamans' ceremonies, during potlatch dances and to emphasize important points of oratory among the Tlingits and Tsimshian. Many were beautifully and intricately shaped, often in the form of a grouse, oyster catcher or raven. The sleek raven rattle form was used throughout the Pacific

Northwest by the close of the nineteenth century. The body of the rattle was in the form of a raven, with a reclining male figure (probably a shaman) on the bird's back. Sometimes the shaman's long, protruding tongue was joined to that of a frog or bird facing him — apparently a representation of the transference of spiritual power. The eyes were sometimes inlaid with trade beads, while the caving was often colored with black, red, blue and green pigments. The sound of the rattle indicated the presence of a supernatural being.

Rattles were occasionally made of mountain sheep horn. Vegetable fiber, babiche and/or wire served to lash them together. Shell, mirror glass and/or abalone were inlaid for increased dazzle. Rattles are as elegant as transformation masks or house posts — but less bulky to display. Few are being made today.

Before an auction of "Important American Indian Art" held October 26, 1979, at Sotheby Parke Bernet, a rattle of raven holding the sun in his beak was assigned an estimated value of $8,000 to $12,000.

For details about chief's rattles, shamans' rattles, and the protruding tongue motif, see Aldona Jonaitis' *Art of the Northern Tlingit.*

Museums: American Museum of Natural History (New York City); Denver Art Museum; Museum of Anthropology and Ethnography (Leningrad); Museum voor Landen Volkenkunde (Rotterdam); Royal Scottish Museum; Smithsonian Institution.

Practitioner: Joe Daird (Nootka).

Sources: Burke Museum gift shop (Seattle); Corrington's (Skagway); Isabel Miller Museum (Sitka).

RAVEN'S TAIL WEAVING

Raven's Tail is a type of Tlingit weaving, a variant on the form commonly known as the "Chilkat blanket." (The Chilkat are a people within the Tlingit linguistic group. They gave their name to an important trade route with Interior peoples, the Chilkoot Trail of Klondike Gold Rush fame.)

Raven's Tail alternates mountain goat wool and fur in the warp. From one side, the robe appears to be woven completely in white wool. From the other side, it seems to be twined of thick, dark fur. The "robe" or "blanket" was not bedding; it was a sign of wealth and prestige worn as a cape for dancing and ceremonies such as the potlatch.

Breathtaking in its intricacy, Raven's Tail weaving has only recently been revived by a handful of practitioners. A single robe (four by three feet) may require in excess of 800 hours of labor. For more information, see Cheryl Samuel's *The Chilkat Dancing Blanket* (University of British Columbia Press, 1987).

See also BLANKETS, CHILKAT BLANKET.

Practitioner: Irene Bieneck (Ketchikan, studied with Cheryl Samuel); Louise Clark (Ketchikan); Dee Southard (Ketchikan); Jeannette Tabor (Juneau); Marie Laws (Sitka).

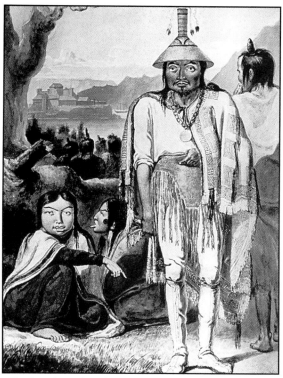

Chief Katlian, the Tlingit leader who led the last major battle against the Russians at Sitka in 1804. The Russians bombarded the Tlingits with cannon and ultimately won the battle. Katlian is wearing a Raven's Tail robe as well as a basketry hat hung with ermine skins. In the distance is Baranof's Castle.

REINDEER HORN

Reindeer horn is a material relatively new to Alaska's Inupiat people. Reindeer were introduced as a food source in northwestern Alaska between 1892 and 1902 by Sheldon Jackson, superintendent of education for Alaska. The total of 1,280 deer imported formed the basis for future herds, including those of the present day.

Reindeer ownership is restricted to Native Alaskans, and there are currently about a dozen herds on the Seward Peninsula, amounting to about 28,000 animals. The meat is sold to restaurants and sausage makers. Harvested in June, the antlers are ground and sold abroad, primarily in Asia, or used for carving.

The horn doll represents a distinctive craft that blossomed because of the introduction of reindeer horn as raw material. This charming little doll is made only in Shishmaref.

See also ANTLER/HORN, HORN DOLL.

Insider Tip: To sample reindeer stew or ribs, eat at the Downtown Deli (Anchorage).

Practitioners: Daniel Iyatunguk (Shishmaref); Florence Iyatunguk (Shishmaref); Bill Jones (Shishmaref).

Sources: Shishmaref Native Store, Nayokpuk General Store (Shishmaref); occasionally at shops in Anchorage.

ROOKERY

A rookery is a breeding place or colony of sea birds or marine mammals. In the past several decades, Alaskan ivory carvers have been recycling the bases of walrus tusks as bird rookeries, exposing the jagged, crystalline interior of the tusk as "rock."

Birds (murres, puffins, etc.) are carved separately and attached with glue. Penguins, of course, do not live in Alaska, and so do not appear on Inuit carvings.

In *Artists of the Tundra and the Sea* (1961), Dorothy Jean Ray calls the rookery "the most recent development in the conservation of ivory (by Eskimo carvers)."

See also IVORY.

Practitioner: George Mayac

Sources: Anchorage Museum of History and Art; NANA Museum of the Arctic (Kotzebue)

ROOTS

Basket weavers collect spruce feeder roots in the spring when the tree has time to generate replacement roots.

Rookery by George Mayac, walrus tusk ivory, 1976, 4 inches tall. Birds are puffins, cormorants, gulls, murres.

"When we get the roots, we cover the ground back up with moss, so there's no chance of the tree being unearthed by erosion," says Haida master weaver Delores Churchill. "I like to teach [students] to respect all living things...to be cognizant that we're the intruders."

Athabascan basketmakers collect willow roots.

See also BASKETS, SPRUCE ROOTS, WILLOW.

ROSE QUARTZ

Quartz is the commonest mineral on earth, silicon dioxide; it occurs in crystals, grains and masses. Violet-colored quartz is the semi-precious stone amethyst. Rose quartz is pink. Many colors of quartz are used in jewelry.

Sources: Alaska Shop (Seward); Pristine's (Fairbanks).

SCRIMSHAW

Also called "engraved ivory," scrimshaw is detailed etching or drawing on polished ivory surfaces. A design or vignette of daily life is incised into a whale tooth, whale bone or walrus tusk with a sharp object. Then India ink, soot or another coloring agent is forced into the lines drawn. When American sailors on whaling vessels coined the term around 1860, scrimshaw was originally black on white only; today full-color designs or portraits are all the rage — especially those mounted on fossilized sled runners or tools.

Seal scrimshaw on ivory with silver back and surround, and baleen bands, by Jean Byrne, 1981.

Marius Barbeau calls the art of scrimshaw "the only important indigenous folk art, except that of the Indians....Its practice was so widespread among the ships that it may be said to have been universal. In their spare time for a matter of seven or more decades, the better part of 20,000 whalemen, year in and year out, spent most of their leisure hours trying to fashion something beautiful."

Sailors used files to scrape off the ribs of their raw material, then a finer file, and finally sandpaper, sharkskin, ashes or pumice. The design was etched with a jack knife or any sharp, pointed instrument that came to hand, such as a sail needle set in a bone handle. Then India ink was rubbed into the design. Shell, silver and mother-of-pearl were sometimes inlaid into the ivory. The final polishing was done with the palm of the hand.

In addition to scenes of ships and whales or religious or patriotic tableaux, scrimshanders sometimes produced articulated pieces, such as toys with moving parts, guillotines and pie crust crimpers.

Today's scrimshaw is executed with dental tools; in the best pieces, the incisions can barely be felt with the fingernail or fingertip.

Practitioners also work on polymer cast in imitation of ivory and occasionally on baleen.

When I interviewed him in 1981, Inupiat carver George Mayac was working as a security officer at Prudhoe Bay; the two-weeks-on, two-weeks-off schedule suited his

MARVIN OLIVER

Marvin Oliver is one of the most versatile artists associated with Alaska. His work includes monumental sculpture installed in Seattle, Fairbanks, and Jackson, WY. He uses a variety of media ranging from cedar to bronze to enameled steel. His body of work includes serigraphs, cast glass, masks, wood panels--and a series of Pendleton blankets.

Oliver is of Quinault/Isleta-Pueblo heritage. He received a B.A. from San Francisco State University in 1970, and an MFA from the University of Washington in Seattle in 1973.

Among a wide range of assignments over the past 20 years, he has been an instructor of traditional Northwest Coast sculpture in Ketchikan, a folk arts project evaluator for the National Endowment for the Arts, and Board President (84-86) of the Institute of American Indian Arts in Sante Fe.

His works include the "Raven and Bear Pole" at Chautauqua Elementary School on Vashon Island (1995), "Eagle 'Bearing' Wealth" at North Seattle Community College (1995), "Arctic Lights" at Arctic Light Elementary School in Fairbanks (1995) and the bronze and wood sculpture "Salish Spindle Whorl" in Seattle (1986).

In the fall of 1997, Oliver was a professor of American Indian Studies at the University of Washington and also served as curator of contemporary Native American art at the Burke Museum of Natural History and Culture. In addition, he served as acting director of the American Indian Studies Center at the University of Washington.

lifestyle just fine, because during his two weeks off he could devote himself to ivory.

"At present I am doing scrimshaw," he told me. "This particular piece, one side of the tusk has sea scenes, with polar bears; and the other side covers land: a mountain ram, moose, wolves, bear, musk oxen. On the narrow side I will be putting some wild-fowl and some small animals like the fox. It is taking me a long time because I am making it for my own house....usually I have nothing to show when people come to my house, so I am making an example of my best work." Scrimshawing a walrus tusk typically required three or four weeks, full-time, Mayac said, "but I am taking longer on this one."

Carved or scrimshawed walrus ivory or other marine mammal parts fashioned into clothing or crafts may not be exported to a foreign country without a permit. Contact the U.S. Fish and Wildlife Service in Anchorage or Fairbanks for details.

For more information, see Ruth E. Tordoff's "Scrimshaw; Alaskan or Whaler Art,"

The Alaska Journal, II, 3; or Susan W. Fair's *Alaska Native Arts and Crafts* (1985). A book for both the craftsman and the collector is *All Hands Aboard Scrimshawing* by Marius Barbeau (1966, Peabody Museum).

See also BALEEN, BRACELETS, CRIBBAGE BOARDS, IVORY.

Museums: Anchorage Museum of History and Art; Corrington's (Skagway); Mystic Seaport Museum (Mystic, CT.); Peabody Museum (Salem, MA); University of Alaska Museum (Fairbanks).

Historic Practitioners: Homer Apatiki (Siberian Yupik, Gambell); Happy Jack; Peter Mayac (King Island, d. 1976, etching on sperm whale teeth); Andy Tingook (Nome; story bracelets).

> During the 17th and 18th centuries, secular ivory articles produced included parts for microscopes, terrestrial and celestial globes, snuff-boxes (prized by collectors like the dandy Beau Brummel), handles for swords and canes, fans, needle cases and gunpowder flasks.

Practitioners (on ivory and fossilized ivory): Alvin Aningayou (Siberian Yupik, St. Lawrence Island); Keith Greba (Sitka); George Mayac (King Island, b. 1939; brother of Teddy, Aloysius, Raymond, Joseph and George; son of Theresa and Peter); Frank Miller (Teller); George Milligrock (Siberian Yupik, Shishmaref); Harry A. Morgan Jr. (Anchorage); Mary Mueller (represented by Johannes Gems, Anchorage); Heidi Robinchaud (Gustavus). Bill Sidmore (Wasilla). Many artists who market scrimshaw in Alaska do not live in Alaska. In recent years, these have included Terry Nelson (b. NYC, 1950), Gary Dorning (b. Montana, 1957), Margie Myer, Jean Byrne, Michael Cohen, Kurt Sperry, and Kelly Mulford (b. Seattle, 1949).

Sources: Alaska Ivory Exchange (Anchorage); Anchorage Museum of History and Art; Cha's (Juneau, catalog available); Chilkat Art Company (Anchorage); Corrington's (Skagway); Gambell ivory carvers' cooperative; Johannes Gems (Anchorage); Savoonga Native Store; Ivory House (Anchorage); Ivory Broker (Anchorage); Alaska Native Arts & Crafts (Anchorage).

SCULPTURE

"You can carve a chicken. A sculpture is a carved thing that has meaning."
— Jacques Regat, Alaskan Art & Writing number of *Northward Journal*, 1981.

Sculpture as free-standing art objects is a foreign concept to Native Alaskans. Their "sculpture" was more utilitarian; it epitomized wealth and told stories (totem poles), provided light and heat (pecked stone lamps) or held up the roof (house posts).

Modern carvers, however, understand the demand for art objects, and many work in a variety of media. Gertrude Svarny sculpts in ivory, bone, baleen and soapstone.

She may combine mediums within one work; for example, she may carve a soapstone basketweaver, and place in the weaver's hands an Aleut grass basket under construction. Some of her sculptures are part of the permanent collection of the Anchorage Museum of History and Art.

Aleut artist Fred J. Anderson, born in Naknek, in 1949, works in marble. One of his most famous pieces, "Native Craft," which is available for display in public buildings through the Alaska Contemporary Art Bank, combines wood, stone, leather, fur and bird feet.

James Schoppert is considered to be one of Alaska's most influential contemporary Native artists. He is well-known for sculpted panels based on Northwest Coast design, masks and works on paper. The Alaska State Museum (Juneau) held a retrospective exhibition of his work, June 1 to Oct. 11, 1997.

Alex Duff Combs, born in Kentucky in 1919, studied at Temple University, the Tyler School of Art, the Accademia de Belle Arti (Florence) and with Victor D'Amico at the Museum of Modern Art. He has lived in Alaska since 1955; he works in oil on canvas but is best known as a ceramist and sculptor.

"Flight out of body into the tunnel of light," Susie Bevins. CIRI Collection.

John Hoover's imaginative wooden sculptures, which combine aspects of masks and triptychs, may be seen in Anchorage at both the Egan Convention Center and the new (1997) Alaska Native Medical Center.

Award-winning artist Kitty Cantrell creates small preliminary models called maquettes before she tackles her full-size bronze castings through the lost wax process. Her life-size eagle, "Windwalker," combines bronze, pewter, and 24-karat gold vermeil finished in hot-torched acid patinas. "Windwalker" (58" without pedestal) comes in a certified limited edition of 150. Maquettes (11.5 inches) are also available in a limited edition of 1,250.

Work in this art form can take a wide variety of appearances. A show of contemporary art from the collection of the Anchorage Museum of History and Art, "Divergent Vistas" (April 24-Sept. 15, 1997), included paintings and sculptures. Sculptures were by Ken Gray, Jeff Patrick, Ted Gardeline, Robert Pfitzenmeier, David Edlefsen, Gary Marx and Christine Dragella. The press release for the show

said, "These works cannot be simply classified. Societal, spiritual, geographic and physical concerns are some of the many issues introduced, using found objects, industrial materials and other non-traditional materials not usually associated with sculpture."

For more information, see *Eskimo Sculpture* (Circumpolar Press, Anchorage).

Alaska Alive: Artist Suzanne Bach (Creative Design Studio, Anchorage) periodically gives lessons in sculpture to children six and older.

Historic Practitioners: Melvin Olanna.

Wood carving, "Bullseye," 48 inches diameter, 3 inches thick, ash, by Bob Espen. Private collection.

Practitioners: Frederick John "Fred" Anderson, Keith Appel (b. Minnesota, 1934); Jannah Atkins (Anchorage); Sylvester Ayek, Lawrence Ahvakana; Suzanne Bach (Creative Design Studio, Anchorage); James Bachman (Anchorage); Susie Bevins (Anchorage); Buz Blum (Palmer; also works in jewelry); Kitty Cantrell (see above); Mark A. Chihuly (Ninilchik); Susan E. Chihuly (Ninilchik); Alex Duff Combs, Gerald C. Conaway; T. Mike Croskrey (b. 1957, former auto body worker, work inspired by traditional form-lines); Wendy Croskrey (b. 1960, multi-media); Don Decker (Anchorage gallery owner; also works in photography, painting, sculpture); Christine Dragella; David Edlefsen; Ted Gardeline; Andy Goldworthy (Fairbanks; creates outdoor sculptures from natural materials); Ken Gray; Diane Hendrix; John Hoover (Grapeview, WA); Bill Kanerva (Wasilla, functional art and metal sculpture from wrought iron); Eloise Larson (multi-media constructions and monotypes; "Enquiring Minds Want to Know" construction series); Keren Lowell; Gary Marx (often entered All Alaska Juried Art Exhibition Series); Jeff McMillan (mixed media; represented in Alaska Contemporary Art Bank); Robert Meaghar (Anchorage); Brenda Milan (Anchorage); Marilyn Miller ("Support Systems," clay sculptures chronicling her experience with breast cancer); Lynn Marie Naden (Homer); Jeffrey Patrick (Anchorage); John S. Penatac; Robert Pfitzenmeier (Girdwood, also works in jewelry); Bill Prokopioff (Aleut, steel and alabaster; look for his "Char String" at the Anchorage Museum); Bill Sabo (multi-media, multi-dimensional, interactive works; exhibits at Side Street

"The Break of Day," 1984, basswood, galvanized steel, copper, brass, pigment, Kathleen Carlo. CIRI Collection.

Espresso); Michael Schaas (mixed media; represented in Alaska Contemporary Art Bank); Jim Schoppert; Gertrude Svarny (Unalaska); Leo Vait (Homer).; Sheila Wyne (mixed media, "Sands of Time," "The Hester Series").

See also ALABASTER, BRONZE, CARVING, SOAPSTONE.

Sources: Alaska Shop (Seward; jade, Legends, pewter, Genesis); Angler's Retreat (Ninilchik); The Artworks (Campus Center, Fairbanks); Aurora Fine Art (Anchorage); Boreal Traditions (Anchorage); Bunnell Street Gallery (Homer); Carr-Gottstein Gallery (Alaska Pacific University, Anchorage); Creative Metal Design Studio (Wasilla); Decker/Morris Gallery (Anchorage); Dockside (Ketchikan); Halibut Cove Artists (Halibut Cove); International Gallery of Contemporary Art (Anchorage); Jewelry Art Treasures, Linda Colleen Murphy (Skagway); Lynch & Kennedy (Skagway); Resurrection Bay Galerie (Seward); Scanlon Gallery (Ketchikan); Sculptors' Gallery (lobby of Anchorage Hilton); Side Street Espresso (Anchorage); SITE 250 Fine Art (Fairbanks); Starbird Studio (Seward); Stephan Fine Arts (Anchorage); Toast Gallery (Anchorage); Town Square Art Gallery (Wasilla); Walleen's Northlight Gallery & Gifts (Anchorage); Wildlife Art & Frame Shop (North Pole).

SEA LION WHISKERS

The long, flexible whiskers of Steller's sea lion were traditionally used as protru-

sions from the tops of Tlingit dancing headdresses and from the backs of Aleut bent-wood hats. The whiskers wave like willow boughs with the slightest movement or breeze.

A sea lion has only four whiskers, so a profusion of these rarities atop a hunter's hat showed his proficiency as a hunter.

Because of restrictions in the Marine Mammals Protection Act, man-made whiskers are substituted by contemporary artists.

Reproductions of sea lion teeth: Mike Warner (Anchorage).

Reproductions of Aleut hats with whiskers attached: Rich LaValle (Portland, OR).

SEALSKIN

This luminous, often spotted plush material is regularly used as slipper vamps, sometimes with beadwork on felt applique´d over the top. Scraps of this precious material are used to dress Eskimo dolls and to create beaded Christmas tree ornaments. On rare occasions one sees a sealskin parky.

At Point Hope, seal skins are sewn into a blanket with rope handles around the edge, and the blanket is used for the famous Eskimo blanket toss. (On St. Lawrence Island, such blankets are made of walrus skin.)

Non-Natives are forbidden to hunt seals.

See also FUR, MUKLUKS, PARKY.

Historical Practitioners: The Nome Skin Sewers Cooperative Association, formally organized in 1939.

Practitioners: Lisa Borchgrevink (Soldotna); Carl D. Calugan (Valdez); Mary Eshak (Anchorage); Angie Garner (Juneau, sealskin wallets); Aquilina Bourdukofsky (St. Paul, Pribilof Islands; Pribilof Stewardship Program); Maggie Irrigoo (gloves, purses, booties); Cecilia A. Muktoyuk (Nome, sealskin slippers).

Sources: Alaska Native Arts and Crafts Coop (Anchorage); Alaska Native Medical Center gift shop (Anchorage); Shishmaref Cottage Crafts Project (c/o Shishmaref Tannery, hand-beaded seal slippers).

SILVER

Alaska contains significant silver deposits, but Alaska's indigenous peoples did not mine silver before the coming of Westerners. (They did, however, mine copper, which they hammered into jewelry, ceremonial coppers, and additions for frontlets and amulets.) Tlingit carvers admired the shiny silver dollars introduced in the early 1800s by traders, prospectors and tourists, and quickly learned how to hammer the coins into stock and shape them into spoons, bracelets and other jewelry. The decorative engraving patterns for these pieces were usually transferred directly from the form lines and ovoids of traditional totems, house posts, painted house fronts and grease bowls.

The engraving of silver is thought to have been introduced to Tlingit craftsmen at Sitka by the Russians in about 1800. In addition to silver bracelets, pins and ornaments for themselves, the Tlingits produced cane handles, napkin rings and jewelry for trade.

Some modern artists working in silver also work in pewter.

For more complete information, consult Nancy Harris' essay "Reflections on Northwest Coast Silver" in Bill Holm's *The Box of Daylight.*

Insider Tip: Collectors of limited edition Alaskan silver medals (1960 Festival of Music, Emperor Hirohito 1971, Earthquake, Pope and President Visit Fairbanks 1984, Captain James Cook, Fairbanks Eskimo Olympics, Anchorage National Baseball champs, Seward Silver Salmon Derby, Valdez F.O.E. Aerie 1972, etc.), should consult Kaye Dethridge (Sitka).

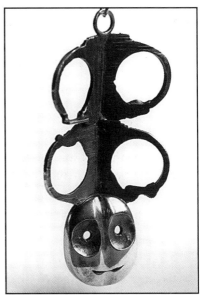

Insider Tip: Several silver jewelry makers often show at the annual Crafts Weekend, the three days immediately following Thanksgiving, at the Anchorage Museum of History and Art.

Silver pendant, 3.25 inches x 1.75 inches, by Ron Senungetuk, 1983. Private collection.

See also FORM LINES, JEWELRY, CARE OF MATERIALS.

Teacher Alert: Ancient Graffiti (Middlebury, VT) produces kits inspired by ancient peoples around the world. One of their kits deals with Sterling Silver Jewelry.

Museums: Museum of Anthropology, University of British Columbia. The collection includes a silver bracelet by Charles Edenshaw.

Historic practitioners: Charles Edenshaw (Haida; great-grandfather of Robert Davidson of Masset, b. 1946).

Practitioners: Robert Aaronem (bronze); Johnnie Avatock (Haines); Rick Booth (Ketchikan); Kitty Cantrell (sculptures in blends of precious metals, Lynch & Kennedy, Skagway; Dockside, Ketchikan); Shannon Cartwright (Talkeetna, also makes jewelry and illustrates children's books for Paws IV); Cha (Juneau, Eskimo angels); John Cross (Haida); Tara Davies (Kake); Pete Esquiro (Sitka); George Estrella (Juneau); Sue Folletti (Haines, also works in gold); Judie Gumm (Fairbanks; featured on the QVC televised shopping channel in May, 1997); Greg Horner (Haines); Ed James (Sitka); Barbara A. Kruk-Seamount (Chugiak); Lisa McCormick (Kodiak, silver jewelry); Frank Meisler; Louis Minard (Tlingit, Sitka); Jo Pedersen

(silver jewelry); Bill Reid (Haida); Jan L. See (Sitka); Ronald Senungetuk (Fairbanks); Glen C. Simpson (potlatch spoon in sterling, ebony and walnut); Amos Wallace; Frank Wrenn; Kathy Kato Yates (Klawock).

Frank Meisler has carried out major international commissions. His original works have been given as gifts from Israel's Prime Ministers and Presidents to Heads of State and world leaders.

Sources: Elaine S. Baker (Anchorage; represents Robert Aaronem as well as glass-blown sculpture by Elio Raffaeli); Cha (Juneau); International Gallery of Contemporary Art (Anchorage); Lone Wolf Gifts (Chugiak); Alaska Knife (Anchorage); Frank Meisler Gallery (Ketchikan, miniature sculptures in bronze, silver and gold); The Kachemak Goldsmith (Homer); Goldsmith Galleries (Sitka, silver charms); Mt. Juneau Trading Post (Juneau); New Horizons (Fairbanks); North Wind Fine Gifts (Homer); William's Antiques (Anchorage).

Sources (coins): Loose Change Coin Co. (Anchorage); Roy Brown Coins & Collectibles (Anchorage); Alaska Mint (Anchorage); Carl's Jewelers & Gifts (Anchorage); Odyssey Stamps & Coins (Anchorage); Sitka National Historical Park; Southeast Alaska Indian Cultural Center (Sitka).

SINEW

Sinew is a thread prepared from the tendons of caribou, moose or beluga whales. It is stripped and twisted into lengths for sewing. Sewing with sinew is the only method that guarantees waterproof seams in indigenous Northern clothing. The most finicky seamstresses and dollmakers still use it, although many skin sewers have switched to waxed dental floss or to faux sinew.

See also FUR, GUT, PARKY.

Reproduction: Black Elk Leather (Anchorage).

SOAPSTONE

"If you're hunting Alaska's gift shops for Native-motif carvings, you might see soapstone pieces by Chupac, Eddy Lyngoc or Ronald Komok.

"Native art? Not really.

"Chupak is a Cambodian. Lyngoc is a name used by Vietnamese artist Ngoc Ly. Ron Komok is a Native carver who sold the rights to his name to Ly's Seattle carving studio ... Selling non-Native art as Native work is deceptive trade practice, which is overseen by the Federal Trade Commission ... When shopping for authentic Native crafts, ask lots of questions."

— "Bali, Alaska," by Bruce Melzer, *Anchorage Daily News*, Dec. 10, 1995

One of the earliest known uses of soapstone by Eskimos was during Dorset times; Dorset sites in Baffinland (northern Canada) from the second millennium BC show

the introduction of small stone lamps and with them cup-sized pots of soapstone, grooved for suspension over the lamps and probably used for cooking.

In contemporary Alaska, soapstone is worked into small carvings, typically sea mammals, animals or birds. A curio cabinet of soapstone will set the collector back much less than a cabinet of ivory; a soapstone loon, for example, might cost only $25, while an ivory bird will run $100 and up.

Soapstone is softer than ivory or jade and thus considerably easier to work. The smooth, lustrous surface of a finished carving has a slightly soapy feel, and requires waxing or oiling to preserve its texture and appearance. Many kinds of soapstone occur in natural deposits in Alaska, but most of the blanks for carving are quarried in the Pacific Northwest and Canada.

Soapstone is most commonly dark green, but also occurs in brown, dark orange,

> "The greatest difference in (Alaska) Native art can be seen in the use of materials traditional to our people. Just about everything we use is either protected, endangered, soon to be extinct or illegal. This makes for a highly unusual situation, and one that may be unique in the world, for we are a people stymied from practicing art traditions developed over the centuries because of the enactment of concern by others far removed from our ancestral ways."
>
> "Between the Rock and the Walrus," contemporary Tlingit artist Jim Schoppert, writing in *Wood, Ivory and Bone* (1981).

light gray and tan. Many chunks of stone are mottled with several colors, and the crafty carver may use the varying hues to set off specific sections of his carving. Model kayaks are being produced in soapstone, sometimes with fittings of sinew, intestine, wood, baleen and/or ivory. Dancers may wear masks and hold dance fans, feathers or drums. Hunters may wear slitted snow goggles of contrasting material.

In the past decade, masks in soapstone have become common. In addition to a life-size central face, miniature masks may be attached to concentric willow hoops; the whole assemblage, a kind of miniature universe, is considered a "mask," although it is danced with rather than intended for wear over the dancer's face.

See also ALABASTER, MASKS, SINEW.

Practitioners: Rolin Allison (North Pole); Fred Anderson; Sylvester Ayek; Dale Hanson (Sitka; soapstone bears and loons; ivory and whale bone grizzlies); Kululak Ituluk (Lake Harbour, Baffin Island, Canada); John Komakhuk (Eagle River); Simon Koonook (Haines); Robert Koezuna (Nome); Roger Kunayak; Clara M. Mattice (Anchorage); Susan O. McKittrick; Edith Oktoolik; Frank Sinka Prince (Seward).; Benedict Snowball (Anchorage); Glenn Tootkayolok (spirit masks combining wood, ivory and soapstone).

Sources: Alaska Native Arts & Crafts Coop (Anchorage); Alaska Shop (Seward); Alaskan Ivory Exchange (Anchorage); Alaskan Ivory Outlet (Anchorage); Anchorage Museum of History and Art gift shop; Arctic Art (Anchorage); Arctic Images (Whitehorse, Yukon Territory); Aurora Fine Art Gallery (Anchorage); Birch Tree Gift Shop (Fairbanks); Boreal Traditions (Anchorage); Chilkat Art Co. (Anchorage); Civic Center Gallery (Fairbanks); Fire & Ice Alaskan Gold Design & Gallery (Seward); Inua, Spirit of Alaska (Homer); Northern Trading Post (Yellowknife); Scanlon Gallery (Ketchikan); Stewart's Photo Shop (Anchorage).

SOUL CATCHER

Shaped like a miniature "flute," the soul catcher is a shaman's tool of carved bone or ivory, sometimes inlaid with abalone shell. The soul catcher was applied to the skin of patients and used to "suck out" demons causing ill health. It is rarely made today.

Source: (soul catcher ring): Rusty Harpoon.

SPRUCE ROOTS

Three kinds of spruce are available to Alaska's Athabascans and Tlingits: the white *(Picea glauca)*, the black *(Picea mariana)* and the Sitka *(Picea sitchensis)*. Their roots were used as a renewable resource.

Traditionally, a mature, thriving spruce tree was chosen as a source for roots; only a limited portion of its roots were harvested, so the tree would not be killed. Roots were dug from any one tree only once every three years. Furthermore, this harvesting was carried out in spring so that each tree would have the rest of the growing season to replace its removed roots.

As with all Native baskets, considerable labor goes into the preparation and curing of the raw materials. As the roots are pried and coaxed from the forest duff, care is taken not to break them. Next, the slippery roots are coiled. As soon as the gatherers return home, they must peel off the bark before the sap hardens. To loosen the bark, the roots are roasted over a fire. The stripped coils then cure for the rest of the summer.

When a basketmaker is ready to weave, she softens a coil of roots in water. Then the roots are split to the proper size with a thumb nail aided by a blue mussel shell knife.

This tough arboreal "string" was used to lash rims to birchbark baskets, to tie together rafts of logs and for weaving dip nets, work hats and ceremonial hats.

A great variety of spruce root baskets were made, each with a different purpose. There were berrying baskets, baskets to store a shaman's bird down, finger puppets, soul catchers and other paraphernalia, "stone cups" (cooking baskets, so called because the method of cooking involved adding heated stones to the food and

water), children's eating dishes, flat spoon bags (cases hung on the wall to store goat's-horn eating spoons), water buckets, babies' cradles and tobacco pouches. Sizes varied considerably, from 25-gallon oil storage baskets to small snuff boxes worn pendant around the neck. Flat baskets, today called "trays" or "plaques," were used for winnowing inedible leaves and twigs out of berries. ("Plaque" is also used to refer to wall hangings sewn of felt and fur.)

Roots were not the only parts of the spruce that Northwest peoples harvested. Among the Bella Coola, the cambium layer of the bark of spruce was processed with skunk cabbage to make a bread-like food.

For additional information, consult Frances Paul's seminal *Spruce Root Basketry of the Alaska Tlingit* (*Indian Handcrafts*, no. 8, Department of the Interior, Bureau of Indian Affairs, 1944) or Sue Devine's "Spruce Root Hats of the Tlingit, Haida and Tsimsian," *American Indian Basketry Magazine*, no. 6, 1982.

The trunk of the spruce was valued for dugout canoes that could handle journeys on the swells of open ocean as well as along the sheltered stretches of the Inside Passage. A tall, sound tree, straight and free of limbs for much of its length, was a valuable gift from the forest to the Tlingits. Sarah Eppenbach, writing in *Southeast Alaska* (Graphic Arts Center Pub. Co., 1988), beautifully documents the ceremony deemed appropriate to the sacrificing of such a tree, when she recounts the concern of 90-year-old George Dalton Sr. of Hoonah, about speaking properly to the tree before it was cut down. If an explanation of its sacrifice was not given in the proper manner, the canoe carved from the tree might split.

In his native tongue, Dalton spoke to the canoe tree thus, "We are going to hurt you. We are going to cut you with sharp instruments because we are going to man- ufacture an object for survival. We are doing this for a good use, for a noble effect."

Slowly Dalton walked four times around the tree, making his way laboriously with his cane about the daunting circumference of its root mass. As great roots blocked his way, his sons tried to dissuade him from this difficult pilgrimage. But he pressed on, slowly, until the charm was properly wound up. Now the canoe would be reli- able.

See also BARK, BASKETS, ROOTS, WILLOW ROOT.

Trivia: The West Coast Auction house of Butterfield & Butterfield recently sold a painted spruce root hat from the first half of the 19th century for $112,500, a world auction record. The hat was decorated with beads, dentalia and sea lion whiskers.

Museums: Anchorage Museum of History and Art; Burke Museum; Makah Museum (WA.); Smithsonian.

Historic Practitioners: Isabella Edenshaw (Haida); Selina Peratrovich.

Practitioner: Delores Churchill (Haida, Ketchikan); Tri Roskar (Sitka).

Sources: Alaska Native Arts & Crafts Coop (Anchorage); Saxman; Sheldon Jackson Museum (Sitka).

STAR OF ALASKA™

Star of Alaska™ is a naturally occurring metallic mineral which seems to resemble the state flag. Gem Shapes Designs manufactures this original copyrighted gem stone — a cobalt blue with golden pyrites. Look for the GSI stamp on all authentic Star of Alaska jewelry.

Source: Gem Shapes Designs (Juneau).

STONE LITHOGRAPHS

Noted Anchorage artist Byron Birdsall describes stone lithography as "slow, laborious and exhilarating." He relishes the process so much that he has completed more than 50 stone lithographs in the past decade.

The process requires a series of limestone slabs. Each color is drawn separately on its own slab, and the drawings are superimposed on a single sheet of paper. Six or seven superimposed images/colors may be used.

Tlingit artist James Schoppert (b. 1947) received instruction in stone lithography at the Instituto de Allende, San Miguel de Allende, Mexico. His work is represented in collections at the Anchorage Museum of History and Art; Heard Museum: Newark Museum; Calista Corporation; Cook Inlet Region, Inc.; Rainier Corporation (Seattle); Burlington Northern Company (Seattle); and Delta Corporation (Anchorage). Schoppert's commissioned art includes Seattle Arts Commission (1986); Alaska Mutual Bank (Bellevue, WA.); Yukon Baha'i Institute (Carcross, Canada); and Kenai Community College (Soldotna, AK).

See also LITHOGRAPHS, PRINTS.

Practitioners: Byron Birdsall (Anchorage); Guitta Corey (Anchorage); Fred Machetanz (Palmer); R. James Schoppert.

Museums: Anchorage Museum of History and Art.

Sources: Artique Ltd. (Anchorage); New Horizons (Fairbanks); Rain Song Gallery (Juneau); R.T. Wallen Gallery (Juneau); Solstice Press (Anchorage).

TOTEM POLES

"... the totem poles are doing the work intended. They draw the people."
— Alaska Governor John Brady, writing to his son Hugh from the St. Louis Exposition, June, 1904

In 1778, British explorer Captain James Cook became one of the first Westerners to enter a Pacific Northwest Coast post and beam house and write about it. He was particularly struck by the carved house posts: "These are nothing more than trunks of very large trees...set up singly, or by pairs, at the upper end of the apartment, with the front carved into a human face; the arms and hands cut out upon the sides, and variously painted; so that the whole was a truly monstrous figure.

The tradition of massive, functional house posts with carved reliefs eventually moved outdoors to decorative carvings that didn't support roofs and walls, but stood alone. We call these totems.

John Bartlett, a sailor trading in the Queen Charlottes in 1791, described a plank house with frontal post: "The entrance was cut out of a large tree and carved all the way up and down. The door was made like a man's head and the passage into the house was between his teeth."

Totem poles are massive red cedar trunks that have been felled, stripped of bark and carved with totems (or crests) of the Tlingit or Tsimshian kinship groups: frog, beaver, wolf, grizzly bear and killer whale. Other images used on totems include glaciers, caves, thunderbirds, ravens, flying frogs, the cannibal bird Huxwhukw, plants, insects (especially the pesky mosquito), starfish, sun, moon, stars and rainbow, the

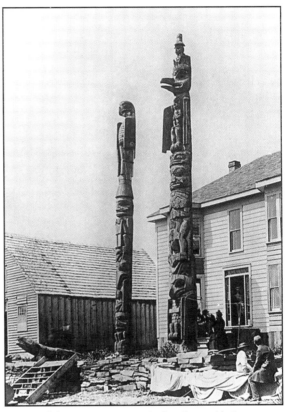

Turn of the century totems in Southeast Alaska.

wood worm of legend and half human/half animal creatures. Some totems are topped by a man in a split spruce root basket hat; this is the watchman.

Totems were brightly colored. Traditionally totems were painted in red, black, green, white and yellow. Red came from the mineral ochre, powdered and mixed with oily salmon eggs. Black came from graphite, charcoal or lignite.

Totem pole carving was traditionally undertaken only by men, and often by men hired from neighboring villages or peoples. Poles demonstrated the resources of the person able to commission one. They also passed on Tlingit culture and history in the same way stained glass windows passed on Bible stories to medieval European congregations.

As Tlingit master carver Nathan Jackson wrote of totems for *Alaska Geographic* magazine, "In the olden days, the poles would reflect different stories relating to a

particular clan. Since there was no written language, it was a way to remind the Elders to tell the young people about their heritage by what the totem poles meant. Some were stories of heroism and morals, and then some were about unpaid debts. Usually the tallest poles would show rank and nobility, and so in the olden days when a canoe full of people would come to a village, they would know which house to go to first."

Totems are carved from one straight old-growth red cedar, preferably one with few knots. Occasionally slabs hewn from a second cedar were attached for projections: the wings of eagle or thunderbird, the spine of a sculpin, the beak of raven, multiple rays

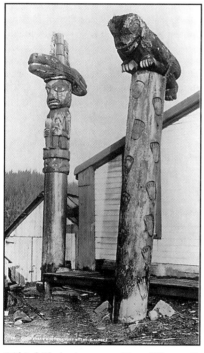

"Chief Shakes' totems, Fort Wrangell, Alaska." Photo by Winter and Pond.

of a sun mask or the dorsal fin of killer whale. If the totem served as a clan house portal (rather than a free-standing feature of the house), raven's beak might be as much as nine feet long, dropping down to form a ramp, an impressive ceremonial entrance into the multi-family dwelling.

Outside Alaska, but culturally and geo-graphically contiguous, the Kwakiutl, Nuu-chah-nulth and Coast Salish people of British Columbia also carved totems.

The purpose of a totem was to demon-strate wealth, social position and prestige. Chiefs or skillful traders who could afford to own totems did not carve themselves, but usually hired craftsmen — sometimes from a neighboring tribe. Totems were raised to cel-ebrate marriages, to mark deaths of notable persons, or at the succession of a new chief. The raising of a totem generally went hand in hand with a potlatch. Feasting and displaying of wealth in the form of masks, stories, songs, dances, and other heirlooms were all aspects of the potlatch.

A truly lavish feast required enough food that the guests could take home left-overs.

A large pole might require a year of labor from a single carver. In damp Southeast Alaska conditions, the average life of a pole was 60 to 80 years.

The peak of the totem pole tradition came at the close of the 19th century when trading with newcomers gave Southeast people greater disposable wealth. However, soon the depredations of disease and the call of boomtowns and schools caused many Tlingit villages to be abandoned; their splendid totems were carried off by museums

or looters or left to rot. The banning of the potlatch by the Canadian government in 1884 also did its part to suppress ancient traditions as well as the occasions for dance regalia, masks and totems. For more information, see Norman Bancroft-Hunt's *People of the Totem: The Indians of the Pacific Northwest* (University of Oklahoma Press, 1988). See also Edward Keithahn's *Monuments in Cedar* (Superior Publishing Company, 1973), and *The Wolf and the Raven: Totem Poles of Southeast Alaska* by Viola Garfield and Linn Forrest (University of Washington Press, 1956). And let's not forget *Out of the Silence* by photographer Adelaide DeMenil and carver Bill Reid.

The efforts of Governor John C. Brady to transport intact totems and Tlingit plank houses to the Alaska Pavilion of the St. Louis Exposition in1904 generated considerable public interest while simultaneously laying a stronger foundation for the notion that Native culture might be something worth preserving. Partially as a result of Brady's outreach, in 1939 the Civilian Conservation Corps was put to work in Sitka replicating decaying totems from the19th century.

In the past decade there has been a Southeast Alaska renaissance in the art of totem carving. In 1996, for example, a 35-foot totem was carved by Wayne Price, Tommy Joseph and Will Burkhart — the first traditional totem raised by the Sitka Tlingits in more than a century.

Collectors, however, should beware of totems carved in Taiwan.

Good manners requires that observers should not lean against, sit on or climb totems, or in any way alter their surfaces.

See also ARGILLITE, CEDAR.

Alaska Live: The craft of totem carving is on the upswing. Active totem workshops may be visited at Haines, Sitka, and Saxman. Festive totem raisings sometimes occur in Southeast villages, as well as on the grounds of public buildings as far north as Anchorage.

Alaska Live: Next to the Juneau cruise ship dock is Native Artists Market, where a different group of artists and craftsmen is hosted very week. The market is large enough that 20-foot cedar logs can be carved as you watch.

Teacher Alert: Yvonne Merrill's colorful and inspiring children's book *Hands on Alaska* offers directions for making a paper totem pole.

Museums/displays: Canadian Museum of Civilization; Captain Bartlett Inn (Fairbanks); various indoor and outdoor locations in Saxman, Ketchikan, Wrangell, Sitka and Haines; atrium of Anchorage Museum of History and Art; Southwest Museum (Pasadena, CA); Yorkshire Sculpture Park (England); Seattle Center (Seattle, WA); Muks-kum-ol housing group (Terrace, British Columbia); Native Learning Centre (University of British Columbia); Stanley Park (Vancouver); Maclean-Hunter Building (Toronto, Ontario); PepsiCo International Sculpture Park (Purchase, NY); Bushy Park (London). An Eagle totem and a Raven totem carved by

Lee Wallace were erected outside the new Anchorage Court House in April 1997.

Historic Practitioners: Thle-da, carver of the "Lincoln Totem."

Practitioners: Warren Alby (Haida); Will Burkhart; Walter Harris (Tsimshian); Nathan Jackson (Tlingit, Saxman/Ketchikan). Jackson received a 1996 National Heritage Fellowship award, presented by First Lady Hillary Clinton at the White House.

Additional practitioners include Dempsy Bob (Tsimshian); David Boxley (Tsimshian, Metlakatla); Joe David (Nuu-chah-nulth); Robert Davidson (Haida totem pole carver, print maker and sculptor); J. Darald Dewitt (Ketchikan); Freda Diesing (Haida); Wayne Hewson (Tsimshian, Metlakatla; creates dance regalia, masks, totems); Tony Hunt, Richard Hunt and Calvin Hunt (Kwakiutl); Henry Hunt (Kwakiutl, son-in-law of Chief Mungo Martin); Tommy Joseph; James Sewid (Kwakiutl, Alert Bay); Israel Shotridge (Ketchikan); Norman Tait (Tsimshian); Art Thompson (Nuu-chah-nulth); Wayne Price; Bill Reid (Haida, Vancouver); Lee Wallace (Ketchikan); David Williams (Hoonah). Totems in excess of seven feet are generally carved only on commission, and priced by the foot.

Sources: Alaska General Store (Anchorage and Juneau); Native Artists Market (next to Naa Kahidi Theater, Juneau); Southeast Alaska Indian Cultural Center (Sitka). The work of Nathan Jackson is available at the Beaver Clan House in Saxman, the only clan house built in Alaska in the last 50 years. Saxman is located two miles south of Ketchikan.

Sources (miniatures/models): Alaska Wild Berry Products (Homer); Grizzly Gifts (Anchorage), Trapper Jack's (Anchorage).

Insider Tip: A Haines web site (http://www.akgallery.com) offers Tlingit totem poles at $1,500 per foot, as well as links to sites that sell Alaska Native art, from mukluks to ivory and bone carvings. Web master at this site is Leigh Horner.

Referrals: Alaskan Indian Arts (Haines); Chilkat Valley Arts (Sue Folletti, Haines); Inside Passage Artisans (Haines); One Percent for Art Program, Alaska State Council on the Arts (Anchorage); Sea Wolf Gallery (Haines); Southeast Alaska Indian Cultural Center (Sitka); Tlingit and Haida Indian Tribes of Anchorage.

Note: Miniature totems can be resin reproductions molded in Hong Kong. Check labels carefully.

TRADE BEADS

Trade beads are spheres of glass with a central piercing that makes them suitable for stringing or sewing. No matter what country they have been traded in, most were made in Italy and central Europe.

Trade beads came to Alaska with explorers such as the French, British and Russians and traders such as the Hudson Bay Company. Large blue glass beads are often called "Russian trade beads," and considered excellent collectibles. However, some of the

same beads (the Cornaline d'Aleppo, for instance) that were traded a century ago are being replicated today; it's hard to tell the difference without microscopic examination for signs of wear.

The subject of trade beads is a complex one, and those wishing to know more about it should consult experts in the field. Novices might begin by reading Lael Morgan's "Trade Beads: Alaskan Native Heritage" *(Alaska Journal,* III, 4) or Michael Jenkins' "Trade Beads in Alaska" *(Alaska Journal,* II, 3).

Some modern craftspeople use combinations of trade beads to make original pieces of jewelry. Such items are carried by Artique Ltd. (Anchorage).

Insider Tip: Trade beads that have been dug up will be dull colored on the outside, like "beach glass."

Source: Ann's Tiques (Sitka); Kaye Dethridge (Sitka).

TRANSFORMATION MASKS

Transformation masks were created by the Nootka, Tlingit and other Indian artists of Southeast Alaska and the neighboring Pacific Northwest. (The Yoruba of Africa created them, too.) Intended for theatrics at potlatches, they are articulated masks, capable of puppet-like movement. For example, when its "sides" are shut, a Nootka mask resembles the crest face of a wolf. When the mask is splayed open, the face of the sun is revealed, crowned by a tiara of wooden feather-rays.

Often an animal or bird mask — such as a heron or sculpin — shows its human-appearing spirit when it opens.

> "I see a lot of my work as my personal statement of where I'm from. It's my intent to disclose to other people what I feel is important about my culture."
> — Joseph Senungetuk,
> *Northward Journal, 1981*

For example, when closed, a Kwakiutl mask (c. 1870) in the collection of the Denver Art Museum is an eagle with strongly hooked beak. But when four hinged flaps swing aside, the action dramatizes the metamorphosis of the eagle to human form. Four separate beaks on another mask in that collection, a Hamatsa mask, clack open and shut fiercely to emphasize the voracious nature of the familiars of the cannibal spirit.

The mask would be worn by a dancer whose dance would change as his secret aspect or alternate being was revealed by his mask. The moveable parts of the mask were controlled by strings.

These large and complex masks may contain up to 40 pieces of carved and painted red and yellow cedar, plus cloth, canvas, and cedar withes; they are rarely made today.

See also MASKS.

Museums: Burke Museum (Seattle); Makah Museum (Olympic Peninsula, WA.)
Historic practitioners: Mungo Martin (Kwakiutl, f. 1920).
Source: Makah Museum (WA.).
Reproductions: Rich LaValle (Portland, OR; by commission only).

ULUS

The ulu is a crescent-shaped knife used by Eskimo women. Yupik girls were given their first ulus when they went out to gather beach grass for baskets for the first time.

Traditionally blades were made of slate and other materials that could take an edge, with handles of wood, bone or ivory. Large ulus were used for skinning seals and cutting meat and fish; smaller ones, in skin-sewing applications.

In contemporary Alaska, shiny metal ulus often take the place of plaques — engraved and handed out as awards. Handles may be of wood or jade.

Practitioners: Dave and Marilyn Hendren (Billikin Gift Shop, between Anchor Point and Homer); Rebecca Kelly (Fairbanks); Maurice F. Ivanoff (Elim; wood handle ulus); William Nelson (Dillingham); Jerry R. Omedelena (Nome); Will L. Smith (Anchorage, ivory ulus, knives, pins).

Sources: Alaska Wild Berry Products (Homer); Alaska Shop (Seward); Arctic Circle Gifts (Juneau); Ben Franklin Store (Juneau); Birch Tree Gift Shop (Fairbanks); Burnt Paw Northland Specialties (Tok); Billikin Gift Shop (custom ulus; between Anchor Point and Homer); Great Northern Cutlery Company (Anchorage); Ivory Jack's (Nome); Trapper Jack's (Anchorage); The Ulu Factory (Anchorage).

WALRUS IVORY

Bering Coast Eskimos are the only people allowed to harvest the Pacific walrus. Every part of the walrus has its use: The hides of females are used to cover boats; the meat is dried and frozen; the intestines become fabric for *kamleikas*; the ivory tusks are carved. The whole tusk may be used as the material for a single carving, such as a cribbage board, or the tusk may be sliced into sections. Sections nearest the skull contain a core of dentine, and this dentine may be used to simulate the central "rocks" of a carved seabird rookery.

Numbering about 180,000 in 1991, the Pacific walrus is neither endangered nor threatened. Nevertheless, U.S. Fish and Wildlife oversees the harvest of walrus. All legally harvested tusks are marked with a wired-on seal. Unworked tusks may not be sold, except as part of a walrus skull mount.

See also CRIBBAGE BOARDS, FOSSIL IVORY, IVORY, NUNIVAK TUSK.
Museums: American Museum of Natural History; Anchorage Museum of History and Art; Smithsonian Institution; University of Alaska Museum (Fairbanks).
Practitioner: Laura Grimes-Pahnke (Unalaska, walrus ivory jewelry).
Sources: See IVORY.

WATERCOLOR

Watercolor is a pigment or coloring matter that is mixed with water for use as a paint, or a painting executed with such paints.

In Alaska, watercolor is used to portray dozens of subjects, from totems to traplines, from wildflowers to log cabins, from huskies to Yupik dancers, from snowy mountain fastnesses to cats napping on a windowsill blessed with a southern exposure.

Bob White, a self-taught watercolorist trained in art history and sculpture at Southern Illinois University, creates watercolor tributes to Alaskan sportfishing. His paintings include "Saturday Morning Preflight, Tikchik Narrows" and "Last Fish of the Day, Nuyakuk Falls." White's paintings can be found in private collections from Sydney to Washington, D.C.

Anchorage artist Byron Birdsall was influenced by Russian Orthodox icons he saw in the churches of small Aleutian and Pribilof villages. In the mid '80s, he began to paint original icons in watercolor. He ornaments them with pearls and gems as well as gold leaf.

For additional information, consult Kesler Woodward's *Painting in the North*.

"Mother's Day," c. 1990, watercolor, JoAnn Wold. Limited edition print, 12 x 19 inches. "This is based on the house I grew up in, in Northern Minnesota. That's Mom on the porch. She never actually had time to sit because I came from a family of 14 — so I figured she deserved a day on the porch."

See also ICONS, PAINTINGS, PRINTS.

Alaska Alive: JoAnn Wold, past president of the Alaska Watercolor Society, gives instruction at UAF (Bristol Bay Campus) and conducts workshops throughout the state in watercolor and drawing. Peggie Hunnicutt occasionally teaches basic watercolor composition, color theory, design and techniques at UAA.

Museums: Anchorage Museum of History and Art; National Museum, Kampala (Uganda, Birdsall); Jean Haydon Museum (Pago Pago, American Samoa; Birdsall);

Smithsonian Institution (30 watercolor sketches by Kakarook).

Historic Practitioners: George Aden Ahgupuk (b. 1911 in Shishmaref); Edmond James FitzGerald (also worked in oils and murals); E. Helgason; Guy Kakarook; Joseph Kehoe (1890-1959); Robert Mayokok (1903-1983); James Kivetoruk Moses (1900-82); Mikhail T. Tikhanov.

Practitioners: Jody Agimuk (Fairbanks); Marlene Anderson (Anchorage); Teresa Ascone (Anchorage, posters, limited edition prints, notecards); Dot Bardarson (Seward); Kitty Bauer; Byron Birdsall (Anchorage); Marc R. Bourassa (Anchorage); Barbara Brease (Denali National Park); Jocelyn Cox (also works in prints, photography, mixed media, drawing); Paula Dickey (Homer); Mary Ann "Andy" Dunham (also works in clay, painting); Susan Pennewell Ellis; Naome Elton; Jackie Feigon (Aniak); Dora Gibler (watercolors, inks and pastels); K.N. Goodrich; Sheri Govertson-Greer; Jane Gray (Anchorage); AKA J.R. Gray); Spence Guerin (Anchorage); Steve Hileman (Soldotna); Peggie Hunnicutt; Susan Kraft (Eagle River); Katherine Little; Kathleen Adell Logan (landscapes and still lifes); Kathleen Lynch (formerly of Anchorage; now residing in Victoria, Canada); Sandy MacDaniel; Bill Sabo (also works in drawing, clay, sculpture); Charlen Jeffery-Satrom (Anchorage); Jackie Stewart (also works in glass); Jacquie Cote Suter; Tom Missel (Seward); Xenia Oleksa (Juneau); Helen J. Mason-Semeonoff (Anchorage; Kodiak Aleut artist); Gloria Rankin; Joyce Reynolds (water media); Willa de Sousa; Jean Shadrach; John Svenson (Juneau, represented by Cha's gallery); Nancy Taylor Stonington; Jacquie Cote Suter (Anchorage); Jane Terzis (also works in painting, mixed media); Dorothy Thompson (bold florals); Kara Thrasher (charcoal, silver leaf); Bob White (outdoor sports, sport fishing); Anne Williams; Gary Winegar (whimsical animals); JoAnn Wold (Anchorage, Rainbow Art and Frame).

Sources: Adventure Cafe (Anchorage); Alaskan Portfolio (Anchorage); Annie Kaill's (Juneau); Artique, Ltd. (Anchorage); The Artworks (Fairbanks); Elaine S. Baker (Anchorage, represents Bob White, Alexei Antonov, Yuri Sidorenko, Michael Boze, Robert Aaronem); Borders Books & Music (Anchorage); Cha (Juneau); Decker/Morris Gallery (Anchorage, represents Alvin Amason, Carol Crump Bryner, Ray Troll, Kes Woodward, Sheila Wyne, and many more); Fireweed Gallery (Homer); The Frame Workshop & Gallery (Anchorage); The Frameworks (Anchorage); Heritage Art & Frames (Anchorage); House of Wood (Fairbanks); Impressions (Sitka); Kaladi Brothers (Soldotna); Kirsten Gallery (Seattle, WA); Kolstad Gallery (Anchorage); New Horizons Gallery (Fairbanks); Northern Exposure Gallery (Kodiak); Petersburg Gallery (Petersburg); Rainbow Art and Frame (Anchorage); Resurrect Art Coffee House Galerie (Seward; original paintings and sculptures only, $350 to $25,000); Scanlon Gallery (Ketchikan); Side Street Espresso (Anchorage); Snowbird Designs (Anchorage); Toast Gallery (Anchorage); Through the Seasons (Kenai); Walleen's Northlight Gallery (Fifth Avenue Mall, Anchorage);

"Three's a Crowd" by Maryanne Wieland, 11 x 15 inches, embossed print.

Wayward Winds Studio of Art (Anchorage); Wolf Song of Alaska (Anchorage).

Referrals: Watch the Arts Section of the Sunday *Anchorage Daily News*, and their Friday magazine, 8. Visit the *Daily News*' web site at http://www.adn.com. And get in touch with the newly formed Kachemak Bay Watercolor Society, Homer, 907 235-6780.

WEB SITES, E-MAIL ADDRESSES OF INTEREST TO COLLECTORS

By Nature catalog, Miami, FL, carries amber, hematite, rose onyx, Ojibwa birch bark canoe replicas, etc. http://www.bynature.com.

A few Alaska artists maintain their own web sites. They include Ray Troll's FinArt (http://www.trollart.com), Raven's Window (http://kcd.com/ravenswindow), Teresa Ascone's Alaskan Portfolio (http://www.alaska.net/~alaskan) and Perimeter Alaska Artists Online (http://www.akgallery.com).

Troll commented to the *Anchorage Daily News* (Sept. 8, 1997), "I have conversations with guys in Brazil, people in England, fishkeepers in Denmark...."

Woodcarver John A. Nelson of Homer may be reached at http://www.xyz.net/~kkh711. A carver with 18 years experience, Nelson offers a full-color catalog for $5 (refundable with first order).

Norm Hays of Anchorage has won blue ribbons for his one-of-a-kind ornamental glass creations. They can be seen only at his home. E-Mail: norman@alaska.net.

Penelope Cyr-Lorenson of Kodiak will ship her handmade baskets anywhere. Call 907 486-5144 to discuss your needs, or dial up wildiris@ptialaska.net. Cyr-Lorenson weaves wonderful Adirondack backpacks in three sizes, as well as plant baskets with feet, distinctive and decorative key baskets, corn husk baskets — you name it.

Ivory and bone carver Cha, also known as CHA RNACIRCLE, keeps track of her work. She has carved 4,600 pieces as of December, 1997. She works in many unusual materials, such as fossil ivory, whale ear drums, oosiks, and walrus femurs, and has her own Juneau gallery. To request a color catalog of her work and the work of painters John Svenson and Bruce Shingledecker, address cha@juneau.com or www.juneau.com/cha. Her gallery also stocks bronzes by the Re'gats and blades by David Mirabile.

Fiber artist Colleen White of Palmer designs and weaves her own exquisite musk ox hair creations. They need to be seen and caressed to be appreciated. In lieu of personal sensuous contact, E-mail colleen@qiveut.com. Her internet address is www.qiveut.com. A color catalog is available at 800 478-5838.

For stained glass, contact Veronica and David Bennett at Eagle's Peak Stained Glass Studio in Tok, AK, at eglspeak@polarnet.com, or call (907) 883-GLAS.

A number of photographers also have electronic access. Among them:

* Ken Graham Stock Photo Agency & Assignments (Girdwood), 250,000 images from 58 Alaska photographers, kgraham@alaska.net.

* Flora and Fauna (Anchorage), works about Pacific Rim, www.floraandfauna.com

* Gage Photo Graphics (Anchorage), halgage@alaska.net

* Square Peg Studios, Kristen Kemerling, Anchorage, specializes in "people, people and people. No wildlife." www.alaska.net/~kristenk

* Alaska Stock (Anchorage), akstock@alaska.net

* William Bacon Productions (Anchorage), baconiii@juno.com

* Alaskan Wilderness Images, wildlife and nature stock, Leo and Dorothy Keeler (Anchorage), www.awimages.com

* Lisa J. Seifert, Wolf Studios, Anchorage. Commercial and public relations, interior architecture. seifert@corcom.com

* Southeast Exposure, Art Sutch, Paul Helmar and Mark Farmer, Juneau. Custom black and white and cibachrome printing. Wire service and legislative cover, portraits, events. sexpose@ptialaska.net

* Marion Stirrup (Kodiak), whose clients include General Mills, Patagonia, UNOCAL, Falcon Press, etc., 75734.176@compuserve.com

* Third Eye Photography, Randy Brandon (Anchorage), architectural, aerials, annual reports; 350,000+ images, thirdeye@alaska.net

* Photographer J. Pennelope Goforth, Aleutian Photography, and CybrrCat Productions can be reached in Ketchikan at jgoforth@ptialaska.net.

Mill Pond Press produces prints on paper and canvas for artists including Bob

Kuhn, Robert Bateman, Larry Fanning, Carl Brenders, Fred Machetanz, Daniel Smith, Luke Buck and others. Their e-mail address is 74774.3332@compuserve.com.

Alaska Auction Company in Anchorage holds auctions of art and antiques on a regular basis, sometimes as often as once a week. (907) 349-7078; www.AlaskaAuction.com.

For limited edition belt buckles, hand-tinted photos, old calendar plates from Juneau or Valdez, limited edition silver medals, souvenirs from the Alaska Yukon Pacific Exposition in Seattle (1909), the occasional red cedar bark basket, string of cobalt blue trade beads, carved Tlingit paddle, or "Bering" cigar box label, E-Mail dealer Kaye Dethridge in Sitka at aktoken@hotmail.com. Request his latest catalog.

For prints, originals, sculpture, native arts and crafts, and jewelry, browse at the two locations of Stephan Fine Arts in Anchorage. To reach them by E-mail: gallery@alaska.net.

Birchgrove Fine Arts & Antiques (Prosser, WA.) deals in first and second market prints by such artists as Bateman and Doolittle. e-mail: sales@birchgrove.com. web site:www.birchgrove.com.

Anchorage's Platinum Jewelers features the "Alaska Collection," platinum jewelry with Alaska gold nuggets. E-Mail: platinumjewelers@servcom.com. URL: http://alaskan.com/vendors/platinum.html.

Alaska's largest publisher is Alaska Northwest Books, celebrating its 40th year in business in 1998. AKNW publishes eight books a year, concentrating on the niche market of Alaska and the Pacific Northwest. They usually man a booth at major trade shows. To query them, dial aknwbook@aonline.com. A free catalog (published twice yearly) is available by calling Graphic Arts Center Publishing Co. at 800 452-3032.

Wizard Works of Homer publishes a Small Press Catalog mailed twice annually to more than 1,000 libraries, book stores and gift shops in Alaska, as well as about 1,200 book stores and libraries Outside. The catalog represents Alaska's small publishers, including the Alaska Native Language Center and Alpine Publications. It is listed on the internet at www/xyz.net/~wizard. Catalog publisher Jan O'Meara represents her clients at major trade shows, such as the Made in Alaska Trade Show, the Make it Alaskan Festival and the Alaska Library Association Conference.

Artique Ltd. in Anchorage has been offering fine arts and crafts since 1971. They can be reached at http://www.artiqueltd.com.

Readers interested in unusual craft supplies, crafting as a business, or how-to kits should know about Lark Books (Asheville, N.C.). Visit their website at http://www.larkbooks.com/. Or reach them via e-mail at larkmail@larkbooks.com.

WHALE BONE

"Their fishing and hunting implements lie ready upon the canoes, under straps fixed for the purpose. They are all made, in great perfection, of wood and bone; and

DALE DEARMOND

Limited edition woodcut prints were the forte of Alaskan artist Dale DeArmond.

"I've always made things with my hands," DeArmond reflected in 1979,

"crafts, painting, printmaking. My primary interest for a number of years has been printmaking. Something about repeating images and the surprising things that happen when you put ink on wood or metal and impress it on paper is endlessly fascinating."

For many years, DeArmond lived in Juneau. She created prints and woodcuts, intaglios and test runs on thick, Japanese raw pulp rice papers. Her images included woodcuts of historical Juneau, a series illustrating raven legends, and miscellaneous spirited birds and animals. Occasionally she created a landscape that seemed almost abstract in its bleakness, like "Night on an Ice Island" (1967, edition of 10). Sometimes there was an ode to a narrow-gauge northern railroad or yet another Russian Orthodox church. Alaska was canneries and cormorants, fishermen and wild iris.

Book cover, 1975.

"...the wood itself has its own message so that you can hardly fail to produce something interesting," she said modestly.

Dale DeArmond was born in Bismarck, N.D, and bred in St. Paul, MN and Tacoma, WA. She married in 1935 in Sitka, worked as a librarian in Juneau, and began gouging out her distinctive woodcut prints in 1960. Her books include *Juneau: A Book of Woodcuts* (1973), Raven (1975), and *Dale DeArmond: A First Book Collection of Her Prints* (1979). Many of her prints were sold through *Alaska* magazine. In addition, her work was shown in an exhibit of 100 prints at the Boston Museum of Science in 1978.

Dale now resides in the Sitka Pioneer Home with her husband, historian and book reviewer Robert "Bob" DeArmond.

differ very little from those used by the Greenlanders."
— Captain James Cook, writing of the people of the Aleutians, in October 1778

"In one particularly poor village (Melvin Olanna) could find nothing to use as a medium to demonstrate the (arts and crafts) program. Close questioning of the people brought no solution. So, he went for a walk and was kicking at things along the beach while trying to answer the question, 'What can these villagers use to start with?' He kicked again and stopped.
'That was it! Whale bone from the beach.'
"He collected several pieces, hurried back to the village, and experimented with carving the bone. It 'worked' fine and finished beautifully. He sent young boys to collect more whalebone and scheduled a meeting that night to show the people....Many times Mel has had to resort to his imagination to enable villagers to work with locally available media, thus avoiding debts for the purchase of ivory or other expensive material."
— Esther T. DeWitt, "Melvin Olanna," *Alaska Journal,* Autumn, 1971.

Because trees do not thrive on Arctic tundra, Eskimos "in the old days" recycled the long, strong, curving ribs of whales as roof supports for their cozy sod houses. Smaller bones from whale skeletons were sometimes collected and burned as fuel for cooking. Ribs and jawbones were used to make bow drills for carving.

Today, Eskimos live in Western-style frame houses. Whale bones, particularly the central cores of vertebrae, which can be 10 inches thick, are used for carving. The natural porosity of the lightweight, pale gray-to-brown bone gives it an attractive, openwork surface. Whale bone carvings may be accented with inlaid ivory or baleen, or with ink. Slabs of whale bone are commonly used as bases on which ivory carvings such as snow geese and standing polar bears are mounted.

In an essay in *Eskimo Dolls,* Susan Fair surmises that the current interest in whale bone carving in certain Alaskan villages "can be traced to workshops in 1971 in which Gabriel Gely, a Canadian arts specialist and artist who had worked in similar programs in Canada, came to Shishmaref to impart enthusiasm and new ideas to village carvers."

Gely also passed on some Canadian marketing techniques.

Esther DeWitt paints a somewhat different picture in her article "Melvin Olanna," in *Alaska Journal* (quoted above). Olanna, a resident of Shishmaref, used the material he recommended to others himself, and was awarded major public commissions in Anchorage, Fairbanks and Nome for works featuring whale bone.

The whale bone used is scrounged from the beach. It needs to be aged bone because recently butchered bone leaves residue on clothing and smells foul. Some bone is scavenged from archaeological sites and historic house ruins, but most of it is

gathered on the surface.

Author's Note: During the 19th century, white traders and whalers mistakenly called baleen "whalebone." However, the words are not synonyms. To differentiate between them, I have used "whale bone" (two words) to indicate the skeletal parts of whales.

For more information, refer to *Whaling: A Way of Life* (Circumpolar Press, Anchorage).

See also BALEEN, CARVING, SCULPTURE.

Museums: Anchorage Museum of History and Art; NANA Museum of the Arctic (Kotzebue, AK); Carrie McLain Museum (Nome); Rasmussen Collection, Portland Museum of Art (Portland, OR.).

Historic Practitioners: Melvin Olanna (Shishmaref).

Practitioners: Cha (Juneau, whale ear drums, etc.); Louis Iyakitan, Jr.; Bill Jones (Shishmaref); Burt Kuzuguk (Shishmaref); Harrison Miklagook, Sr. (Savoonga); Harry A. Morgan Jr. (Anchorage); Glenn Nayokpuk (Shishmaref); Herbert Nayokpuk (ivory and bone, Shishmaref); Reuben Nicholson (Wales); Wilson Okoomealingook (Savoonga; known for his lifelike detail); Arnold Olanna (Brevig Mission); Karen Olanna (Juneau); Leonard Olanna (Brevig Mission); Victor and Davis Ongtowasruk (Wales); Carson Oozeva (Gambell, whalebone masks); Wilson Oozeva (Gambell, whalebone bears); Bert Oozevesuek (Gambell, owls and puffins); Aaron Oseuk (Gambell walrus and ptarmigan); Charlie Pardue (Haines, handcrafted knives); Alvin Pootoogooluk; Robert Pootoogooluk, Jr. (Shishmaref); Harvey Pootoogooluk (Shishmaref, whale bone dancers, flounders wearing masks); Edith Rivera (Anchorage); Bellarmine A. Seeganna (Nome); Daniel Seetook (Wales).

Sources: Aatcha's Shop (Haines); Alaska General Store (Anchorage); Arctic Art (Anchorage; also carries soapstone, ivory, antler and horn); Cha For the Finest (Juneau); Chilkat Art Co. (Anchorage); Inu Craft (Kotzebue; also features ivory, birch bark, jade); Inua (Homer); The Ivory Broker (Anchorage); Ivory House (Anchorage); Little Switzerland (Ketchikan); NANA Museum (Kotzebue); St. Lawrence Island Ivory Carvers' Coop (Gambell); Nayokpuk General Store, c/o Percy Nayokpuk (Shishmaref); Point Hope native store; Portfolio Arts (Juneau).

Referrals: Photographer Jim Magdanz, Nome and Kotzebue.

WILLOW

More than 50 species of willow grow in Alaska. They vary from tiny alpine shrubs whose reptilian trunks seem to creep along the moist tundra like floral sidewinders, to shrubs and sizeable trees.

Native Alaskans used particular species in specialized applications, from medicinal to culinary. Young willow leaves are edible. Willow bark was twisted into twine suitable for weaving into fishing nets and fishing lines. Withes from the supple Sitka willow *(Salix*

"Kluane," 38 x 30 inches, woodcut., by David Mollett of Fairbanks

sitchensis) were used for weaving baskets, and to reinforce birchbark baskets.

Willow roots were used by Athabascan basketmakers. In the Yukon River region, they were collected in late spring when river water fell from its breakup high. As the flood retreated, it exposed willow roots, which were collected by gently pulling them from the soft, muddy, yielding banks.

Collected roots were steamed over a fire to loosen their outer skin. Then they were pulled through a split stick or through the weaver's teeth to remove the bark. Once the bark was removed, the roots were split with a thumb nail into the proper size for weaving. The finished material was stored in neat bundles or coils until needed.

Just before weaving, some roots were dyed. These were used for the decorations that would be woven into the basket. Designs were traditionally geometric, although flowers and butterflies are popular today.

Grass baskets are soft and foldable. Willow root baskets, however, are sturdy and rigid, and can carry heavy loads. For more information, peruse *From Skins, Trees, Quills and Beads: The Work of Nine Athabascans*, which contains a profile of Lina Demoski.

See also BASKET, DIAMOND WILLOW, SPRUCE ROOTS.

Practitioners: Lina Demoski (Anvik); Rolin Allison (North Pole); Bonnie Gale; Janice E. Perkins (Sleetmute).

Practitioners (mixed media willow sculptures): Brenda Milan (Anchorage, One Woman Designs).

Sources: See under BASKET.

WOODCUTS

A woodcut is a print or impression made from a block of wood engraved in relief. It is also called a "wood engraving" or a "wood-block print." In the 1800s, wood engravings were used to illustrate books and newspapers.

Blocks to which a layer of linoleum has been glued are used with a similar technique, to produce "linoleum block prints."

One of the best-known Alaska practitioners in the woodcut medium is Dale B. DeArmond, an Alaskan since 1935. One-person exhibitions of her work have been held at the Charles and Emma Frye Art Museum (Seattle), the Anchorage Museum of History and Art, the Alaska State Museum (Juneau), and the Museum of Science (Boston). The prolific DeArmond also published two books, *Juneau, A Book of Woodcuts* (1973) and *Raven, A Collection of Woodcuts* (1975).

Another talent to watch is Eric Bealer. Bealer uses end-grain blocks of maple for his images, and a hand-operated press to produce each individual print. His editions are signed and numbered. Then the block is canceled.

For more information, read M.B. Michaels' *Woodcuts: Prints by Six Artists From Fairbanks* (Sky High Publishing, 1996).

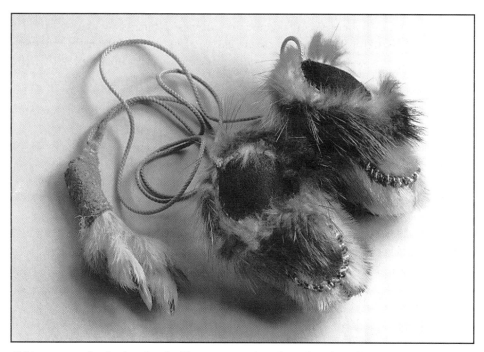

Eskimo yo-yo, fur, leather, beads, felt, commercial cording, thread, stuffing, with ptarmigan foot handle, Lucy Beaver, Bethel, 1987. Each "moccasin," 2.75 x 1.75 inches. "I catch that ptarmigan. I eat that ptarmigan. I use that foot," Beaver told the author. Private collection.

Historic Practitioner: Ted Lambert.

Practitioners: Eric Bealer (Skagway); Dale DeArmond (Sitka); Spence Guerin; Scott Hansen (Fairbanks); Dorothy "Dee" Oldham Joesting; Bernard Tuglamena Katexac (b. 1922, King Island, Nome); Darleen Masiak (Fairbanks); Martha Maskowiak (Unalaska); David Mollett (Fairbanks); Rebecca Poulson (Sitka, represented by Decker/Morris); Carolyn Reed (Unalaska); Joseph E. Senungetuk (Eskimo, b. 1940); Wendy Shaft (Anchorage; linoleum); Todd Sherman (Fairbanks); Susan Woodward Springer (Seldovia, hand-rubbed linoleum block prints); Lynn St. Armand; Vivian Ursula (Fairbanks).

Sources: Artique Ltd. (Anchorage); Decker/Morris Gallery (Anchorage); Mailboxes Etc. (Anchorage); Hering Bay Mercantile (Seldovia); Nicky's Place (Unalaska); Rain Song Gallery (Juneau); Rie Munoz Gallery (Juneau); SITE 250 Fine Art (Fairbanks); Soho Coho (Ketchikan).

YO-YO (ESKIMO)

The Eskimo yo-yo is a toy composed of two "orbiters" at opposite ends of a stout cord of 30 to 40 inches in length. It is a relative of the South American bolo, used for

downing game birds. The orbiters are generally spherical, but may also take the form of matched sealskin mukluks, seals, gloves or other cultural items. They are miniature examples of skin-sewing, often trimmed with seed beads. A village where yo-yos are still made is Quinhagak (70 miles south of Bethel).

Teacher Alert: For directions on using this toy, consult Chris Kiana's *50 Eskimo Yo Yo Tricks* (H&K Corp., Grand Junction, CO.). An instructional video by Kiana is available from Tokotna Video.

Practitioners: Lucy Beaver (Bethel); Annie C. Don (Mekoryuk); Chris Kiana (Anchorage); Kimberly Mosquito (Anchorage); Susie Shavings (Mekoryuk); Olia Pauk Sutton (Togiak); Lillian Tiulana.

Sources: Alaska Native Medical Center gift shop (Anchorage); gift shop at Innoko National Wildlife Refuge (McGrath); Olia's Alaska Native Arts (Togiak); University of Alaska Fairbanks Museum.

A QUESTION OF AUTHENTICITY

"Alaska's vibrant, dynamic indigenous people and their art and crafts are significant visitor attractions. In recent years there has been a renaissance of Alaska Native art and crafts, and a growing pride and awareness of Alaska's unique indigenous art. Of note, entrepreneurs outside Alaska also capitalize on this growing market. An estimated 85 percent of art and crafts sold as Native-made are not authentic."
— "Cultural Resources Sector Working Group Report," Marketing Alaska, Draft 10/11/95.

When you shop in Alaska, be sure what you are purchasing.

Because the Native arts and crafts industry amounts to many millions of dollars annually, counterfeits and frauds have entered the market. Some sweat shops in Asia have purchased Native names — or made up Native names — with which they "autograph" carvings, pottery or other souvenirs. Furthermore, visitors may be led to believe that mass-produced items have been individually created. In fact, it is reported that authentic ivory carvings have been used to create molds without the artist's permission.

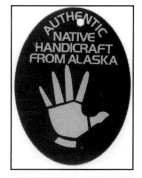

How can you be sure you are looking at authentic Alaskan arts and crafts? First of all, don't be shy. Ask shopkeepers to authenticate. Ask for the name of the artist and his or her tribal affiliation.

Secondly, the Alaska State Council on the Arts is a good starting point for detailed information on Alaska's contemporary art activities. The Council can be reached in Anchorage at info@aksca.org.

Thirdly, for a state-wide listing of museums and cultural centers, write to the Alaska State Division of Tourism, Box 110801, Juneau, AK 99811-0801; 907 465-2010. Another source of information is the Alaska Tourism Marketing Council, at http://www.travelalaska.com. If planning a vacation in Alaska, trip-planning materials are available from the Council at Box 110801, Juneau 99811.

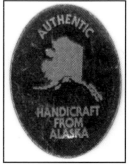

Fourth, when visiting any particular town or city in Alaska, call the local convention and visitors bureau for recommendations of artists and galleries, and for listings of permanent or special exhibits.

Last but not least, collectors should look for three reliable symbols, established in the early 1960s by the State of Alaska: "Silver Hand," "Alaskan Resident," and "Made in Alaska."

Each of these symbols appears on an oval tag, silver print on a black background. The "Silver Hand" logo shows an open hand with the words "Authentic Native Handicraft From Alaska." This guarantees that the article to which the tag is attached was hand-crafted by an Alaskan Eskimo, Aleut or Indian craftsman or artist. Inside this folded tag the artist will have recorded his or her name, village of residence, and perhaps his or her Silver Hand registration number. An "Alaska Native" is defined as being at least one quarter Alaska Native blood and a current resident of the state.

The Silver Hand name and logo have been registered by the Department of Commerce and Economic Development and are protected by Alaska statute. It is a class B misdemeanor to misuse the logo.

Each year, the Alaska Division of Trade and Development issues a Silver Hand Directory of authenticated artists and craftspeople. The Directory includes addresses and phone numbers. Using the Directory, collectors can get in touch with Native artists directly, visit them in their homes or workshops, and be assured they are acquiring genuine indigenous art.

Update: The Silver Hand program was moved from the Department of Commerce and Economic Development to the Alaska State Council on the Arts on Aug. 21, 1997. Revised plans for how to deal with marketing, promotion, outreach to artists and enforcement of federal laws regulating the labeling of Native American art are now in the works. Call (907) 258-2878 for details.

The "Alaskan Resident" tag bears a silver outline map of the state, with the words "Authentic Handicraft from Alaska." This tag indicates that the article was created in Alaska by a resident, but stops short of identifying any particular ethnicity with that resident.

If you want a Yupik doll created by a Yupik skinsewer, therefore, look for the Silver Hand label rather than the Alaskan Resident label.

The "Made in Alaska" logo is a mother polar bear nose-to-nose with her cub. This indicates an item genuinely manufactured in Alaska.

Whenever possible, art or craft items bearing these tags have been made with Alaskan materials, but this is not feasible in all cases. (See FEATHERS.)

In recent years, masks have been a particular favorite of craftsmen in workshops in foreign countries, who copy them from books or museum catalogs. When purchasing a mask, feel free to ask the salesman for proof of origin.

Because of the concern by many Americans about endangered elephants, ivory is particularly suspect. Walrus are not an endangered species and no one need be concerned about purchasing walrus ivory. (See WALRUS IVORY for facts about har-

vest limitations.) Furthermore, when museums with ivory carvings in their collections reproduce these carvings in a polymer material, the copies are clearly marked with the museum's initials or some other readily apparent device.

Anyone with knowledge of art counterfeiting or other frauds is asked to report them to the Alaska Division of Trade and Development, 3601 C Street, Anchorage, AK 99517, or to the Federal Trade Commission, 2806 Federal Building. 915 Second Avenue, Seattle, WA 98174.

THE PLACE OF ART IN RURAL ALASKA

"In many rural communities subsistence comes first, and art is secondary."
—"Cultural Resources Sector Working Group Report," 10/11/95.

If you fall in love with the art of a particular Native artist, have patience. The entire male carving population of St. Lawrence Island goes out whaling every day in April, weather permitting, and will not be interested in producing a standing ivory bear for you during that month. In May, all the carvers may be after walrus. Wait until a more opportune time. Be persistent. Write cordial notes. Keep in touch with local cooperatives and the proprietors of village stores.

Meanwhile, don't hold your breath.

IVORY FRAUD

Forgers have attempted to reproduce everything from the diaries of Adolf Hitler to canvases by every Impressionist in the Louvre. In brief, art frauds are anything but rare, and ivory fraud is no exception.

As long ago as 1930, popular travel writer Mary Lee Davis warned consumers in *Uncle Sam's Attic:* "Old ivory has for ages been precious for its lovely soft color; and tourists in Alaska to-day pay high prices for long strings of exquisite old ivory beads. But I warn you, before buying, to consult one who knows, just as you would in buying rare furs or precious stones. The soft velvety colors of truly prehistoric mastodon are so prized that sharpsters have discovered artificial means of coloring new walrus ivory (by a short boiling in seal oil or, so I'm told, even in coffee!) so that it takes on a temporary coloring similar in appearance to that acquired by centuries of genuine soil burial...."

Antiquing ivory continues in the area of scrimshaw, says William Gilkerson in *The Scrimshander* (1978). Gilkerson writes that "people who, while perhaps not forging teeth, want to color their work in passing to give it an antique-looking pati-

na," will employ baths in strong tea for "that old, yellow look."

How does one distinguish genuine teeth or tusks from cleverly contrived fakes? Collector E. Norman Flayderman gave this caution in his massive bible of the craft, *Scrimshaw and Scrimshanders* (1972): Trust your instincts. "If it does smell bad (seem fraudulent) in any way, then accept it as bad and leave it alone."

When examining scrimshaw of ships, boaters have an advantage; examine the hull and rigging for technical errors. The genuine 19th-century whaler or sailor who passed his spare time engraving knew ships' gear intimately; the forger with the X-acto blade probably doesn't — although he may crib from illustrations in books about sailing.

Dealing with the living carver face-to-face, it's hard to go wrong.

Another method, of course, is to consult a knowledgable appraiser, such as Butterfield & Butterfield of San Francisco; 213 850-7500.

SHIPPING COLLECTIBLES HOME

Many collectors will hand-carry their masks and other purchases to Minnesota or wherever they call home.

(I know when I purchase a new "prize," I request yards of bubble wrap inside a carton--and then never let the piece out of my sight, even if that means taking a mask to dinner and on walks along the beach! Sorry, honey!)

Collectors who enter Canada with certain items should be aware of laws governing inter-state commerce. Art or crafts created from the body parts of wild animals are subject to international regulations regarding trade in endangered species. When Americans attempt to carry art purchases into or through Canada, regulations established under the Convention on International Trade in Endangered Species (CITES) will apply.

Whale parts, for example, are restricted under CITES. However, Americans may purchase by-products of whales taken for subsistence by Eskimos and hand-crafted. Mere polishing or autographing of a walrus tusk or piece of baleen does not constitute "handcrafting," however.

Since 1993, tourists carrying arts and crafts in their personal luggage have been allowed to bring them into Canada if they have a Personal Exemption Certificate. These certificates can be obtained from U.S. Fish and Wildlife offices in Anchorage, Fairbanks, Juneau, Ketchikan, Sitka and Tok. Animals to which the certificate applies include bears, river otters and walrus. Items will be seized by Canada Customs if the proper permits do not accompany them.

Americans may mail hand-crafted walrus ivory home to another state of the union without a certificate.

On the other hand, products made from animals on the most-endangered species list (which changes annually) cannot be transported without an import and an export permit. These permits are granted only when the item is to be used for educational purposes or scientific research.

The collector would do well to consult the U.S. Fish and Wildlife Service (907 271-6198) or the Alaska Department of Fish and Game well before driving up to an international border checkpoint. For further customs information, write U.S. Customs Service, 1301 Constitution N.W., Washington, DC 20229.

CARE OF MATERIALS

Even if the objects you are collecting cost under $25, you owe it to yourself to conserve them carefully.

Large galleries and museum shops should be able to provide collectors with instruction sheets for the care of bronzes, alabaster carvings, paintings with appendages, masks adorned with feathers, etc. Frame shops should inform you about acid-free mats and other means of protecting prints and photographs. (If a frame shop doesn't know what you're talking about, go elsewhere.)

Details are available from the Conservation Department of the Alaska State Museum in Juneau.

AMBER:

Clean with a soft cloth dipped in warm water mixed with a few drops of mild dish-washing liquid. Don't use a brush. Wrap in cotton, and then store this soft, fragile stone separately from other jewelry to prevent chipping and breaking. Remove amber jewelry before immersing yourself in salt water or chlorinated pools; salt, chlorine and laundry detergents can erode amber's luster and finish.

Amber is a natural material, not a stable manufactured substance; it should not be cleaned with a sonic jewelry cleaner.

BASKETS:

Whether made of split beach grass, spruce or willow root, cedar bark or birch bark, baskets are fragile collectibles. Careful handling is a must.

1) Do not fold baskets, or store them one-inside-the-other.

2) Keep from heat sources, lamp light and direct sunlight.

3) Most baskets benefit from humidity. Fifty to 55 percent is ideal. However, do not expose baskets to steam or water directly.

4) Avoid keeping things in baskets which will change their shape or react with their materials.

5) Clean grass baskets by gently running a small, clean paintbrush over their surfaces, or using a tiny vacuum (the type used on computer keyboards). However, over time, even this can cause abrasion.

Insider Tip: Emily Johnston of Nunivak Island is one of the few Alaskans who can repair grass baskets, bowls, trays and dance fans. She weaves in traditional Cup'ik Eskimo style, a coiled style learned from her grandmother Pansy and her mother Carrie.

CORAL:

Do not clean with a sonic jewelry cleaner.

Some beads can be damaged by perfume or hairspray; don your beads after using these products.

FABRIC:

Any collectible executed on fabric should be considered an "heirloom" fabric from the very start, and given exacting care. Never wait until the material is yellowing, fading or fraying to preserve it.

Act before signs of age appear.

Sculptures in stone or metal can take a good deal of abuse, but textiles are unforgiving. Light, insects, food stains, and even touching textiles does them no good. Touching, for example, can deposit minute amounts of skin oils, and these deposits will age differently than the rest of the fabric--often discoloring.

1) Do not store heirloom fabrics (button blankets, etc.) in a cedar chest. Cardboard boxes and processed paper are also verboten for storage because wood and processed paper can leach damaging substances into fabric.

The serious collector invests in acid-free storage boxes.

2) Never store aged textiles in plastic wrap. The plastic can trap moisture and even discolor fabric.

3) Don't fold. Any fabric folded for a long time can disintegrate along the fold lines. Roll large items around an acid-free cardboard tube.

4) Do not machine wash, because machine agitation can destroy weak fibers.

5) Don't display/hang the fabric in such a way that stress is put on any one part. If suspending it in a frame, have a professional suspend it with invisible stitches of nylon fishing line from all sides.

6) Keep textiles from heat sources and out of direct sunlight. (Above the mantel of a fireplace is a risky position for any collectible except perhaps a bronze casting.)

7) Dust particles can scratch and roughen; protect fabrics from dust.

FUR:

Whether mink teddy bears or hair seal parkys, collectibles made of fur must be

kept out of the reach of dogs, who will treat them as small prey animals.

1) Dust and dirt are harmful to fur. Some collectors preserve their fur-dressed Eskimo dolls or fur-trimmed skin masks in shadowbox frames. Others find glass display domes handy protection for small dolls and baskets.

2) Parkys should be dry cleaned by firms skilled in leather cleaning.

3) Hang fur in a dirt-free, grease-free place free of mice or other vermin.

4) When shipping, do not fold, wad or stuff. Roll fur pieces into their container.

Master furrier David Green of Anchorage gave these recommendations about collectibles made of fur or dressed in fur:

A) "Use a hand-held blow vacuum cleaner to take out the dust that settles into the fur; that dulls it.

B) "Keep from heat and light.

C) "Once in a while [i.e., every 5 to 7 years), it wouldn't hurt to rub with some cleaning solvent by hand. But apply the solvent sparingly so it won't work into the leather at the base of the hairs."

IVORY:

Obviously, walrus ivory grew in a damp habitat. Carvers allow green (i.e., newly harvested) tusks to dry for at least two weeks and up to several months before they are carved, but finished carvings may still develop cracks. To prevent cracks, oil your ivory about every six months with a generous amount of mineral oil.

Smooth the mineral oil on, rubbing well. Allow the oil to set for 24 hours. Then wipe off with a soft cloth.

Avoid placing ivory in direct sunlight or above a heat source such as a length of hot water baseboard or a forced-air furnace vent.

Alaska collectors often keep their ivory in a glass-fronted case, and include in the case a small cup of water to increase the humidity therein.

Ivory is a stark bond paper white when new, but after about 30 years acquires a pleasing creamy color. This sign of genuine antiquity should not be disturbed.

Keep delicate ivory carvings out of the reach of children.

Dingy elephant ivory piano keys? The Yankee Magazine Home Fix-It book instructs, "To clean the ivories, try any of the following: denatured alcohol, yogurt or a solution of whiting powder found in paint stores. Avoid getting the whiting solution between the keys."

PHOTOGRAPHS:

Avoid magnetic or "no stick" photo albums. Most of the adhesives in such albums will eventually damage prints.

Keep photos in a dark, cool place, ideally below 70 degrees F.

Keep photos away from paint, varnish and cleaning solvents, because fumes from

such liquids accelerate deterioration.

Resource: The Better Image, Box 164, Pittstown, NJ 08867; 908 730-9105; an experienced conservator of photographs.

PRINTS:

Several states, including California, Georgia, Michigan and New York, have passed laws providing for disclosure in writing of information concerning fine art prints prior to effecting a sale of them. These laws require that the gallery/gift shop provide a Certificate of Authenticity which discloses the identity of the artist, the authenticity of the artist's signature, the medium ("oil on linen," "acrylic on canvas," "torn paper collage," "mixed media on posterboard"), number of artist's proofs created, whether the print is a reproduction, information about the plate or master used to produce the print, and the number of multiples in a "limited edition."

In states with these laws, a potential purchaser can request this information be transmitted prior to payment. If, after payment and delivery, it is revealed that the information provided is incorrect, the purchaser may be entitled to a refund upon return of the print in its sale condition.

In addition to a Certificate of Authenticity, a gallery may give a purchaser a Portrait of the Artist — a single-sheet resume´ which highlight's the artist's background and significant achievements.

When framing a print, terms to know are "archival foamboard," "conservation framing," "acid-free shrink wrap," and "non-glare acrylic." "Conservation framing" is a method which utilizes special materials designed to preserve artwork in its original condition for generations. Acrylic, for example, is often recommended instead of glass, because acrylic is several times more shatter resistant than glass, and possesses ultraviolet light filtering properties.

The best hinges are Japanese paper made with wheat- or rice-starch paste.

For referrals to framers with high conservation standards, call your local museum, or query the American Institute for Conservation of Historic and Artistic Works, Washington, D.C. (202) 452-9545.

See also LITHOGRAPHS.

SOAPSTONE:

A soapstone carving is chiseled and rasped into its basic shape. Then it is finished with wet and dry sandpaper, and rubbed with oil. The oil may be linseed, mineral or even baby oil or car wax. When purchasing a soapstone carving, inquire about the oil used to finish it. Annually wash the surface with a gentle soap. Allow to dry overnight. Then apply a fresh coat of oil.

STERLING SILVER:

Frequent wear helps prevent tarnishing. Chlorine can cause pitting.

Paste jewelry cleaner is best for intricate designs and small crevices.

Keep from light, air, and damp.

Never store sterling silver in cotton-filled boxes. Cotton makes it tarnish more quickly.

WOOD:

As it dries, wood can become brittle and crack. Regulated humidity helps, as does keeping it from heat sources and direct sunlight.

Don't use worked wood pieces for activities for which they were not intended; for example, a diamond willow cane is not a pry bar, and a cedar rattle is not a tack hammer.

For information about caring for contemporary woodworking, contact John Magee of Anchorage, a member of the Alaska Creative Woodworkers Association.

Ann Chandonnet

Recommended reading

Birdsall, Byron. *Byron Birdsall's Alaska and Other Exotic Worlds* (Graphic Arts Center and Epicenter Press, 1993).

Boas, Franz. *Primitive Art* (Dover Publications, Inc., 1955).

Campbell, L.J., Staff Writer. *Native Cultures in Alaska,* Vol. 23, No. 2 of Alaska Geographic (The Alaska Geographic Society, 1996).

Carved History, illustrations by Joann George (Alaska Natural History Association, 1979, 1996).

Chandonnet, Ann. "The Goodales," *Alaska Journal,* V, 4 (Anchorage, Alaska Northwest Publishing, 1975).

Chandonnet, Ann. "Ten Alaskan Artists: An In-Depth Look at Their Lives, Their Craft, and Their Works," *Anchorage* Magazine (Anchorage, 1, no. 8).

Chandonnet, Ann. "Sophia Pletnikoff's Cloth Made of Grass," *Alaska Journal,* V, 1 (Anchorage, Alaska Northwest Publishing, 1975).

Chandonnet, Ann, Editor. "Alaskan Art & Writing," double issue of *Northward Journal,* Nos. 21/22. (Ontario: Penumbra Press, 1981).

Chandonnet, Ann. "Whale Bone Carvers of the Bering Sea," Land's End catalog (December 1997).

Coe, Ralph T. *Lost and Found Traditions: Native American Art 1965-1985.* (The American Federation of Arts, 1986).

Coe, Ralph T. *Sacred Circles, Two Thousand Years of North American Indian Art* (Arts Council of Great Britain, 1976).

Collins, Henry B., Frederica De Laguna, Edmund Carpenter and Peter Stone. *The Far North: 2000 Years of American Eskimo and Indian Art* (National Gallery of Art and Anchorage Historical and Fine Arts Museum, 1973).

Corey, Peter, Editor. *Faces, Voices & Dreams: A Celebration of the Centennial of the Sheldon Jackson Museum* (University of Washington Press, 1988).

Duncan, Kate C. *Some Warmer Tone: Alaska Athabaskan Bead Embroidery* (University of Alaska Museum)

Duncan, Kate C. and Eunice Carney. *A Special Gift: The Kutchin Beadwork Tradition* (University of Washington Press, 1988).

Fair, Susan W. "Alaska Native Arts and Crafts." Vol. 12, No. 3 of *Alaska Geographic.* (Alaska Geographic Society, 1985).

Fienup-Riordan, Ann. *The Living Tradition of Yup'ik Masks* (University of Washington Press, 1996).

Fienup-Riordan, Ann, Editor. *Agayuliyararput, Our Way of Making Prayer, Yup'ik Masks and the Stories They Tell* (Anchorage Museum of History and Art, 1996).

Frost. Orcutt W., Editor. *Cross-Cultural Arts in Alaska* (Alaska Methodist Universi-

ty Press, 1970).

Himmelheber, Hans. *Eskimo Artists* (Fieldwork in Alaska, June 1936 to April, 1937) (University of Alaska Press, 1993).

Holm, Bill. *The Box of Daylight: Northwest Coast Indian Art* (Seattle Art Museum and University of Washington Press, 1983).

Holm, Bill. *Northwest Coast Indian Art: An Analysis of Form* (University of Washington Press, 1967).

Holm, Bill. *Spirit and Ancestor: A Century of Northwest Coast Indian Art at the Burke Museum* (Burke Museum and University of Washington Press, 1987).

Jonaitis, Aldona. *From the Land of the Totem Poles: The Northwest Coast Indian Art Collection at the American Museum of Natural History* (University of Washington Press, 1988).

Jones, Suzi, Editor. *The Artists Behind the Work.* (Life history and craft of Nicholas Charles, Sr., Frances Demientieff, Lena Sours and Jennie Thlunaut) (University of Alaska Press, 1986).

Laughlin, William S. *Aleuts: Survivors of the Bering Land Bridge* (1980).

Lavallee, Barbara and B.G. Olson. *Barbara Lavallee's Painted Ladies and Other Celebrations* (Epicenter Press, 1995).

Morgan, Lael. *Art and Eskimo Power: The Life and Times of Alaskan Howard Rock* (Fairbanks, Epicenter Pres, 1988).

Moses, Shirley and Holly Krieg, editors. *Sharing Alaska Native Cultures: A Hands-On Activity Book.* (Teacher Alert: For children in grades K-12; activities include making snow goggles, masks, button blankets, parky trim, birchbark baskets and Aleut visors) (University of Alaska Press, 1993).

Ray, Dorothy Jean. *Eskimo Masks: Art and Ceremony* (University of Washington Press, 1967).

Samuel, Cheryl. *The Chilkat Dancing Blanket* (Pacific Search Press, 1982).

Steinbright, Jan, Editor, with Dixie Alexander and others. *From Skins, Trees, Quills and Beads: The Work of Nine Athabascans* (Institute of Alaska Native Arts 1985).

Stewart, Hilary. *Looking at Indian Art of the Northwest Coast* (Douglas & McIntyre and the University of Washington Press, 1979).

Stewart, Hilary. *Looking at Totem Poles, with a foreword by Norman Tait* (Douglas & McIntyre and University of Washington Press, 1993).

Van Zyle, Jon. *Jon Van Zyle's Alaskan Sketchbook* (Epicenter Press, 1998)

Wallen, Lynn Ager. "The Dancers and the Dance," *The Alaska Journal,* Vol. 16 (Alaska Northwest Publishing Co. 1986).

Wingert, Paul S. *American Indian Sculpture, a Study of the Northwest Coast* (J.J. Augustin, 1949).

Woodward, Kes, with an introduction by Suzi Jones. *Wood, Ivory and Bone: 1981 Native Art Competition.* (Alaska State Council on the Arts, 1981).

◆◆◆◆◆

INDEX

"The Hunter," embossed print, 11 x 15 inches, by Marianne Wieland.

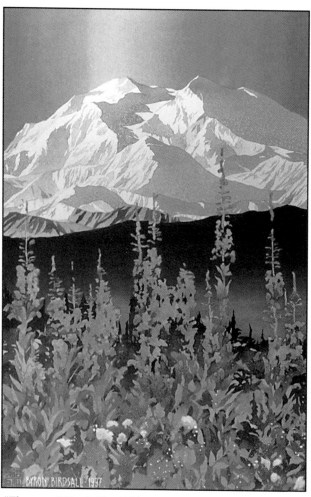

"Flowers of Fire," 17 x 10" by Byron Birdsall

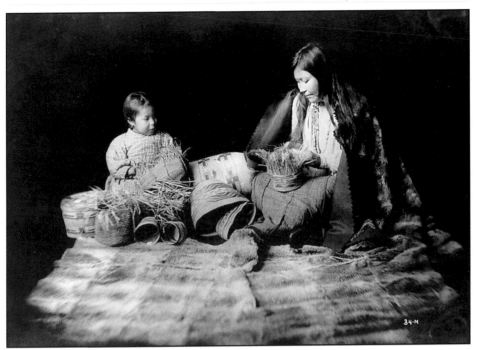

"Native basket weaver," mother and child seated on a fur robe, copyright 1906 by Case & Draper.

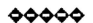

Photo credits/Permissions

Photos are by Ann Chandonnet, Fernand L. Chandonnet and Roy Corral as noted. These are the property of the author and may be reproduced in reviews, with a limit of three per review. Others are listed below:

AC, back cover (bentwood hat).
FLC, **43, 131, 132.**
RC, **background of front cover, front cover, back cover,** xi, 42, 52, 53, 54, 82, 139, **161.**

xiii, photo by Alan Austin, courtesy Pat Austin, Port Townsend, WA. Page **2,** "Waiting for the Wolf Dance," AMHA, # 85.63. Pages **8, 35, 59, 121,** Dover Publications.**15,** grass basket, Anchorage Museum of History and Art (AMHA). **19,** AMHA. **26,** photo by Boyer Photography, 1995, courtesy Barbara Lavallee. **33,** "Tussock Trekker," Wendy Croskrey, Fairbanks. **38,** Picture Alaska Art Gallery, Homer. **47,** Winter & Pond, AMHA. **49,** AMHA. **50,** Sydney Laurence, AMHA. **55,** Decker/Morris Gallery and Don Decker, Anchorage. **57,** The Anchorage *Times.* **58,** Decker/Morris Gallery. **65,** Bella Coola house front, Image FCP 26, courtesy Larry Garfinkel, Garfinkel Publications, Vancouver, B.C. **67,** photo by Art Sutch Photography, Juneau, courtesy Cha. **75,** Byron Birdsall. **79,** Byron Birdsall. **93,** mask, T. Mike Croskrey, Fairbanks. **101,** AMHA. **111,** Mary Beth Michaels, Clear, AK. **104,** photo by Art Sutch Photography, Juneau, courtesy Cha. **106,** Eustace Ziegler, AMHA. **107,** Susan Lindsey. **108,** AAJAES chart reproduced courtesy Wanda Seamster; copyrighted material from *Vizual Dog,* October, 1997, Wanda Seamster, publisher. **110,** Decker/Morris Gallery, Anchorage. **113,** Todd Sherman. **114,** parky by Norton, AMHA, CIRI Collection, # 86.6. **123,** Judi Rideout, Palmer. **124** and various decorative elements from linoleum block prints/cards throughout (such as the one at the top of this page), Susan Woodward Springer, Seldovia. **128,** The Anchorage *Times.* **130,** The Chilkat Dancers. **135,** "Flight out of body into the tunnel of light," AMHA, CIRI Collection, # 86.34. **136,** Bob Espen, The Turner's Den, Anchorage. **137,** "The Break of Day," CIRI Collection, AMHA. **145,** totems in Southeast Alaska, Alaska Historical Library, Juneau. **151,** JoAnn Wold, Rainbow Art, Anchorage. **159,** David Mollet, SITE 250, Fairbanks. **177,** "The Hunter," Marianne Wieland, Sand Lake Studio, Anchorage. **182** and **back cover,** Byron Birdsall. **182,** "Flowers of Fire" (fireweed and Mt. McKinley), Byron Birdsall. **187,** "Native basket weaver," Case and Draper photo, Alaska and Polar Regions Archives, Rasmuson Library, University of Alaska, Fairbanks, # 83-204,240N. Every effort has been made to obtain permission for artwork reproduced here.

About the Author

Ann Chandonnet first encountered Alaska's arts and crafts on Kodiak Island in 1965. Since 1973, she and her family have resided in the Anchorage area.

Chandonnet's span of interests and publications characterize her best as a Renaissance woman. She has interviewed and profiled such 20th century lights as psychiatrist Anna Freud, singer James Taylor, poet Gary Snyder and artist Judy Chicago. Noted for her versatility, Chandonnet also covered the first female/midget wrestling match staged in Alaska, wrote the first comprehensive history of the Athabascan village of Eklutna, and edited an important international appreciation of the arts and crafts of Alaska. Her writing has been translated into Russian, French, Spanish and Italian.

She was a staff writer for The Anchorage *Times* for 10 years. Her articles about history and the arts appeared there, as well as *Early American Life* magazine, *American Indian Basketry, Alaska Journal*, the Anchorage *Daily News, California Girl, Pacific Search, Alaska Geographic*, and a variety of other publications. Most recently, she profiled Bering Sea whale bone carvers for the Land's End catalog. Chandonnet is also a food historian and author of the award-winning *Alaska Heritage Seafood Cookbook* (1995).

Other titles by this prolific writer include *Chief Stephen's Parky* (1989), *Ptarmigan Valley* (1980), and *Canoeing in the Rain* (1990).

"With a brush, you make a stroke and it's there forever. You don't do anything about it, just go on to the next. With writing, you never know when you are done. I rather like it."
— Byron Birdsall in *Byron Birdsall's Alaska & Other Exotic Worlds* (1993).